THE LANDSCAPES OF 9/11

THE LANDSCAPES OF 9/11

A PHOTOGRAPHER'S JOURNEY

PHOTOGRAPHS BY JONATHAN HYMAN

Edited by Edward T. Linenthal, Jonathan Hyman, and Christiane Gruber

University of Texas Press ‖ *Austin*

Library of Congress Cataloging-in-Publication Data

Hyman, Jonathan
 The landscapes of 9/11 : a photographer's jour-
ney / photographs by Jonathan Hyman ; edited by
Edward T. Linenthal, Jonathan Hyman, and Chris-
tiane Gruber. — 1st ed.
 p. cm.
 Includes bibliographical references and index.
 ISBN 978-0-292-72664-2 (cloth : alk. paper)
 ISBN 978-0-292-74908-5 (pbk : alk. paper)
 1. September 11 Terrorist Attacks, 2001—
Social aspects—United States—Pictorial works.
2. Memorials—United States—Pictorial works.
3. Memorials—Social aspects—United States.
4. Oral history—United States. 5. Documentary
photography—United States. 6. Memorials—
Social aspects. I. Title
 HV6432.7.H96 2013
 973.931—dc23 2012035501

doi:10.7560/726642

CONTENTS

ACKNOWLEDGMENTS

I owe my deepest gratitude to Leon Golub, my painting instructor at Rutgers University. A person known for his integrity and intellectual honesty and curiosity, Leon is also well known for his artwork, which, among many things, speaks to the issue of social justice. Our student-teacher relationship evolved over time into a friendship and we remained in touch over the years until his death in 2004. His influence on me was broad, ranging from the use of materials in my work and the process by which I made it to the way I generated ideas, looked at pictures, and thought about myself as an artist and photographer. We often spoke as much about non-art-related matters as we did about art. Leon stressed that all of the things one knows and does come to bear upon the creation of art. And so it is with me.

The central goal of my work as a documentarian revolves around presenting what I see as impartially as possible. But it was Golub who really made me see that I had a responsibility to show the good, the bad, and the ugly—all of it—without self-censoring, while at the same time ensuring that no one else would censor my work either. Twenty-three years ago when I began

to focus on photography more than painting, he supported this shift because he understood that I, unlike himself, was having difficulty expressing the things that were important to me by making paintings. He said to me, "Photography is easier when you think about it. But likely harder once you start messing around with it. You could always stay a painter because you're pretty good at that. Or maybe you shouldn't. Tricky business, this art thing, no?" He chuckled. I winced. But I understood exactly what he meant.

I had a sense from a young age that I might become an artist, and though I had always taken pictures and made art in school, I entered college not knowing enough about art or myself to actually make that happen. At a point in one's life when being taken seriously is a novelty, I had the good fortune to be involved with instructors who not only encouraged me but also demanded that I think, read, make art, and report back to them. As an undergraduate art major at Rutgers University in the late 1970s and early 1980s, I had the good fortune to learn from a number of engaging and talented teachers. In addition to Leon Golub, I wish to acknowledge the people whose instruction in art and art history was invaluable to me. Without the constant encouragement and high standards set for me over the course of four years by Phil Orenstein, I might have never become an artist. I also benefited greatly from studying with Lloyd McNeil, Peter Stroud, and Matthew Baigell. While at Hunter College as a graduate student, I was helped immeasurably by Robert Swain, Sanford Wurmfeld, Vincent Longo, and, in particular, by Mark Feldstein, who insisted that I submit to my passion for public expression

and begin to take pictures of all kinds of art on the side of the road.

Early on in my long-term work documenting the visual culture of the 9/11 attacks, there were a number of supportive people without whom I might have either not continued my work or failed to see the meanings and importance of particular iconography, imagery, patterns of expression, or social and historical context. In addition to discussing and viewing my work with me, all, at one time or another, supported my work when they didn't have to. Jan Ramirez and Charles Brock, both of whom have made significant contributions to this volume, have been thoughtful colleagues and generous listeners. Smithsonian photo historian and curator Shannon Perich and Yale sociologist Jeffrey Alexander provided suggestions and ideas about the practice of cultural memory, art, documentation, and photography that situated my work in a context that not only raised more questions than the answers they delivered, but also set me on a path of discovery. I have been assisted immeasurably by my friends and colleagues at the Solomon Asch Center for Study of Ethnopolitical Conflict at Bryn Mawr College. Clark McCauley, Marc Ross, Paul Rozin, Roy Eidelson, and Lee Smithey have all engaged me in insightful and instructive conversations that have enhanced my understanding of my work and compelled me to think differently about how others view and interpret my documentary project. Rutgers University American Studies Professors Michael Rockland and Angus Gillespie worked with me, on campus and off, to discuss and disseminate my documentary work—at a time when many were still unwilling to engage in serious conversation about the folk art

made in response to the attacks. The self-lessness and fearlessness of my friend and assistant Manuel Peña was and continues to be an inspiration. The friendship, ongoing encouragement, and assistance I have received from Marc and Rayna Pomper and Dennis Wheeler have been a source of strength to me. Several times when I wanted to put my 9/11 documentary work down, they wouldn't let me.

I have had the good fortune of working with and listening to the stories of some very thoughtful and helpful members of the New York City Fire Department and their families. In particular I owe a debt to T. C. Cassidy, Steve Orr, Bob Stiehl, Mike Jezycki, Ernie Bielfeld, and John Leonard. I received invaluable help from both the artists whose work appears in the photographs I made and the people who had their own bodies tattooed, and I wish to thank them as well. Special thanks go to Joe Indart, Rocco Manno, Lenny Hatton III, Billy Pfaff, Thomas McBrien, and the fire departments of Nashua, New Hampshire, and Tinton Falls, New Jersey. The openness and willingness of all of these people to participate in my work has been one of the most touching and rewarding experiences of my life.

There are a number of other people who, through their professional assistance and advice, made contributions to this book. Alyssa Adams, Michelle Bird, Wally Bird, Peter Bunnell Michael Bzdak, Fred Caruso, Bruce Clark, Randall Collins, Alix Colow, Paula Gillen, Howard Gillette, Karen Glynn, Ron Grele, Alex Harris, Jeff Hirsch, Juha Hollo, Jeff Howard, Po Kim, Pedro Lasch, Jack Lee, Tim Marr, Milly Marmur, Crary Pullen-Nichelsberg, Kathy Reid, Tracy Revis, Steve Salemson, Silvia Schultermandle, Michael Shulan, Brendan To-

bin, Charles Traub, Alan Weitz, and Bonnie Yokelson were all most helpful. A special thanks goes to curator Jeffrey Wechsler, whose advocacy and curatorial efforts on my behalf have been uncommonly kind and insightful.

I wish to thank the National September 11 Memorial & Museum, the National Constitution Center, and Duke University's Special Collections Library for their willingness to exhibit my work and present it to an international audience. In particular, it was Gretchen Dykstra and Clifford Chanin who ensured that my work was the national 9/11 museum's first public programming. I am grateful that the museum continues to support my work. Rick Stengel and Steve Frank made my National Constitution Center exhibition a success. At Duke University, University Librarian and Vice Provost for Library Affairs Deborah Jakubs (with assistance from the Center for Documentary Studies) provided the support for engagement with my work over a period of time that led to the display of my work and accompanying substantive programming. All three exhibitions proved to be invaluable because they provided me with a perspective on my own work and documentary process that was essential in helping me organize both my thoughts and the materials for this book.

I have the good fortune of being friends with three great photographers. Without their counsel and material support I would never have accomplished much at all. A special and hearty thanks to Joseph Coscia Jr., Dana Duke, and Courtney Grant Winston.

I am grateful to the contributors to this volume for their interest in my work. Credit for the University of Texas Press imprima-

tur on this book goes to co-editor Christiane Gruber. It was she who organized the presentation materials that convinced our editor, Allison Faust, that this book was worth making. Allison's patient care and her conviction that my photographs and the materials surrounding my project were important and worthy of a wide audience, combined with Christy's unparalleled editing, writing skills, and visual acuity, make this a book worth reading and looking at.

Thanks also to our fine editorial and design team at the press.

Lastly, there would be no book without my other co-editor, Edward Linenthal. I am indebted to him for his support both personally and professionally over the course of many years. He has shown me wisdom, kindness, a steady hand, and a generosity of spirit that are, in effect, not only his signature on this book, but a life's lesson.

Jonathan Hyman

THE LANDSCAPES OF 9/11

INTRODUCTION

Edward T. Linenthal

The Landscapes of 9/11: A Photographer's Journey introduces readers to the extraordinary multiyear photographic project of Jonathan Hyman, whose work comprises approximately twenty thousand photographs encompassing a range of American memorial expression in response to the September 11, 2001, attacks. His journey took him to nineteen states and Washington, D.C., over the course of a decade. This book is, however, much more than a selection of his photographs. Hyman takes readers on a most unusual journey, explaining why he undertook this venture, recollecting the aesthetic and logistical issues he faced, and recalling some of the relationships he formed along the way.

Hyman is a photographer passionately engaged with the dynamic and diverse memorial aftermath of catastrophe. His work reflects a sensitivity both to the diverse landscapes populated by memorial expression and to the personal stories that animated and gave shape to so much of this expression. "I have tried," he explained, "to present the 9/11 memorial response I saw as woven into the fabric of the landscape and indeed the fabric of daily life." Hyman has photographed urban murals;

1

interior and exterior memorials at firehouses; memorial gardens (often accompanied by sculpture); roadside memorials; street signs memorializing an individual; a wide variety of hand-painted and decorated cars and trucks; and houses, trees, and yards bedecked with handmade and factory-produced American flags.

Of particular interest to Hyman were those individuals who chose to imprint on their bodies the memory of 9/11 through tattoos. The act of making oneself a permanent memorial to those murdered speaks powerfully about an evolving memorial culture that not only allows people to be memorialized in novel pictorial ways but also heightens the sense of loss, since individuals have given over—sacrificed—a portion of their body. Hyman worked conscientiously to establish good relationships with people whose body art he wished to photograph. "Sometimes," he recalled, "it took two to three months or more of phone calls and screenings by friends or family members before I could meet and photograph a tattoo subject." Eventually, many people revealed to him what for them was intimate memorial expression and allowed him to capture on camera these revelations of self.[1]

Beyond the years of Hyman's labor and the sheer mass of the archive, what makes this project worthy of a book? After all, 9/11 was a horrific visual spectacle. There are legions of coffee table books capturing the intimate entanglement of horror and allure that is a constitutive component of the visual record of catastrophe. While he was not speaking specifically about photographs, the World War II veteran and academic philosopher J. Glenn Gray called our attention to the "delight in seeing" and the "delight in destruction" he experienced in wartime. We are fascinated, he wrote, with "manifestations of power and magnitude . . . astonishment and awe appear to be part of our deepest being."[2]

Photographers captured the drama of the agony of the World Trade Center towers in New York City, the wounded Pentagon, and, equally eloquently, a single photograph of smoke that offered evidence of the crash of United Flight 93 in a field near Shanksville, Pennsylvania. In New York, professional and amateur photographers captured people escaping from the towers, running through lower Manhattan in search of safety. Photographers recorded the last moments of the lives of firefighters and other responders climbing the tower stairs in search of survivors. They took photographs of other people taking photographs. They photographed people looking at the towers as events unfolded. In "I Took Pictures: September 2001 and Beyond," Marianne Hirsch wrote, "Through photography I can become a witness in my own right, a witness not so much of the event as its aftermath, a witness to the other acts of witness all around me."[3]

Certainly, professional photographers have paid some attention to post-9/11 memorial expression, often focused on the immediate and spontaneous forms that arose in lower Manhattan, at the Pentagon, and in Shanksville. The visual eulogies ("Portraits of Grief") to those murdered in the World Trade Center, published in the *New York Times* in the weeks after the attack, offered another distinctive form of memorial expression. Jonathan Hyman's project, however, is unmatched in duration and scope. For example, sometimes Hyman returned to previously photographed sites to docu-

ment the life cycle of images. At one point a wall in a gritty urban neighborhood featured the *Flower Power Mural*, depicting the World Trade Center towers containing or being made of flowers in multiple colors, framed by a luminous cityscape and night sky with red, white, and blue stars (Figure 2.1, next chapter). After the passage of several years, however, the same wall was blank, except for three solitary splotches of red, white, and blue (Figure 2.2, next chapter). Other murals revealed several "generations" of interpretation, as original images were wholly or partially painted over. These images were overlaid with new symbols or overwritten with new text, resembling visual jazz "riffs" on enduring memorial themes. These successive images are visual time capsules of popular American memorialization.[4]

Hyman's discriminating eye also captured a fascinating range of portrayals of the iconic image of the World Trade Center towers. The sheer number of images in which the towers appear allows readers to appreciate their symbolic malleability. They appear, for example, in vibrant colors, perhaps signifying new life emerging from death; they are black, on fire, smoking, in rubble, appearing as candles, crosses, as if living on in a transcendent realm and transformed into towering firefighters. One of Hyman's photographs shows two such living towers, one holding a baby, clearly evoking the central icon of the Oklahoma City bombing, a photograph of firefighter Chris Fields cradling in his arms the fatally wounded one-year-old Baylee Almon[5] (Figure 1.1).

Ubiquitous in the aftermath of the attacks, the American flag was no less malleable than the towers. Like anyone who went out in public, Hyman was confronted with flags of all types, many generic, some spectacular in their size and rendering, and still others magnificent in their inventiveness. The flag has been used variously in the public response to the attacks by people from all political points of view. In fact, Jonathan's own mother-in-law turned down a photograph that he had gifted to her because it featured a hand-painted flag that was used by others in a manner she disliked. Given the flag's symbolic polyvalence, each contributor to this volume considers the varied meanings of the American flag, its uses in a political context, its cultural inflections, and its strategic application to different places and surfaces.

I first met Jonathan Hyman in the spring of 2006, when Steve Frank, vice president of Education and Exhibitions at the National Constitution Center in Philadelphia, invited me to participate in a day-long meeting to select some of Hyman's photographs and write some brief text panels for the center's five-year anniversary exhibition of Hyman's work, *9/11: A Nation Remembers*, which ran from September 8, 2006, through January 1, 2007. It had been approximately five years since my book, *The Unfinished Bombing: Oklahoma City in American Memory*, had been published, virtually on the eve of the 9/11 attacks. Because of this book, I was drawn inexorably into post-9/11 memorial conversation. In December 2001, I joined several friends from Oklahoma City—the attorney Robert Johnson, who for many years directed the memorial project, and Phillip Thompson, whose mother's remains could not be recovered from the wreckage of the Alfred P. Murrah Building for five weeks—to speak at a town meeting at Shanksville High

School, not far from where the actions of the passengers and crew caused the crash of United Flight 93 in western Pennsylvania. Approximately a year and a half after that meeting, I organized a three-day seminar in Oklahoma City for family members of those killed on Flight 93, along with others already active in memorial planning in the Somerset/Shanksville, Pennsylvania, area. Shortly after that, I accepted an invitation to serve as a member of the Flight 93 National Memorial Federal Advisory Commission. By the time Steve Frank invited me to Philadelphia, I was immersed in and intrigued by the complexity of 9/11 memorial expression. When I joined Steve and Jonathan at the center, I was stunned by the rich world of memorial culture captured in Jonathan's photographs.

The authors of the essays in this book ponder the significance of Hyman's work through a diverse engagement with visual culture. Jan Seidler Ramirez, chief curator and director of collections at the National September 11 Memorial & Museum in New York City, has tracked Hyman's work since shortly after the event, and she believes that his photographs "are invaluable because they preserve a baseline of the nation's memorial fervor before a professionalized design process began to coalesce around the permanent National September 11 Memorial & Museum." Understanding Hyman as a singular figure among the "second responders" to 9/11, Ramirez explains that Hyman's photographs served as visual referents to the many sensitive issues that confronted the museum staff in shaping the museum's presentation. "For almost every topic weighting our interpretive discussions at particular junctures," she writes, "his picture library could be re-

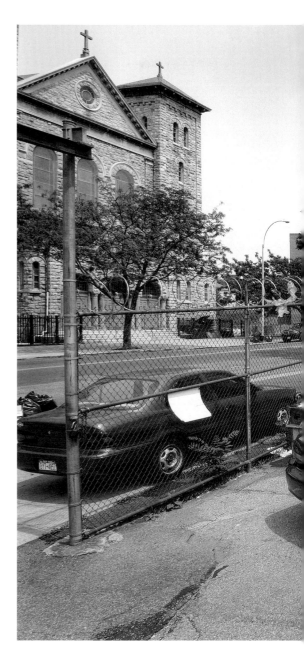

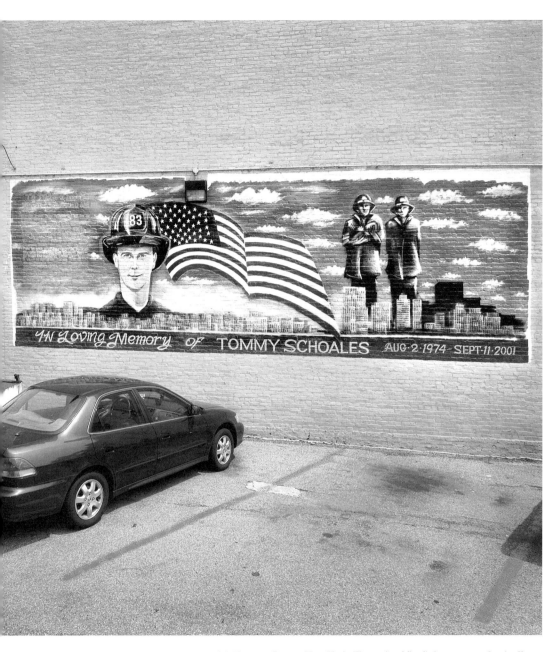

FIGURE 1.1. *Tommy Schoales Mural with Firemen*, Bronx, New York. The pair of firefighters metaphorically standing in for the World Trade Center towers in the New York City skyline evokes the central icon of the 1995 Oklahoma City bombing: the photograph of a firefighter cradling a fatally wounded one-year-old child. Photograph by Jonathan Hyman, 2007.

lied on to offer visual correlatives addressing these same issues or arguments, often at their formative stages."

Archival memory can only contain what is noticed, what is remembered. No matter how diligent Jonathan Hyman was, he could not capture what was for many too painful to record. However, as Ramirez notes, he did find and choose to photograph a rare mural representation of someone forced to leap from the towers. Even though such photographs depict one of the horrific realities of that morning, there remains for many an enduring concern that the integrity to "tell all and show all" can fuel a popular hunger for the spectacle of graphic violence. "Hyman's choice to eternalize the content of this mural," Ramirez wrote, "parallels the rationalizations and instincts influencing those who opted to preserve visual witness of these ineffable final moments." And the larger issue of what the memorial expression preserved by Hyman recalls and ignores is an important one. Components of visual culture can certainly soften or sanitize. Perhaps it is unrealistic to expect such popular images to do more than express widely comprehensible and easily digestible memorial forms.[6]

The next essay, by Charles Brock, associate curator of American and British paintings at the National Gallery of Art, situates Hyman's work in a historical context that goes far beyond the visual culture of contemporary catastrophe. The "documentary impulse" evident in Hyman's endeavor is deeply rooted in similar projects, Brock observes, for the "mixing of artistic pursuits with the more scientific, academic accumulation and organization of knowledge has been part and parcel of American culture since at least the time of Charles Willson Peale." Hyman's archive reminds Brock of the post–Civil War photography of Alexander Gardner, of Jacob Riis's shocking photographs of urban poverty in the late nineteenth century, of the photographs of New York City taken by Berenice Abbott in the 1930s, of the thousands of images of American folk culture gathered by the Works Progress Administration's Federal Art Project, and of the "nuclear-age atmosphere and revelatory qualities" of the photography of Robert Frank. For Brock, Hyman's photographs captured "transience and metamorphosis: buildings, bodies, flags, and eagles constantly meld and shift their identities." Hyman's archive, he believes, is invaluable for tracking changes and continuities in 9/11 aesthetic commemorative sensibilities.

Northwestern University's Robert Hariman and Indiana University's John Louis Lucaites, leading figures in the study of rhetoric and public culture, address the poverty and promise of vernacular expression and the instability of memory, arguing that the visual evidence in Hyman's photographs reveals a "limited repertoire of signs, marginal spaces, processes of decay, and a lack of cultural resonance." They are less confident than Hyman that there is much of a public conversation emerging from these vernacular images. They also worry that this memorial vocabulary is often made up of kitsch—"cheap imitation of stock images for sentimental appeal"—that is incapable of challenging viewers into more profound engagement through visual imagery. The iconography, they write, "comes almost entirely from the state or the entertainment industry, and the political sentiments run the gamut from A to B—more specifically, from patriotism to

vengeance." At best, they think it an open question whether such a limited memorial vocabulary can play a meaningful role in processes of civic restoration.

Their essay engenders important questions: Is some of the value of Hyman's archive not in its documentation of a rich, vibrant memorial culture, but in its documentation of an impoverished culture, at its worst nurturing limitless rage and increasing body counts of innocents here and around the world? And is it the case that, for example, the presence of the *Flower Power Mural* suggests that the memorial vocabulary is somewhat more diverse than Hariman and Lucaites allow? Does the presence of popular culture superheroes indicate the triumph of kitsch, or is their use as appropriate as the use of an eagle? Perhaps the more traditional, publicly situated memorial shrines present in Hyman's photographs serve, as Jack Santino argues, to "insert and insist upon the presence of absent people," restoring the dead "back into the fabric of society, into the middle of areas of commerce and travel, into everyday life as it is being lived," and serve mainly as immediate cries from the heart of the bereaved, soon to be as invisible as any other part of the everyday landscape.[7]

Of course, investigations into the cultural functions of memorial culture transcend the boundaries of the United States. The final two essays, by filmmaker and photojournalist Philip Hopper and art historian Christiane Gruber, respectively, use some of Hyman's photographs to recall their own explorations in memorial visual culture in Northern Ireland, the Palestinian West Bank, and Iran. Hyman's work helped Hopper think about tensions between official national narratives of "heroism, martyrdom, and victimhood" and vernacular images in Belfast, Bethlehem, and the Palestinian refugee camp at Dheisheh. He notes the power of visual culture to alter the terms through which someone experiences space and place as an "insider," or perhaps alienated by an assaultive message, and he argues that some of the murals at these sites are more open to revision than what he sees as the mostly stable 9/11 memorial images in Hyman's photographs. Whether stable or subject to revision, however, how can we know if or how these memorials change the terms through which passersby experience space? When people walk by a building with a mural of a plane crashing into the building's wall, or when they walk by the image of an angry American eagle seemingly staring at them, what is the impact? Does the first transport passersby into the horror of the murderous moment, helping them to "never forget"—as the mural's message instructs? If so, what are they not supposed to forget? The object of memory could be the attack, heroic acts of rescue, or their own personal experiences of the aftermath, which could vary widely depending on, for example, how "American" they looked. Perhaps the eagle comes alive in satisfyingly vengeful ways as reports of other terrorist attacks are made public, or during particularly charged times of U.S. military engagement in Iraq and Afghanistan. Or perhaps the eagle's gaze seems threatening to American immigrants from countries looked upon with suspicion. In either case, the presence of people in these photographs reminds readers that it is only through individual engagement with these images that their diverse meanings are active, come alive.

The dynamic and potent life of visual

culture is dramatically evident in Christiane Gruber's stunning images of Iranian murals relating to the Iranian Revolution (1979) and the Iran-Iraq War (1980–1988). These murals, many of which are made available here for the first time to an American audience, often use images of the American flag and eagle that offer an oppositional reading to their use in American memorial expression. And yet even such clashing messages are dependent on each other in an often harsh battle to own and deploy evocative symbols. For Gruber, the work of comparison reveals more than strategic positioning and repositioning of symbolic resources. It also demonstrates that the "visual cultures of war and trauma share an alluring array of thematic correspondences that reveal to us the various ways that humans—regardless of their national, cultural, and religious affiliations—can express a range of emotion by means of a visual language based on commonality rather than difference." For example, she observes, memorial expression in both countries encompasses nationalistic fervor, vulnerability and fear, hope and transformation. Such comparison can, she believes, "encourage us to look at the other with the grace and humanity with which we ourselves would like to be looked upon."

Both Hopper's and Gruber's studies point to the potential of using Hyman's archive in the service of comparative projects. Whether or not such explorations will lead us inexorably to a more humane vision of those treated as enemies is, I think, an open question. Possibly, more intimate knowledge of "enemies" could lead to a more profound hatred of them, and their defilement of, for example, sacred symbols of the flag and the eagle. And yet the categories of enemy, friend, or betwixt and between are often fluid, as we know from the immediate aftermath of World War II. And we know that meetings between American veterans of the Vietnam War and Russian veterans of the war in Afghanistan led to mutual recognition of suffering and service in controversial wars of choice. Like a double-edged sword, visual culture can contribute to both murderous and humane engagement with those categorized as "enemy."

While not speaking directly to all aspects of the visual imagery contained in Hyman's archive, the novelist Ariel Dorfman wrote movingly of how the photographs and personalized notices of the dead and missing that populated Manhattan immediately after 9/11 reminded him of how women in many countries—"from Chile to Kurdistan, from Argentina to Ethiopia, from Guatemala to Guinea"—stand in public with photos of missing sons and husbands who were murdered, often in acts of state-sponsored terrorism. Dorfman hoped that in the wake of 9/11, "the inhabitants of the most modernized society in the world may now be able to connect, in ways that would be unthinkable before September 11, 2001, to the experience of so many hitherto inaccessible planetary others." The "challenge of the moment," Dorfman writes, is "to find ways to make this new global tragedy draw us all closer to each other, not because we can now kill one another more easily and with more devastating effects, but closer because we share the same need to mourn, the same flesh that can be torn, the same impulse toward compassion." Ideally, Jonathan's project presents us with the opportunity to cultivate this impulse.[8]

Shortly after meeting Jonathan and

viewing several hundred of his photographs, it was clear to me that there was an important book to be done not only to introduce some of his massive collection of photographs to a wide audience but also to share the compelling story of his journey to produce this archive. As a first step toward such a book, I invited him to write an essay for a roundtable discussion we created for the *Journal of American History* entitled "American Faces: Twentieth-Century Photographs." His essay, "The Public Face of 9/11: Memory and Portraiture in the Landscape," appeared in the journal's June 2007 issue. In ongoing conversations with Jonathan, I was surprised to learn that some publishers had been uncomfortable with his photographs, finding some of them too "in your face," too gritty and angry for a book of memorial photographs. However, when I shared some of Jonathan's work with my friend and colleague Christiane Gruber, she immediately grasped the importance of Hyman's work, and led all of us to the University of Texas Press.

Jonathan, Christiane, and I are delighted that the Press has generously presented some of Jonathan's work in color, and that a group of distinguished colleagues agreed to write interpretive essays for this book. However, other challenges await. The photographs in this book represent, after all, only a select few from Hyman's collection of approximately twenty thousand photographs. This archive needs to be housed and preserved in an appropriate institution. We hope that the story of the archive has as happy an ending as the one that resulted in this book.

Notes

1. The significance of concealment as an act far beyond the merely decorative is explored in Marline Otte, "The Mourning After: Languages of Loss and Grief in Post-Katrina New Orleans," *Journal of American History*, 94 (December 2007): 828–836. Quoted material in the last two paragraphs from Jonathan Hyman, "The Public Face of 9/11: Memory and Portraiture in the Landscape," *Journal of American History* 94 (June 2007): 184, 190.

2. J. Glenn Gray, *The Warriors: Reflections on Men in Battle* (New York: Harper & Row, 1967), 28–34.

3. Marianne Hirsch, "I Took Pictures: September 2001 and Beyond," in *Trauma at Home: After 9/11*, ed. Judith Greenberg (Lincoln: University of Nebraska Press, 2003), 78. She continues, "within the first four minutes of the first impact, the *New York Times* had dispatched four photographers on assignment. One hundred people eventually submitted images for the front page of September 12. [. . .] Websites have been created to collect the images of amateurs and professionals, galleries have invited people to submit their images for public viewing, images are being sold for benefit purposes, exhibitions have opened around the country, magazines and newspapers continue to publish and republish professional and amateur photographs," 71. For more specific information on photographic exhibits, see Sara E. Quay and Amy M. Damico, eds., *September 11 in Popular Culture* (Santa Barbara: Greenwood, 2010), 247–291. For a more expansive reading of 9/11 photographs, see David Friend, *Watching the World Change: The Stories behind the Images of 9/11* (New York: Farrar, Straus and Giroux, 2006).

4. "Eventually," writes David Friend, "more than 2,400 Portraits of Grief would run in the *Times*," *Watching the World Change*, 206. These were also published in *Portraits, 9/11/01: The Collected "Portraits of Grief" from the New York Times*, with a foreword by Howell Raines and introduction by Janny Scott (New York: Henry Holt/ Times Books, 2002).

5. David Simpson focuses on the *New York Times* photographs. See David Simpson, "Re-

membering the Dead: An Essay upon Epitaphs," in David Simpson, *9/11: The Culture of Commemoration*, (Chicago: University of Chicago Press, 2006), 21–54. Two important studies of contemporary American memorial culture that offer smart commentary on 9/11 photographs are Erika Doss, *Memorial Mania: Public Feeling in America* (Chicago: University of Chicago Press, 2010), and Marita Sturken, *Tourists of History: Memory, Kitsch, and Consumerism from Oklahoma City to Ground Zero* (Durham: Duke University Press, 2007). Jeffrey Melnick also offers analysis of 9/11 photographs in *9/11 Culture* (West Sussex, England: Wiley-Blackwell, 2009). Judith Greenberg includes a few of photographer Lorie Novak's images of popular memorials in New York in *Trauma at Home*. Martha Cooper offers images of street memorials in New York City in *Remembering 9/11: Photographs and Words by Martha Cooper* (Brooklyn: Mark Batty Publisher, 2011). See Hyman's discussion of this particular mural in "The Public Face of 9/11," 187–188.

6. For more on the intense public discussion of whether or not photographs of those forced to jump should become part of the recognizable visual narrative of 9/11, see Tom Junod, "The Falling Man," *Esquire* 140 (September 2003); Friend, *Watching the World Change*, 127–145; and Rob Kroes, "Shock and Awe in New York City: 9/11 or 9-1-1? The Construction of Terrorism in Photographs," in *Photographic Memories: Private Pictures, Public Images, and American History*, ed. Rob Kroes (Hanover, N.H.: Dartmouth College Press, 2007), 170–182. Both books also mention a Thomas Hoepker photograph of young people lounging on the ground across the river in Brooklyn, seemingly oblivious to the horror unfolding in front of them. While the photograph appeared in a work by Colin Jacobson, Friend writes that it took "Hoepker four years before he was inclined to publish the shot widely." See Colin Jacobson, *Underexposed* (New York: Vision One Publishing, 2002), 143.

7. Jack Santino, "Performative Commemoratives: Spontaneous Shrines and the Public Memorialization of Death," in *Spontaneous Shrines and the Public Memorialization of Death*, ed. Jack Santino (New York: Palgrave Macmillan, 2005), 13. For a critique that focuses on the commercialization of 9/11, see Dana Heller, *The Selling of 9/11: How a National Tragedy Became a Commodity* (New York: Palgrave Macmillan, 2005). On how the ritual life of 9/11 can fuel extremism, see Ronald Grimes, "Ritualizing September 11: A Personal Account," in *Disaster Ritual: Explorations of an Emerging Ritual Repertoire*, ed. P. Post, R. L. Grimes, A. Nugteren, P. Petterson, and H. Zondag (Leuven: Peeters, 2003), 199–213. On the post-9/11 function of superheroes, see Jarret Lovell, "Step Aside Superman . . . This Is a Job for [Captain] America! Comic Books and Superheroes Post September 11," in *Media Representations of September 11*, ed. Steven Chermak, Frankie Y. Bailey, and Michelle Brown (Westport, Conn.: Praeger, 2003), 161–174; and Amy Kiste Nyberg, "Of Heroes and Superheroes," in *Media Representations of September 11*, 175–186.

8. See, for example, John W. Dower, *War without Mercy: Race and Power in the Pacific War* (New York: Pantheon, 1986), 301–317; John W. Dower, *Embracing Defeat: Japan in the Wake of World War II* (New York: Norton, 1999), 203–224; and Ariel Dorfman, *Other Septembers, Many Americas: Selected Provocations, 1980–2004* (New York: Seven Stories, 2004), 3.

A NEW AMERICANA—
VISUAL RESPONSES TO 9/11
A PUBLIC CONVERSATION

Jonathan Hyman

On September 11, 2001, the day of the terrorist attacks, when people began hanging store-bought flags and decorating both private and public property with memorial displays, artwork, handmade flags, and slogans, I knew I was looking at something familiar. For over twenty years, I had been photographing and collecting all kinds of American vernacular art in public places, in particular things by the side of the road. Since childhood, I have been interested in Americana and contemporary popular culture. I collect baseball cards and other trading cards, religious objects, masks, sports posters, comic books, kitsch figurines, and dolls. I also collect folk art, and, while he was still alive, I collected the paintings of an outsider artist who sold his work at a flea market in Pennsylvania Dutch Country. I once made a trip by car from New Jersey to Maine and took pictures of all kinds of Americana: velvet paintings, dolls, carpets, religious objects, chainsaw carvings, mailboxes, and lawn ornaments. I have also traveled to Mexico and parts of the United States to buy black velvet paintings.

In the first few months after the attacks, however, it was too early into my long-term 9/11 photography project to grasp what I

came to understand over time: Americans were talking to each other. Thrust into rare territory where a public and collective national catastrophe encouraged and enabled many people with little or no artistic training to speak out loud—in public, on their cars, houses, places of business, bodies, and anywhere else they could find the space to do it—Americans transformed the landscape by making artwork that became public expressions of mourning and remembrance.

I visited and photographed the attack sites in New York, Washington, and Pennsylvania, where people created makeshift memorials with signs, candles, flowers, pictures of the dead, and other handmade tokens of commemoration. But the memorial response to the 9/11 attacks was not limited to those sites. Like the shocking, unforgettable images of the burning World Trade Center towers, the variety of emotions elicited by the attacks spread across the nation and around the world, and along with them came the need to respond in some way to what had happened.

I began taking pictures on September 11, 2001, and initially set a one-year time limit on my daily documentary work. I then decided to extend my efforts through the five-year anniversary of the attacks. I continued past this deadline as well. During the course of the ten-year anniversary calendar year, I re-shot two hundred memorial objects and murals. Still today, I continue to travel with my camera every day, recording, though with much less frequency, the heartfelt and occasionally idiosyncratic ways people have displayed their sorrow, patriotism, anger, and, in some cases, wish for peace, unity, war, or revenge. I have journeyed from the inner city of my previous home in New York City to rural areas of New York State (where I currently reside), recording whatever I could, from the spectacular to the banal. Including detail shots and objects photographed intermittently over time, my collection contains twenty thousand photographs.[1] Although the majority of the photographs I took were shot within a 150-mile radius of New York City, I also covered territory from Maine to Florida and across parts of the Midwest. I returned to many sites over the course of ten years to take repeat photographs, sometimes from different vantage points in order to record the passage of time and also to document the nuances and particularities of the 9/11 memorial vocabulary. In the future, I believe scholars will consider how this public artwork changed over time a worthwhile and important element in understanding the variety of vernacular responses to the attacks (Figures 2.1–2.8).

The images in my collection depict a range of subjects and artistic styles: murals painted by graffiti artists and lay artists, farmhouses painted with gigantic American flags, firefighters and civilians with elaborate memorial tattoos, memorials to individuals and groups of people, and memorial depictions of the World Trade Center towers. Rather than documenting official, permanent memorials and artwork, I photographed visual and written expressions of of people's feelings about the attacks. Consequently, my photographs capture largely impermanent, spontaneous expressions created and encountered by people in their everyday lives. These unofficial public artworks produced a unique and discrete corpus of Americana surrounding a national catastrophe. These images depict a nation publicly coming to

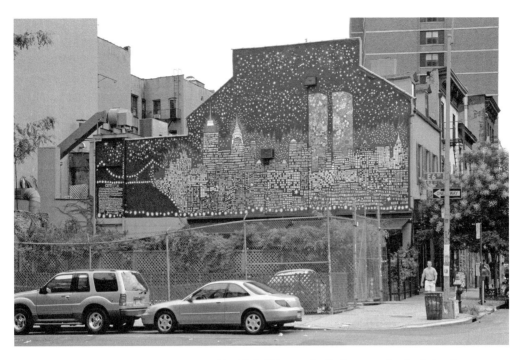

FIGURE 2.1. *Flower Power Mural*, Manhattan, New York. This mural calls for peace by depicting the towers as flowers, in a way that references American cultural history and the anti–Vietnam War "Flower Power" movement. Photograph by Jonathan Hyman, 2002.

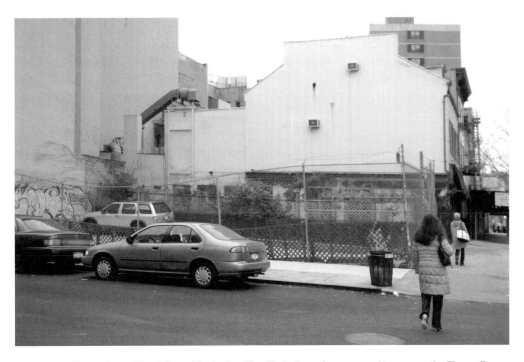

FIGURE 2.2. *Flower Power Mural Gone*, Manhattan, New York. Over the course of ten years, the Flower Power Mural wall has been "scrubbed," and this wall was repainted at least twice. After seeing the original mural missing, someone threw red, white, and blue paint at the wall, creating this unique flag. The entire building was ultimately replaced by a high-rise building. Photograph by Jonathan Hyman, 2006.

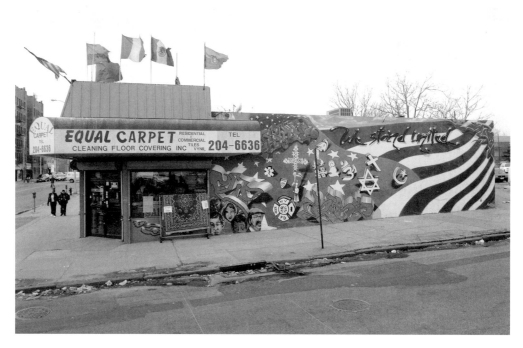

FIGURE 2.3. *Queens Carpet Store Mural*, Queens, New York. Photograph by Jonathan Hyman, 2004.

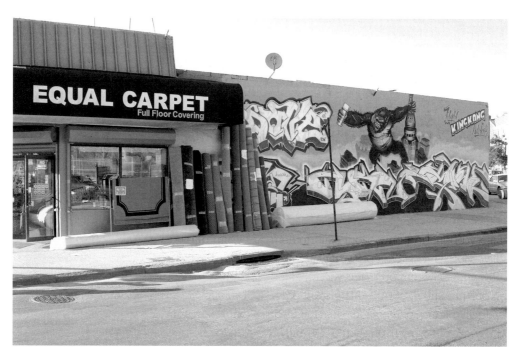

FIGURE 2.4. *Queens Carpet Store Mural Gone*, Queens, New York. Prior to the 9/11 attacks this "permission" wall was used by a local graffiti crew as their gallery space. After having left a 9/11 mural intact for several years, the store owner redecorated and the crew eventually went back to painting murals with subject matter culled from popular culture. Photograph by Jonathan Hyman, 2006.

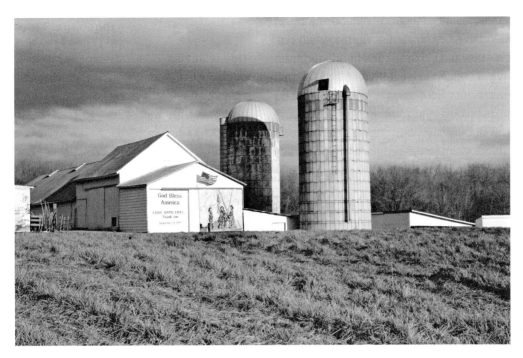

FIGURE 2.5. *Mural with Silos*, Warwick, New York. Photograph by Jonathan Hyman, 2001.

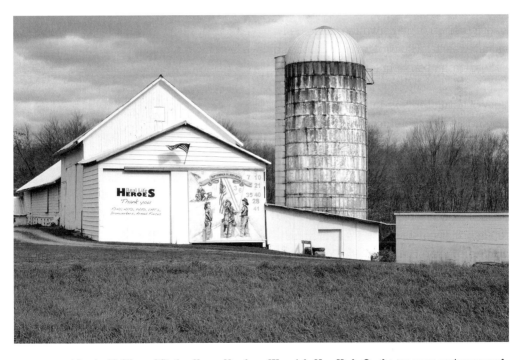

FIGURE 2.6. *Mural with Silo and Station House Numbers*, Warwick, New York. On the ten-year anniversary of 9/11, muralist Rocco Manno repainted the mural he made shortly after the attacks. Over time Manno learned of the large number of New York City firefighters from his community who had died on September 11. Determined to improve upon his earlier generic mural, he set out to create a memorial to specific firefighters whose families he had come to know, but he was dissuaded from listing their names. Instead he painted the numbers of the engine or ladder companies in which the men served. Photograph by Jonathan Hyman, 2011.

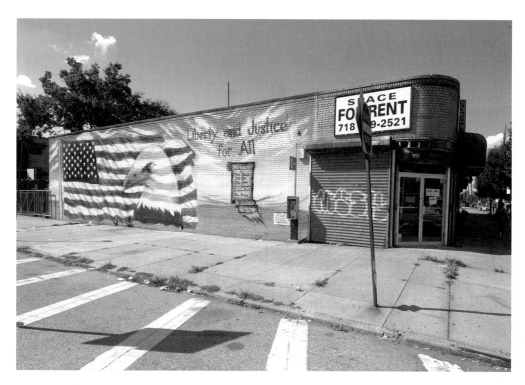

FIGURE 2.7. *Liberty and Justice for All*, Brooklyn, New York. Photograph by Jonathan Hyman, 2005.

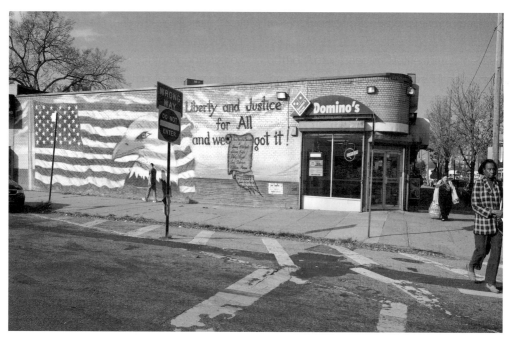

FIGURE 2.8. *And We Got It*, Brooklyn, New York. After United States Navy SEAL Team 6 killed Osama bin Laden on May 2, 2011, muralist Joe Indart returned to a mural he painted shortly after the attacks and, referring to the word *justice*, added the words *and we got it*. Photograph by Jonathan Hyman, 2011.

grips with a horrifying and shocking attack while at the same time confronting its new sense of vulnerability. Together with field notes and the informal oral histories I conducted with many people, some of whom I came to know well, my collection reveals the creation and evolution of a vernacular memorial culture and vocabulary emerging from the events of 9/11.

Prior to moving to upstate New York in late 1997, I lived in New York City for fifteen years. For eight years, starting in 1983, I lived on the southern edge of the Lower East Side in a loft cornering Canal and Ludlow Streets (now considered Chinatown), where I also maintained an art studio.[2] I saw the World Trade Center towers several times a day, every day. I had a girlfriend who worked at the World Trade Center whom I visited on many occasions. I recall once, while visiting her on floor 102 of the south tower, being subjected to a particularly fierce storm. After about fifteen minutes of being bounced around high above the city skyline, a co-worker of my girlfriend's came into her office and said: "When the shit hits the fan, no one gets out of here." So there I sat eleven years later on September 11, 2001, like so many others who had received a phone call from a friend to turn on the television, thinking to myself: "The shit just hit the fan." I called around to check on a few friends who worked in or around the towers; others who knew that I was still frequently in and out of the New York City area called me.

On the day of the attacks I began by taking pictures of a few things that interested me as source material for a photo-collage series I was planning. In the afternoon, on the ride to pick my daughter up from school, I saw flags and handwritten signs on the side of the road, on automobiles and posted at gas stations. The next day more objects and flags appeared, and some of the objects I had seen the day before had been removed or repositioned. As the public response to the attacks began to proliferate, an intense game of "cat and mouse" was playing out at the local gas station and mini-mart in my community of Bethel, New York. The owner of the business at the time was an ex-Marine who told me he was "enraged" by the attacks and considered "the only appropriate response to this mess" to be "a call to arms followed by a good old-fashioned ass beating of those who did this act." He immediately began to decorate the windows of the mini-mart, parts of the exterior walls of the building, and individual gas pumps with handwritten signs calling for people to "kick some terrorist ass," adding an adage of his own: "United We Stand, Together We Kill." As another way to express himself, he cut out the front page of a *Daily News* special issue from a week after the attacks and taped it onto one of the glass entrance doors of the mini-mart. A turbaned Osama bin Laden appeared with an outsized "Wanted: Dead or Alive" headline. Smaller headlines appeared at the bottom of the page announcing gridlocked traffic and a 684-point drop in the Dow. Shortly after that, other notices and items began to appear on both of the glass entrance doors, not all related to the attacks. One day I was struck by the juxtaposition between the *Daily News* front page and, next to it, a detailed handwritten note declaring, "Babysitter Needed!" I thought about how tragic—but interesting and life-affirming—it was that thousands of people died in the attacks, stock market prices plunged, gridlock was everywhere,

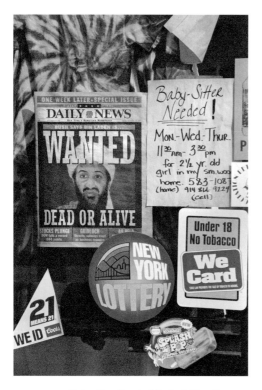

FIGURE 2.9. *Babysitter Needed*, Bethel, New York. Life goes on: whether on motor vehicles, houses and buildings, or human bodies, the public response to the 9/11 attacks was woven into the fabric of daily life. The front door to a gas station mini-mart not only displays news of the aftermath of the collapse of the World Trade Center towers but is also used to help a local family advertise for a babysitter. Photograph by Jonathan Hyman, 2001.

and these people, whoever they were, still needed a babysitter (Figure 2.9).

The expressive signage at the busy gas station and mini-mart did not go over well with a local minister, who was also a public elementary schoolteacher whom I came to know fairly well when he later became my daughter's third-grade teacher. Each day on his way to school, the minister stopped by and removed the makeshift signs he found offensive. Eventually the proprietor formalized his message by ordering professionally designed and lettered signs that expressed sentiments similar to his originally improvised ones. Upon noticing that the owner's signs had become larger and more professionally executed, the minister left them in place and began to cover over the offending words by taping a blank piece of white paper over them. Thus the signs and the messages they conveyed remained in public, but their meaning could now be deciphered only when the viewer imagined the missing words. Both the minister and the store owner knew they were in a battle for what each felt was the right to speak personally and passionately in public, but neither knew the identity of his adversary. Each morning after the minister covered over the objectionable language on his way to school, the owner would make a sweep of the property to liberate his smothered words. Sometimes, before the owner had the chance to remove the minister's cover-up work, customers would write in their own words on top of the blank slate provided by the minister. Next the proprietor turned to subterfuge. He had two sets of signs made: one for the morning, worded so as to avoid "editing," and another for later in the day to express his unrepentant patriotism and anger. Eventu-

ally the minister introduced himself to the owner and asked him to "cool it because there are children seeing the signs every day." Although offended, the owner agreed to stop.

The signs on the property became more generic and less offensive to the minister when the business owner turned to a larger statement that was one part 9/11 memorial project and another part folk art sculpture. Through friends, by way of the Internet, the store owner connected with Ted Walker, a chainsaw carver who traveled 425 miles from Peru, Maine, to execute a work for the gas station owner. Walker made an enormous memorial sculpture from logs using only his chainsaw (Figure 2.10). Walker's creation, a wonder of folk art and esoteric chainsaw technique, mimicked the famous and iconic photograph of three New York City firefighters raising the American flag

in the ruins of the World Trade Center towers that blanketed our popular culture shortly after the attacks. I came to know Walker and his wife, Sharon, both deeply religious Christians, as he labored for days on end to breathe life and meaning into nondescript hardwood logs as Sharon sold his smaller carvings in the parking lot of the gas station. I bought a classic folk art "chainsaw bear" from the Walkers and eventually traded Ted a set of prints from my documentation of his 9/11 memorial for a carving of a Native American with a falcon on his shoulder.

This experience of intimately witnessing others as they responded not only to the attacks, but also to each other, combined with the opportunity to take pictures at my local gas station/mini-mart, led me to realize that people were passionately expressing themselves in public with less of

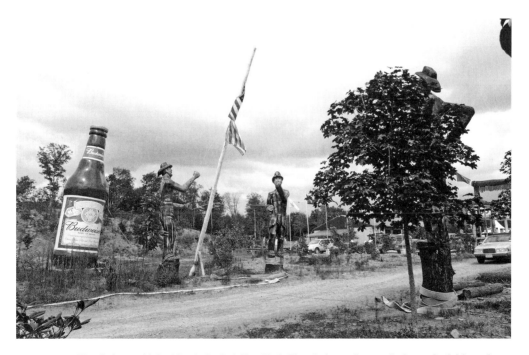

FIGURE 2.10. *Flag Raisers with Bud Bottle*, Bethel, New York. The chainsaw "carver" who crafted this sculpture traveled 425 miles from Peru, Maine, to create this monument. Photograph by Jonathan Hyman, 2001.

a self-imposed filter than I had ever seen before. They were doing it in ways and in places that were unconventional, and with competing language, voices, and imagery. The language, images, and locations would continue to be contested. For example, a gas pump in Paramus, New Jersey, had a handwritten God Bless America sign on it, next to which was a picture of a turbaned Sikh man and a declaration reminding customers that Timothy McVeigh, infamous for carrying out the Oklahoma City bombing, was an American. This was "street life" like I had never seen before. And, as the babysitter sign suggested, life did go on, but 9/11 was not going away. I drew these conclusions because, as I did from the day of the attacks, I watched and listened carefully as I came to know and understand the people whose artwork and public expression I was photographing.

After a month or so of photographing, I had a local drug store develop the fifty rolls of film I had shot. When I began reviewing the 3-in. x 5-in. prints, I realized that what I had been photographing *was* the material, and I was no longer interested in the responses to the attacks as source material for my collage work. Given my longtime interest in both American popular culture and things by the side of the road, and given that I took the attacks—as they say where I come from in New Jersey—"real personal like," I decided that I would have to engage in a prolonged and concerted effort. Because there was such a wide variety of material produced in so many places immediately after the attacks (some of it moving around on motor vehicles and human bodies), I spent some time considering how best to execute my project both logistically and conceptually. It seemed to

me that the response to the attacks was so vast, so pervasive, so woven into the fabric of daily life that I would need to have a camera with me at all times. Still, I had to accept the fact that I could not find or photograph every art object or memorial that was out there. I also had to accept the fact that no matter how systematically I worked, the compiling of this collection would be subject to the vagaries of time and chance.

In 2001, at age forty-one, I was an unknown but mature artist. For years I had been working out issues of content, color, design, composition, and subject matter as a studio artist and photographer. My concept of and feelings about executing my project have changed slightly over time, but the basic tenets of what I set out to do more than ten years ago still hold true now. I carried with me a number of principles I had used to guide my working methods for two decades as a practicing artist. Based on the kinds of things I learned from my photography mentor, Mark Feldstein, from painting teachers Phillip Orenstein, Leon Golub, and Robert Swain, and from painter Chuck Close,[3] I developed a strong sense early on in my project that providing both a structural framework and limitations to my effort would force me to focus clearly. Working within a set of self-imposed guidelines, I hoped, would also foster my intuition. I am convinced that I was able to discover important opportunities for photographs, take them and interpret the content within them, and seek out and gather complicated stories because of the systematic limitations I imposed on myself. I made a commitment to take photographs every day, at any time, no matter where I was. Each day, in an effort to keep things organized and interesting, I set up specific work guidelines. One day I

just photographed cars and trucks; another day only slogans and proclamations; a third day memorials; and a fourth day only handmade flags. Next, I only took pictures at night. Certain days were reserved for one neighborhood or street. Other days I followed up on leads people told me about once they heard I was engaged in this kind of documentary work. I always attempted to locate and photograph art and objects I noticed while driving. If I saw a large sign or painting in the distance when I was on the highway that did not appeal to me or if I felt unwilling to take the necessary time to find an off ramp and locate it, my self-imposed work rules compelled me to ultimately track down that object and photograph it. Some days, I purposely followed no set rules, allowing impulse to direct me. I also allowed myself to break free of my guidelines when my intuition or the chance for a unique photograph led me in a different direction. This was important as well. For example, one day while photographing slogans and proclamations in the form of roadside text, I came across a large patriotic van that was painted in its entirety as a flag. Incorporated into the flag were various inscriptions (such as "God Bless America") as well as iconic American imagery, including the Liberty Bell, the Golden Gate Bridge, and Babe Ruth taking his classic home run swing. To my mind, this was a talking, moving mural, painted on a vehicle that also happened to be a handmade memorial flag. Things always got interesting when genres overlapped. I snapped a picture.

I realized early on that my modus operandi led me to places where I would not have normally ventured or been welcome. Particularly during the first eighteen months after the attacks, both in New York City and within a 150-mile radius around the city, people were occasionally jumpy, suspicious, and not happy to see a photographer around their property. I did my best to stay clear of confrontations. I relied on instinct to tell me whether or not to knock on a door or approach people when I noticed them watching me. When a person was in close proximity to an area or object I wanted to shoot, I introduced myself and explained what I was doing. I also made it a point to ask questions at diners, bars, gas stations, American Legion posts, and fire and police stations. These conversations and street encounters led me to obscure and novel objects that I would not have found otherwise, and, because of these chats, I sometimes was able to uncover the history or authorship of what were mostly anonymous art objects and displays. And, of course, this also gave me the chance to hear many people tell me about how and where they experienced the day of the attacks, what their impressions of the aftermath were, and how the attacks had influenced their lives and the lives of those close to them. Because I spent so much time on the street, urban and suburban, talking to people and watching them, over time I began to take an interest in those who live in the neighborhoods and confront the murals and other 9/11 artwork as part of their daily activities. The photographs I took reveal some jarring juxtapositions (Figures 2.11 to 2.13, and Figure 6.7 in Chapter 6).

There is an inherent tension when an unknown person goes into any neighborhood and starts pointing a camera. During the time I have worked on this project, I have been accused of being an FBI agent, a police officer, a newspaper reporter, a

FIGURE 2.11. *Freedom Isn't Free*, Bronx, New York. Photograph by Jonathan Hyman, 2003.

FIGURE 2.12. *Rogers Avenue Firehouse*, Brooklyn, New York. Photograph by Jonathan Hyman, 2005.

real estate agent, a "repo" man, a robber, a car thief, a drug addict, a terrorist, and a child molester. It was unnerving being an outsider and the object of constant suspicion. While slogging through the back end of a trailer park, I had a shotgun put to my head. Occasionally, when I felt particularly uneasy, I would knock on a door or two to announce myself. Once, while taking a picture of a large mural in a South Bronx neighborhood in New York City, a good friend of mine, Manny Peña, announced loudly in Spanish from the street to an entire building that "a harmless white man" was climbing the fire escape to take a picture. Whenever possible, I traveled with Manny, who speaks the "language of the street" in two languages.[4] Sometimes I would scout out an area alone and return with him to take pictures. His presence was often crucial. He kept an eye out for me and my vehicle when I was taking pictures. He helped spot new objects and artwork to photograph when he was with me as we drove—each one of us looking at a different side of the street—and also at other times when he was on his own. He also directed cars, trucks, and buses clear of me when I was photographing in traffic or on a highway, supported my ladder while I was on top of it, drove while I took pictures in a moving vehicle, and helped negotiate with people on the street to allow me to take pictures and give me information on street art and neighborhood memorials. At times, he had to keep people away from me who were unhappy about having a camera pointed in their direction.

Prior to the 9/11 attacks, I had spent my adult life living and working in different areas in and around New York City. I was well versed in the rhythms of a diverse

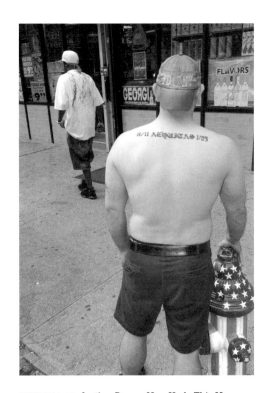

FIGURE 2.13. *Justice*, Bronx, New York. This New York City firefighter, also a soldier, has "inked" the word *justice* in Latin on his back and given the date when he began serving his first tour of duty in the "War on Terror." Photograph by Jonathan Hyman, 2006.

and complex city and its outlying suburban and rural areas. Even if I had never been to some of them, I was knowledgeable about the neighborhoods I explored to take my 9/11 photos. I also understood the varying codes of conduct and dress necessary to get along there. During the course of executing this project I developed a pretty good scheme for success and safety. I traveled with an eight-foot ladder, cell phone, business cards, pepper spray, a photograph of my wife and daughter, and a small portfolio of my 9/11 photographs. I also left in place a small American flag that an unknown person had attached to the rear bumper of my pickup truck shortly after the attacks. (Sometimes I left my pickup truck at home and drove my other vehicle, a Subaru Forester. In upstate New York I traveled with my pickup truck and I belonged. Not so in the South Bronx.) Regardless of the neighborhood, the more clean-shaven I was and the better I dressed, the more accepting people were of me and my camera. The trick was to look trustworthy and approachable, yet strong. Over time, I came to understand that my luck ran like this: when taking a picture, what was in front of me was not necessarily as interesting as what was behind me. One wrong turn unearthed a good opportunity for a picture. A second wrong turn usually resulted in a great find. And the next wrong turn invariably meant trouble.

By taking so many photographs and compiling them into a collection, I realize that I have recontextualized the 9/11 art objects I came to record. Yet it has been my goal to capture the essence of the artwork and memorial displays I encountered as elements in a broader landscape. To this end, many of the pictures in my collection were taken in less than ideal circumstances. I have taken photographs from inside and on top of moving cars, trucks, and buses, in subzero weather, while dodging oncoming traffic on highways, in the pouring rain, while shooting into the sun, hanging off of ladders, roofs, and ledges, and also while running from dogs and people. Working this way allowed me to produce, as best I could, material that was not manipulated or prearranged. I photographed what I saw, usually when I first saw it, and never passed something up because I thought it was ugly, contrary to my beliefs, inconvenient to locate, or difficult or dangerous to photograph. When I came upon an object I always took at least one simple snapshot before I began to consider many other variables involved in making and taking a photograph, such as the light source, angle and distance to the object, lens length and aperture, depth of field, surrounding objects, buildings, and people. I always did my best to present the 9/11 material I saw as literally and figuratively woven into the fabric of the landscape and, indeed, woven into the fabric of daily life.

Interconnectivity

Upon reflection, I realize that while I was striving to systematically and evenhandedly document 9/11 responses, something different and paradoxical was happening. In order to be in a position to uncover artwork to photograph and find information about the pictures I took, I had to immerse myself in the cultures of certain communities of people and in the neighborhoods where the memorial artwork appeared. So while on one hand I prohibited myself from allowing my personal feelings and political

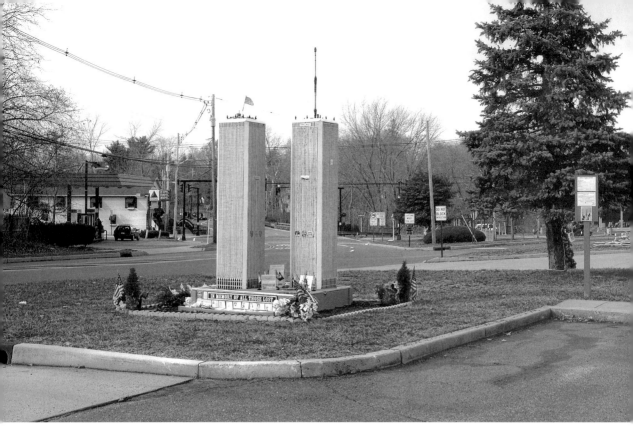

FIGURE 2.14. *Tinton Falls Towers*, Tinton Falls, New Jersey. This detailed, handmade, large-scale sculpture eventually collapsed and was replaced by two generic temporary towers. On the ten-year anniversary of 9/11 they were replaced by two steel beams from the World Trade Center as part of a more formal, permanent memorial. Photograph by Jonathan Hyman, 2005.

beliefs to color the way I took pictures and the choices I made in seeking information about the 9/11 artwork I encountered, I was, on the other hand, necessarily interviewing and befriending people. To one degree or another, I was getting involved in their lives. I watched television and ate lunch and dinner in firehouses from New York City to Boston to Nashua, New Hampshire. I attended community and family picnics, memorial services, beach parties, and birthday parties. I spent much time in people's kitchens and living rooms meeting their families and listening to their stories about "the day" they lost family and friends. Part of my visit included showing people a sizable selection of the artwork I had documented. Within the large pool of individuals, groups, and neighborhoods I photographed, and within each community of people I came to know, there were enough subcultures to ensure that the people I met had diverse interests and political opinions. (For instance, within the New York City Fire Department there are those who play on the FDNY football team, those who play on the FDNY hockey team, those who belong to the same beach club, those who got 9/11 tattoos, those who ride motorcycles together, those who are interested in literature, and so on.) Nonetheless, what I found throughout my journey was an incredible interconnectivity between both the people I came to know and the 9/11 artwork they made, and, indeed, the memorials themselves.

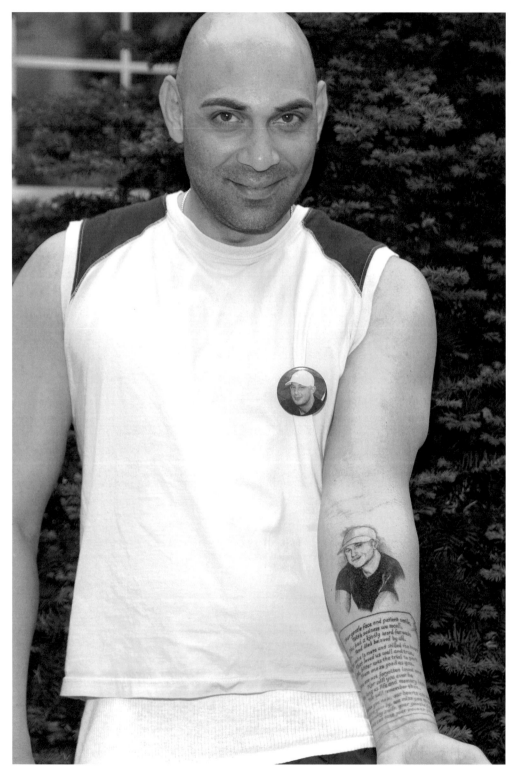

FIGURE 2.15. *Gavin with Paulie on His Arm*, Brooklyn, New York. The tattooed portrait of 9/11 victim Paul Salvio on the arm of Gavin Panday is one of several elements that turn the deceased's best friend into a living memorial. The poem was written by Salvio's girlfriend. Photograph by Jonathan Hyman, 2006.

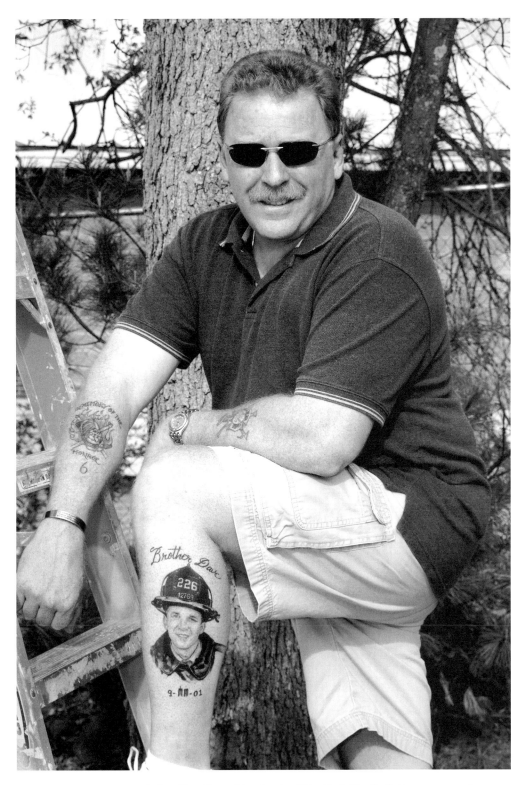

FIGURE 2.16. *Brother Dave*, Nashua, New Hampshire. A retired New York City firefighter permanently memorialized his brother, also a firefighter, who was killed in the 9/11 attacks. Photograph by Jonathan Hyman, 2006.

Tinton Falls

After having photographed (and immersed myself in the story of) a twelve-foot, lifelike reproduction of the World Trade Center towers on the property of the Tinton Falls, New Jersey, Fire Company #1 in 2005, I ended up maintaining a friendship with the group (Figure 2.14). This spectacular memorial was constructed with great attention to architectural detail by Tinton Falls police officer Jared Stevens. Stevens was at the World Trade Center the morning of the attacks and he lost a close friend when the towers collapsed. At the bottom of the memorial towers many people were individually memorialized. One such person was Brooklyn resident Paul Salvio, who was also memorialized in his neighborhood in a large group memorial that would eventually connect me to many other people and memorials. A street in his Brooklyn neighborhood was named in his honor.[5] Through an introduction from the Brooklyn memorial's maker and caretaker, I photographed Salvio's best friend's arm. He was inked with the deceased's face pictured in portrait format, along with a poem penned by Salvio's grief-stricken girlfriend (Figure 2.15). The bearer of the tattoo, Gavin Panday, told me: "I didn't get dressed up for you. I always wear this button with Paulie's picture on it. Paulie was my best friend. I want him with me forever so I gave part of myself to him and his girlfriend." Almost all those I met with a 9/11 tattoo expressed, some more articulately than others, the view that inking a memorial tattoo on their

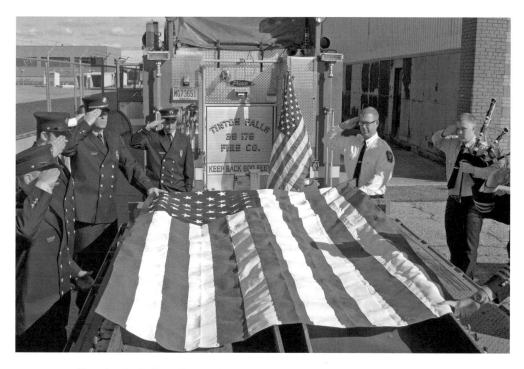

FIGURE 2.17. *Honoring the Artifacts*, Queens, New York. The Tinton Falls, New Jersey, fire company made a special trip to Hanger 17 at John F. Kennedy Airport to secure steel beams recovered from the wreckage of the World Trade Center. Photograph by Jonathan Hyman, 2010.

body was a way to show both their deepest sorrow over the attacks and their willingness to sacrifice a part of themselves permanently in the service of a memorial. In effect those who tattooed their bodies made themselves vibrant living memorials to the 9/11 attacks in general or occasionally to a person who perished in the attacks by carrying on their bodies a permanent portrait of the dead (Figure 2.16; also 2.54, later in this chapter).

I never found out how Paulie Salvio came to be memorialized in south central New Jersey. In November of 2010, at their invitation, I accompanied the Tinton Falls fire company to Kennedy Airport in New York City to pick up two large beams recovered from the wreckage of the towers that had been set aside for them by the Port of Authority of New York and New Jersey. The beams were to be used as replacements for the wooden Tinton Falls towers, which had succumbed to weather[6] (Figure 2.17). As I had done on the fifth anniversary, I went to Tinton Falls on the tenth anniversary of the attacks to attend a large and elaborate commemoration and memorial service. The new memorial, made from the two World Trade Center beams and marble commemorative tablets, had been completed the day before the ceremony. It resembles almost all of the government-sponsored 9/11 memorials I have seen that followed on the heels of the initial generation of spontaneous memorials. Like other such memorials, it lacks the spontaneity and informality that allowed Paulie Salvio and others to be memorialized by name. Thus Salvio is no longer personally commemorated in Tinton Falls.

Liberty George

I also got to know well and document the work of "Liberty George" Dukov, who made memorial papier mâché masks in the shape of the Statue of Liberty that honored individual victims and groups of firefighters and police officers who died in the 9/11 attacks. Gorgi Dukov immigrated to the United States in 1991 from Bulgaria to pursue a career in his field of expertise, industrial design. At that time he was unable to find work due to a downturn in the economy. To make ends meet he fell back onto a craft his father had taught him as a child. Armed with a genuine interest in his new country as well as a fascination with its popular culture, he began making all kinds of papier mâché, decoupage masks. These life-size masks, made to cover a person's face, reflected his curiosity with, and personal connection to, national and international events, American icons, and the cultural phenomena around him. After several years, he decided to narrow down the basic form or template of his work to the shape of the Statue of Liberty. When I met him on the street not far from the Museum of Modern Art in midtown Manhattan, his masks were attached to and displayed on the bicycle he used to transport them over the Queensborough Bridge each day. The masks are well made and beautifully designed. Because I thought Liberty George was an important folk artist and because I felt his topical work and artisanship were both important to the vernacular response to the attacks, I documented all of his masks, 9/11 and others. I was particularly drawn to several 9/11 memorial masks of people who perished in the attacks. I bought three such masks for $55

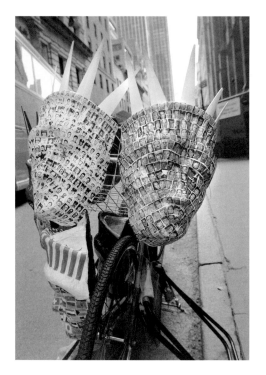

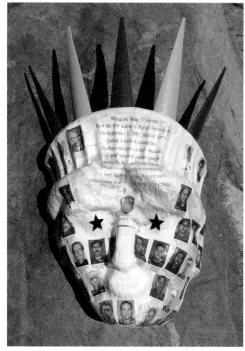

FIGURE 2.18. *9/11 Memorial Masks*, Manhattan, New York. Photograph by Jonathan Hyman, 2003.

FIGURE 2.19. *Port Authority Police Memorial Mask*, Manhattan, New York. Photograph by Jonathan Hyman, 2004.

each from Liberty George while they were on display on the street. One mask is black and white and, resembling a newspaper obituary page, it depicts only New York City firefighters who died in the attacks. The second mask, made with color inks, includes the faces of civilians and rescue workers from various New York City agencies (Figure 2.18). Particularly intriguing to me was a mask that paid tribute to thirty-seven Port Authority police officers who died in the attacks (Figure 2.19). While I was taking pictures of several tattooed Boston firefighters in their firehouse, one firefighter looked through a portfolio of my work and was able to pick out, among several firefighters he recognized on a mask, his former roommate from when he was a New York City firefighter. When I told Du-

kov the story of how his mask connected firefighters in New York City to firefighters in Boston, and that one firefighter was genuinely moved to have seen a close friend memorialized on a mask, he smiled and said: "This is good. I make the masks for the people. The people must know who died. Every person who died is [an] important person to me." Dukov's impulse to memorialize those who perished by cataloguing their faces indiscriminately, without hierarchy, mirrored the way many were remembering the 9/11 victims, including the informal, mosaic-like public displays of the 9/11 "missing flyers," the *New York Times*' "Portrait of Grief" obituaries, and ultimately, the National September 11 Memorial & Museum in New York City.

The Flagkeeper

I am drawn to certain 9/11 handmade objects, whether large or small, that touch my heart. To me, objects that seem to have been done by self-taught artists, or by a group, or by an adult and child together carry an extra degree of intimacy, authenticity, and emotional power. Sometimes, entire towns, schools, or families worked together. I believe, over time, scholarship will be undertaken concerning the type of community building that occurred as average citizens, sometimes unknown to each other, worked together to express their feelings of sorrow, patriotism, and unity by the making and displaying of art. In 2003 a couple I know who live on the former property of Max Yasgur, whose land was used to host the 1969 Woodstock Festival in upstate New York, introduced me to Thomas McBrien. They met McBrien at a motorcycle rally held on their farm. McBrien was there in his self-described role as "Flagkeeper," accompanying an enormous handmade flag on a charity motorcycle ride.

From the town of Upper Black Eddy, Pennsylvania, McBrien coordinated the making of the "9/11 Flag" between local adult volunteers and schoolchildren from Bucks County, Pennsylvania, and Hunterdon County, New Jersey. The collective, from both sides of the Delaware River, worked under the name "United We Stand, United We Sew." This 9/11 memorial flag, 22 feet x 32 feet long and made entirely from American flags (each of 2,993 flags representing the life of each person who died in the attacks), also has sewn into it flags from the eighty-six nations that lost citizens in the attacks.[7] On the perimeter of the flag McBrien sews the patches of

fire departments from around the country and the world given to him by department members he meets during his travels. The flag has been carried and hung all over the country, sometimes with McBrien, sometimes without him, from military bases to aircraft carriers and folk festivals. It was even displayed outside the medical examiner's office in New York City shortly after the attacks. Regardless of whether he is present or not, McBrien insists on at least two conditions. First, a police, fire department, or military escort must accompany the flag when it is delivered to its exhibition place and when it is returned to him. Second, only family members of those lost on 9/11, soldiers, and elected officials (such as mayors, congresspeople, and other dignitaries) who participate in an event where the flag is hung may sign the flag. McBrien is not only "flagkeeper" but also docent: when on site with the flag, McBrien gives a passionate and informative fifteen-minute lecture on the making, meaning, and history of the flag.

In September of 2003 McBrien invited me to join him in on a charity motorcycle ride called "America's Ride," which was bringing his flag across the country from California and displaying it in selected cities along the way. He arranged a private plane trip for us to join the ride in New Castle, Pennsylvania, and from there we began our journey to New York City, getting to know well a handful of the many riders who made all or some segments of the cross-country trip. We made stops along the way at the site of the Shanksville plane crash (Figure 2.20) and the Capitol Building in Washington, D.C., and hung the flag at a ceremony at the Pentagon (Figure 2.21). The ride concluded at ground zero in New York City. A

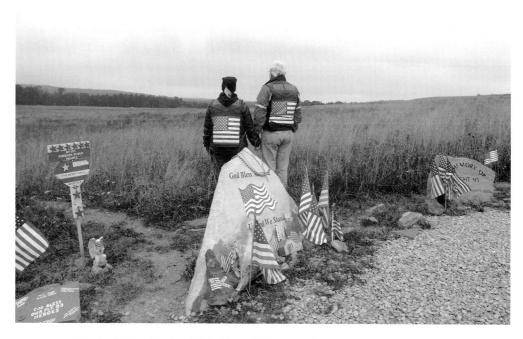

FIGURE 2.20. *Shanksville Handholders*, Flight 93 crash site, near Shanksville, Pennsylvania. The site of the crash of United Flight 93 in a field outside of Shanksville, Pennsylvania, is now a National Park Service site, and an expansive memorial landscape is under construction there. A temporary memorial, which provides a site for spontaneous memorial offerings, has attracted numerous visitors since the crash. Photograph by Jonathan Hyman, 2003.

number of very good photo opportunities and personal relationships arose from this trip. Notably, I photographed the tattoo of Billy Eisengrein, the New York City firefighter made famous as the "firefighter on the right" in the famous reenactment of the Iwo Jima flag raising in the ruins (sometimes referred to as "the pile") of the World Trade Center (Figure 2.22).

In May of 2011 I traveled with McBrien, the flag, and Pennsylvania National Guard staff sergeant Gregory Placentia to Camp Shelby, a National Guard training base in Mississippi, to photograph a series of ceremonies centered on the flag. McBrien dubbed the journey "Operation Never Forget." On each leg of the long journey from his house in Pennsylvania to the entrance

of the Army base in Hattiesburg, the flag was under a military escort. Flying home and reflecting on his most recent journey, McBrien mused aloud in a stream of consciousness. His feelings, he said, had been pent up for almost ten years: "I hate these attacks. What a terrible thing to happen to our country, to these unlucky and undeserving people. No one deserves to die the way they did. We can never forget! But what I have been doing is to make sure, with this flag, that we always remember! You know, I also wanted to do something different. To educate. To show the world we care. That's why I worked really hard to sew all of the international flags into the flag. But in the end, it's our military, God bless them, that will be the ones to make us safe and end

terrorism. That's why I have spent so much time recently using the flag to let them know we care and how important they are. I want to stop doing this. But the flag needs a home already, where it can be seen every day. How do I stop when the flag makes a great, successful tour like this one, and always comes home in a duffle bag?"

The Great Aunt

In the spring of 2002, on Main Street in Deposit, New York, two and a half hours by car from New York City, I took a picture of a hand-painted wooden utility pole. This work of art consisted of four small separate paintings of firefighters that circled around the pole. A generic memorial, it paid tribute to 9/11 in general and firefighters in particular. The artwork on this pole depicted the now iconic scene of the three firefighters raising the American flag in the rubble of the World Trade Center pit shortly after the attacks. I returned two years later and noticed that the pole had been repainted (Figure 2.23). Its rendering slightly reconfigured and colors different, it now singled out one firefighter by name. After rephoto-

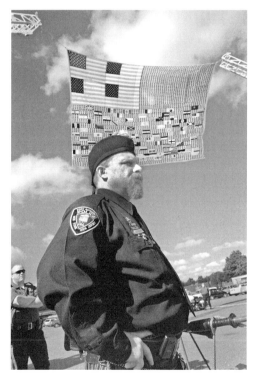

FIGURE 2.21. *9/11 Flag at the Pentagon*, Arlington, Virginia. In 2003, this enormous flag, made from nearly three thousand smaller American flags, traveled across the country from southern California to ground zero in New York City as part of a charity motorcycle ride. Sewn into the flag are the flags of each nation that lost one or more citizens in the 9/11 attacks. Photograph by Jonathan Hyman, 2003.

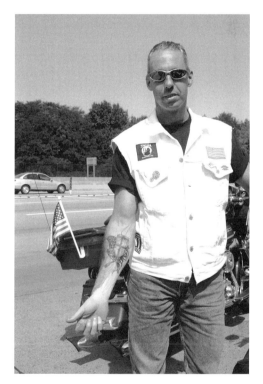

FIGURE 2.22. *Billy's Tattoo*, Staten Island, New York. New York City firefighter Bill Eisengrein is seen here while participating in the Philadelphia to ground zero leg of a cross-country charity motorcycle ride. Eisengrein is the rightmost firefighter in the iconic photograph of the three firefighters raising the American flag in the ruins of the World Trade Center. Photograph by Jonathan Hyman, 2003.

FIGURE 2.23. *Memorial FDNY Pole Repainted: In Honor of Gerard Schrang*, Deposit, New York. Photograph by Jonathan Hyman, 2004.

graphing the pole, I drove to the parking lot of a nearby supermarket. The first person I encountered after I got out of my car was a teenage girl on a break from her job as a cashier, smoking a cigarette. I asked her if she knew who painted the pole down the road. Without hesitating, cigarette in mouth and face buried in a cloud of smoke, she told me the artist was her great aunt. Stunned by my good luck, I asked for her help and waited patiently for her to finish her cigarette. With me in tow, she returned to the supermarket's office and called her mother. Her mother gave her a number where she could reach her grandmother. She proceeded to dial her grandmother on my mobile phone and got permission from her (and the phone number necessary) to call the great aunt at home.

One hour later I was sitting in the great aunt's living room listening to the story of how the art on the pole was originally made and subsequently transformed into a memorial to a specific New York City firefighter. The great aunt, Phyllis Martin, told me that the painting had been ruined by salt and bad weather during the previous winter. While she was repainting it the following spring, a woman whom she had never met before pulled up in a car and passionately thanked her for making a memorial that was especially meaningful to her. The woman went on to explain that her son was a New York City firefighter who, in anticipation of his retirement, had purchased a riverfront plot of land in town shortly before he perished in the 9/11 attacks. After getting to know the firefighter's mother and hearing about her son and how he died, Martin finished repainting the pole, but this time the final product was a specific memorial to the fallen and named

firefighter Gerard Schrang. Then Martin told me: "I was so pleased to have made the connection with the firefighter's family. The best thing that happened was that the pole became identified with a person who deserved to be memorialized. It meant so much to them. It meant a lot to me, too. Sort of like helping one family at a time." Martin told me that when the painting was completed, the firefighter's family took their digital pictures of the memorial to a professional printer and turned the painted tribute on a pole into hundreds of memorial T-shirts that were distributed to family and friends.

"I Bowl with Him"

I visited as many firehouses in and outside of New York City as I could and photographed the offerings and memorial items left in front of them. I photographed many painted firehouse doors in New York City (Figures 2.24 and 2.25), and when given access I photographed the memorials, both professionally executed and homemade, inside firehouses. I had a moving encounter at a Brooklyn firehouse during the spring of 2004 while I was pursuing a tip on a firefighter stationed in Brooklyn who was known to have a huge 9/11 memorial tattoo across his back (Figure 2.26). Not a single firefighter knew the name or the location of the tattooed man I was looking for. I was striking out with an entire firehouse until someone finally phoned upstairs to their lieutenant. When he arrived, in deference to him, his men walked away and left us alone to talk. The lieutenant knew the name and nearby firehouse location of the firefighter in question and confirmed his tattoo after I explained what I was working on and

why I needed to find him. I thanked him. We shook hands and, as I was leaving, the lieutenant said: "I bowl in a league with him every week. Tell him I sent you."

As I was crossing the street, nearly back at my car, the lieutenant spoke again, this time asking: "Hey, can I see what you are working on?" I went back into the firehouse with my portfolio. I provided a limited narrative as the lieutenant scrutinized my photographs carefully and slowly. Then he froze. A full five seconds of silence passed. The hair on his arms was standing up and so was mine. Finally, he looked over at me, pointed to the double portrait of a woman in one of the saddest and most moving memorials in my portfolio, taken at a memorial park in Staten Island called Angel's Circle, and said: "That's my sister"[8] (Figure 2.27). My heart dropped. I said: "Oh man, I'm really sorry. Let's put it away." He said: "No, I'm gonna look." And so he did. When he was finished thirty minutes later, the lieutenant rolled up his sleeve and quickly showed me a tattoo in honor of his sister. He did not want me to photograph it. He said, "You can't have the picture and I don't talk about this stuff." I replied slowly, "That's fine. I understand. Let me know if you ever change your mind." After he finished looking at every picture in my portfolio we stood in the firehouse alone, engulfed by the red glare of recently washed fire trucks, for a good twenty minutes. I listened as he described to me what he and the other firefighters he knew went through during and after the attacks. He said, "This was beyond tough. I mean, guys come to work and they just disappear. They don't come home. Staten Island took it hard. A beating. Families devastated and grown men all torn up." As I was leaving he told me where

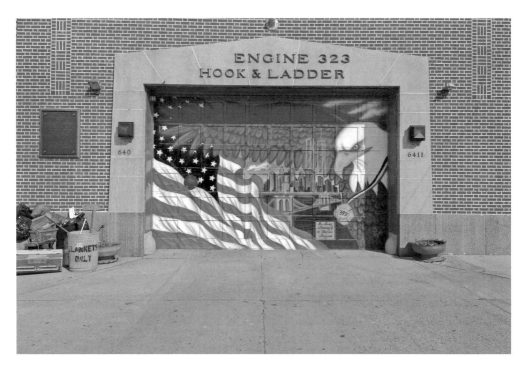

FIGURE 2.24. *Firefighter Thomas Mingione Memorial Door*, Brooklyn, New York. Photograph by Jonathan Hyman, 2005.

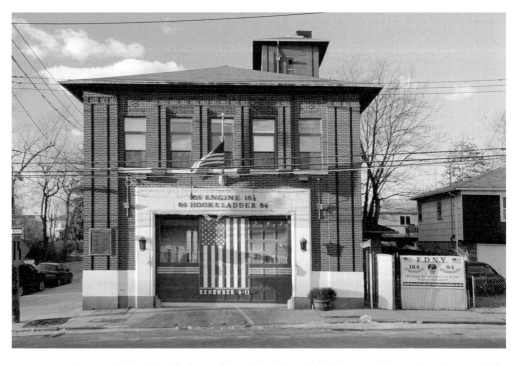

FIGURE 2.25. *Drumgoole Road West Firehouse*, Staten Island, New York. Photograph by Jonathan Hyman, 2003.

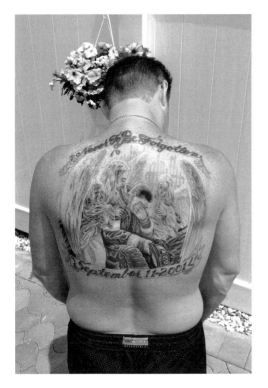

FIGURE 2.26. *Comfort from Angels*, Staten Island, New York. Angels and the heavens have been used as metaphors in a variety of contexts in response to the 9/11 attacks. Often, angels are depicted surrounding the World Trade Center towers or comforting a sitting, kneeling, or grieving firefighter (see, e.g., Figures 2.28, 2.29, 2.49, and 2.66). Photograph by Jonathan Hyman, 2004.

I could find a cemetery where several New York City firefighters were buried. I was touched. He understood what I was doing, trusted me to be discreet, and knew that the tombstones would be an important addition to my collection. He asked me for a print of his sister's memorial and I sent it to him. Three weeks later I photographed his friend's back. The tattooed firefighter, Mike Golding, told me he only agreed to meet with me and be photographed because I was "sent to him by the right guy." Golding, like many of the firefighters I photo-

graphed, was protective of his privacy and deeply concerned about drawing attention to himself. He continued: "I have this problem. I got this tattoo because I felt real strong about the attacks and believe that it speaks to the idea of never forgetting the guys who didn't make it home. But I am uncomfortable with the attention I get because I got the ink."

All Gave Some, Some Gave All

In September of 2002, while in search of a large mural I had seen from the highway in Queens, New York, I pulled my car over and asked a pedestrian if he was familiar with the 9/11 mural I suspected was somewhere in his neighborhood. Although he was un-

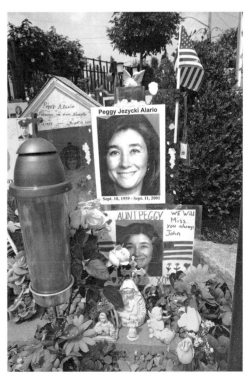

FIGURE 2.27. *Aunt Peggy*, detail from Angel's Circle Memorial, Staten Island, New York. Photograph by Jonathan Hyman, 2003.

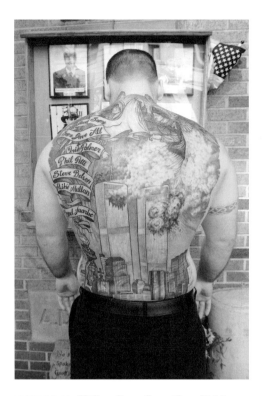

FIGURE 2.28. *All Gave Some, Some Gave All*, Manhattan, New York. When asked why he had such a large and graphic tattoo in honor of firefighters who died in the 9/11 attacks "inked" onto his body, this New York City firefighter responded, "The pain in my back was good for the pain in my head." Photograph by Jonathan Hyman, 2003.

familiar with the artwork I described, Robert ("Bobby") Scott, a retired *Daily News* pressroom paper handler, offered to take me around his and surrounding neighborhoods to either show or help me uncover a number of 9/11 murals and memorials. During the course of the six hours we spent together, Scott told me a number of interesting stories about his life and also gave me the task of tracking down a full back tattoo in Manhattan and a mural in the Bronx.

Both the artwork he helped me find and my encounter with Scott were revelations for me and changed the way I thought about the work I was photographing and documenting. It was at this point that I came to understand the unspoken and often unrecognized interconnectivity between many people and the 9/11 artwork they made or to which they were connected. I began to uncover how people were linked and what their relationships were to each other. A certain work would lead me to another as well as to the people who made it, in the process helping me to understand the response to the attacks themselves. I also discovered that when I embraced this organic form of social networking, it allowed me to put people together who were otherwise unaware that they were somehow connected through the attacks.

Through a friend who had contacts in the New York City Fire Department (FDNY), Scott was able to tell me about the tattoo of FDNY firefighter T. C. Cassidy. Cassidy, who was living near Scott in Queens at the time, has a visually complex, full-back memorial tattoo that lists the names of his five good friends in the fire department who died in the attacks (Figure 2.28). It also depicts the World Trade Center towers burning and exploding and two angels surrounded by

the phrase "All Gave Some, Some Gave All."[9] Cassidy agreed to meet with me and then allowed me to photograph his tattoo because I was sent to him by Scott. As with many of the other people I photographed, I sent the photo to Cassidy on his request. I also agreed to his request that no photos were to be taken of his face.[10]

The 9/11 attacks were a defining moment for our nation, and Cassidy, so deeply affected by them, redefined himself. His tattoo cost $5,000 and was only finished when he took out a loan to make the last payments. Cassidy, who was careful to protect his privacy, told me, "Tattoos are vulgar and I don't like them." When asked why he put the tattoo on his back, he said, "I did it because the pain in my back was good for the pain in my head." Cassidy spent so much time in the tattoo parlor that he got to know and then married the receptionist. Through Cassidy, I came to know some of his fellow firefighters and photographed their tattoos. Todd Neckin was one of several in Cassidy's firehouse who decided to get a tattoo. Like Cassidy and many others in and out of the fire department, he decided to get a tattoo depicting two angels. Angels and halos are a recurring symbol in the vernacular response to the attacks. One of the enduring images to emerge from the attacks is that of a grieving, kneeling firefighter being comforted by one or more angels, perhaps there to escort him safely to heaven (Figure 2.29).

Scott's good friend and fellow retired *Daily News* paper handler Ernie Bielfeld lost his son, FDNY firefighter Pete Bielfeld, in the attacks. The younger Bielfeld was well known in the fire department and much beloved in the Bronx neighborhood where he lived. Scott gave me the basic

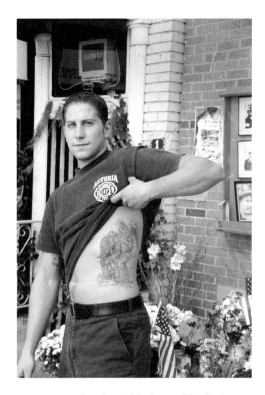

FIGURE 2.29. *One Angel*, Manhattan, New York. Photograph by Jonathan Hyman, 2003.

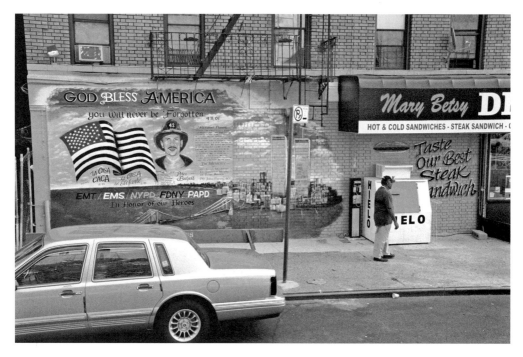

FIGURE 2.30. *Pete Bielfeld Memorial*, Bronx, New York. Photograph by Jonathan Hyman, 2002.

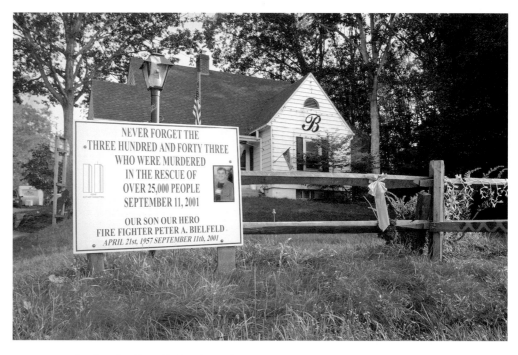

FIGURE 2.31. *Our Son, Our Hero*, Bielfeld family front lawn, Narrowsburg, New York. Photograph by Jonathan Hyman, 2004.

coordinates for the mural painted in honor of his friend's son, and several days later I tracked it down (Figure 2.30). Over the next year I ran into people who knew Pete Bielfeld and then, by chance, on the way to the dry cleaner in the parking lot of the mall closest to my house, I parked right next to an SUV that proclaimed on each side: "Never forget the three hundred and forty-three who were murdered in the rescue of 25,000 people, September 11, 2001." The back of the vehicle also declared: "Our son, our hero, Peter A. Bielfeld, April 21st, 1957, September 11th, 2001."

I waited in my car, but the driver of the SUV did not come back to his truck. I picked up the dry cleaning and returned to my car, but still no luck. An hour later, by chance I ran into Ernie Bielfeld at a nearby Dunkin Donuts shop. We spoke briefly and exchanged phone numbers. The next day, twenty-five miles north of the parking lot, I passed a house with a huge sign on its front lawn. To my surprise, the sign repeated the sentiments that Ernie Bielfeld had posted on his SUV and had a color portrait of Pete Bielfeld on it (Figure 2.31). I pulled into the driveway and went to the front door. Ernie answered and remembered me. We spent several hours together and he told me where I could find another mural in the Bronx honoring his son. Eventually he showed me a room in his house dedicated entirely to the memory of Pete.

Years later, in a situation much like the one at the firehouse in Brooklyn, after taking a picture of a memorial firehouse door in the North Bronx, I was invited inside and ended up meeting Lieutenant Terry Ward. After having seen a picture of Pete's memorial mural in my portfolio, Ward, a family friend of the Bielfelds from years ago,

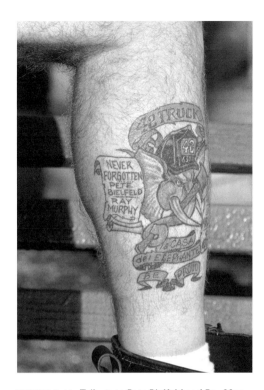

FIGURE 2.32. *Tribute to Pete Bielfeld and Ray Murphy*, Bronx, New York. Just as the civilians who died in the towers are associated with the tower and floor numbers of the World Trade Center where they worked, firefighters who died in the towers—like Pete Bielfeld of Ladder 42—are remembered by their engine, ladder, or battalion designations. Photograph by Jonathan Hyman, 2006.

FIGURE 2.33. *Shoe Warehouse with Memorial Scroll*, detail, Brooklyn, New York. The 9/11 muralists, such as Joe Indart, sometimes employed large scrolls or tablets to make declarations or memorialize those who died in the attacks. (See also Figure 3.7 for a comment on terrorists and Figure 7.15 for a memorial scroll by "Meres.") Photograph by Jonathan Hyman, 2005.

showed me his memorial leg tattoo in honor of Pete Bielfeld (Figure 2.32). Both Ward and Ernie Bielfeld, who had not seen each other in fifteen years, were happy to be reunited at an exhibition of my work that included photographs of a mural in memory of Pete, the Bielfeld family front lawn, and Terry Ward displaying his tattoo honoring his friend.[11]

The Governor

If my friend Manny Peña is the mayor of his block, Joe Indart is the governor of a large area of southern Brooklyn, west to east from Bay Ridge to Bergen Beach. A full-time building superintendent by day, Indart also

works as a widely known sign painter, caricaturist for private parties, and graphic artist for local businesses and police and fire precincts in and around the area of Marine Park, Brooklyn. Shortly after the attacks, though continuing the work he had been doing, he became a muralist, and a prolific one at that. Over time Indart painted forty-seven 9/11 murals for private and government clients, including FDNY firehouses and local businesses, family members and friends of those who died in the attacks, and a New York State assemblyperson.[12]

Because he was making so many murals that appeared in public places and using many of the same symbols and icons in them, Indart was careful to give each mu-

FIGURE 2.34. *Milo Printing Mural*, Manhattan, New York. Muralists Chico and Joe Indart occasionally employed commercial elements in their 9/11 artwork. Photograph by Jonathan Hyman, 2004.

FIGURE 2.35. *Statue of Liberty with a Cup of Coffee*, Brooklyn, New York. Photograph by Jonathan Hyman, 2005.

ral its own voice within the confines of the instruction given to him by those commissioning the mural. Whenever he could, he memorialized by name 9/11 victims who were known to those in the community[13] (see Figures 2.8 and 2.33, and also 3.1 in the next chapter). He felt genuine sorrow over the loss of lives of so many of the friends and family members of firefighters and others in the neighborhood. Like others, Indart occasionally used commercial elements in his 9/11 work, especially when paid to do so (Figures 2.34, 2.35). Eventually, however, he came to see himself differently, more as an artist and muralist with a vital message for his community and less as a commercial artist who simply provided a service.

I met Indart after noticing one of his murals while riding on a hundred-mile, five-borough bicycle tour of New York City. We spent time traveling around Brooklyn together looking at and talking about his work, as well as meeting people in his orbit. I began to think of him as an important figure in the vernacular response to the 9/11 attacks and of his murals as culturally and historically important. So, as with Liberty George, I photographed as much of his work as I could, not just his 9/11 work. A known "go-to guy" for a favor of any type or artwork painted on short notice, Indart has a confident and sure hand as an artist. He is equally adept socially. He maintains relationships with an enormous number of people from all parts of his neighborhood and beyond, and thus is in a unique position to provide mural art for his particular community, where his work is respected and safeguarded.

Joe Indart and I looked out for each other. He pointed out and described 9/11 art-work by other artists for me to photograph. Because I made repeat trips to photograph his murals, I was able to keep an eye on his work as well. I immediately called him when I saw that someone had vandalized his mural in Bensonhurst by painting scars and inscribing "Fuck the Injustice" on a large eagle. Though he admits the American flag functions as an important civic and design element in his murals, at the core of Indart's murals is a stern, protective, and sometimes angry American bald eagle. He is deeply vested in the eagle. Joe was personally offended by the damage done to his work and immediately repaired it. He says, "I did not like the attacks any more than anyone else in the neighborhood did. Hell, we all took it personally. Hey, the eagle is me. I have to put something of myself in the murals, especially when I am sometimes being told what I have to paint. The eagle is strong. The eagle protects. The eagle does not take any shit! This thing where I see people painting crying eagles, that's not me. No, no, no. A crying eagle is wrong because that shows weakness. And Americans are not weak, baby!"

Chance encounters and networking have been vital to my work. While rephotographing another of Indart's murals, I came upon and photographed a memorial in front of a large apartment building for a firefighter whose family I ended up meeting that same day when a neighbor offered to introduce me. During the two hours I spent with the parents of firefighter Joe Henry, they told me about a mural in a schoolyard not far from their apartment, which I photographed later that day (Figure 2.36). One of the most interesting aspects of my encounters with people involved the trading and passing along of memo-

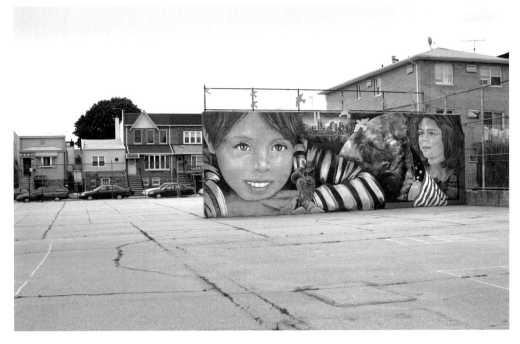

FIGURE 2.36. *Hope on a Handball Court*, schoolyard mural, Brooklyn, New York. Photograph by Jonathan Hyman, 2006.

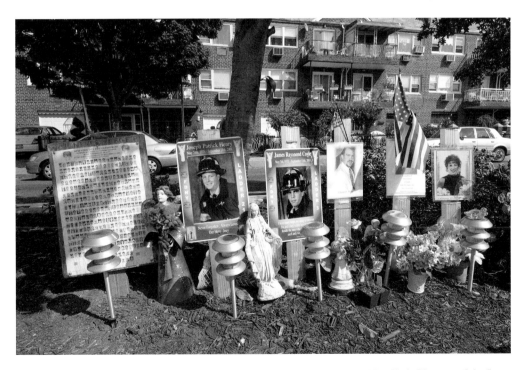

FIGURE 2.37. *Joe Henry and Jimmy Coyle at the "Garden of Angels,"* Brooklyn, New York. Photograph by Jonathan Hyman, 2006.

FIGURE 2.38. *Jesus Holding the Towers*, Brooklyn, New York. Photograph by Jonathan Hyman, 2006.

rial T-shirts, hats, bracelets, mass cards, and other memorabilia in memory of loved ones. I left the Henrys' apartment that day with a large cache of memorial items with instructions to pass them along to friends and family, which I did. Upon viewing family photos of their son, I recognized Joe Henry and showed his parents a photograph of a large roadside Brooklyn memorial in which Joe was memorialized (Figure 2.37). The Henrys had never seen this memorial, which I happened upon after photographing an Indart mural. While getting back into my car, I noticed and then followed an FDNY fire truck with a painted 9/11 memorial on it. My pursuit led me directly to a memorial that resembled Angel's Circle in many ways. Garden of Angels was created, named, and maintained by Josephine Cangelosi, who only learned of the existence of Angel's Circle in Staten Island months after she created her own memorial. Paul Salvio, memorialized in Tinton Falls, New Jersey, is also honored at Cangelosi's memorial. (It was Cangelosi who introduced me to Gavin Panday, whose tattoo honoring Paulie Salvio I photographed; see Figure 2.15.)

When I called the parent representative of the school group that had sponsored the schoolyard mural, she told me about a nearby memorial sculpture of Jesus holding the World Trade Center towers (Figure 2.38) and also informed me that the girl depicted on the right side of the schoolyard mural was the daughter of a friend of hers whose husband, FDNY firefighter Daniel Suhr, died in the attacks. I, in turn, told her about an Indart Marine Park mural unknown to her that memorialized Suhr.[14]

During Labor Day weekend in 2005, Indart and I paid a visit to the Breezy Point Surf Club on the Rockaway Peninsula in

Queens, New York. Many of Indart's neighborhood friends, some of them firefighters, court officers, and police officers, spend their summer weekends here with family and friends. On the perimeter of the club, by the bocci courts, stands a large sign painted by Indart. As we moved around the club from cabana to cabana, I was introduced by Indart to many families and invited by all to eat, drink, relax, and relax some more. Along the way Joe pointed out several cabana door and sign paintings he had made. Men, women, and children were visiting friends and sharing food and drinks; the club was essentially one large family party. I brought my camera but let Joe do the talking and made no attempt to ask any of the many people who had 9/11 tattoos for a photo op. Eventually he introduced me to a firefighter he knew would take an interest in my project. He was right. After spending a few minutes getting acquainted, Joe's friend Steve insisted on taking me around to meet his friends and good-naturedly insisted that they pose for me. It was a great day and I ended up photographing eight tattoos. Better still, I met now retired FDNY firefighter Steve Orr, who helped me to find others with tattoos and get access to firehouses. Most importantly, I left with invitations to photograph the FDNY football team members and a charity touch football tournament in the fall.

As Indart became more sure of his stature as an important 9/11 muralist, he began to worry that he was not using his own voice enough. We spoke about his troubled feeling that upon looking at his murals over time, he felt that though they delivered the message he was paid to deliver and depicted the imagery he was asked to paint, they did not say enough for and about him.

Eventually he decided to self-fund a ten-year anniversary mural that would contain content strictly of his choosing. Joe made this mural after procuring space on a large wall in his neighborhood on the side of a Chinese restaurant. I stayed for two days photographing both his progress and the people in the neighborhood who passed by or actually stopped to watch the mural being made. The mural was completed shortly before the ten-year anniversary. It is much looser in its handling of paint and decidedly more cartoonish in its rendering of people and shapes than his previous work. Most of all, Indart was satisfied because he finally got the chance, using his own money, to do something he had not done in ten years while painting almost fifty murals: he painted ground zero. People in the neighborhood loved the mural and told him so. A firefighter well placed in the FDNY was so moved and appreciative that he told Joe he was going to do him a big favor to pay him back for all of his good work.

On the evening of September 11, 2011, I was in Brooklyn to attend and photograph a yearly commemoration ceremony in the next neighborhood over from Joe's at a 9/11 memorial mural painted on a large handball court that I have photographed over the years, most recently in 2011 after Osama bin Laden was killed by United States Navy SEAL team 6 (Figures 2.39 and 2.40). On my way there I received a call from Joe; he was frantic. He was barely intelligible due to bad cell phone reception. However, I did discern that he wanted me to meet him at his most recent mural as fast as I could get there. As I was hanging up I heard him say, "He's gonna leave!" I arrived as Joe was screaming at me over the phone to hurry up. When I turned the

corner on foot, a large FDNY battalion commander's SUV was pulling away. Joe stood in the street and stopped them. He grabbed me by the arm, pulled me over to the driver's window, and introduced to the uniformed chief. The chief then said: "Mr. Hyman, I brought a friend by to have a look at Joe's mural. It's just great. I'd like you to meet Jon Voight." And indeed, it was Jon Voight. Joe was too starstruck to move, so I invited Voight to join the muralist in front of his work, and he obliged (Figure 2.41). Joe was absolutely giddy about the picture. Later that night after Joe had me show fifteen people the photo of himself with Voight from the back of my digital camera, I said: "Joe, you're the star of this neighborhood." He responded, "I know, I just like to get excited."

Max Found You a House

"Max found you a house! He called me yesterday from the bus on his way to sleepover camp. It sounds spectacular. He says it's an entire house, a big one, painted as an American flag. The way he described the location, I think it's in Connecticut. I'll get more information and get back to you." I received this phone message in June of 2003 from my family member and close friend Ilsa Klinghoffer, who is Max's mother. She and her sister Lisa, an artist, were two of the first people to whom I showed my 9/11 photographs. At an annual family gathering in 2002 we spoke extensively about my portfolio and my evolving understanding of what I was doing. Most importantly, I asked them for their thoughts on my photographs. There was much to discuss. As residents born, raised, and still living in lower Manhattan, they talked about how

they were affected by the attack. Their young sons joined us and also viewed my photographs.

The sisters, six and a half years apart in age, are the daughters of Leon Klinghoffer, a person who many believe was the first American to be the victim of terrorism as we know it today. On vacation with close friends and his wife, celebrating their wedding anniversary aboard the cruise liner *Achille Lauro* in October of 1985, Klinghoffer was shot and killed by Palestinian terrorists while seated in his wheelchair. His body was thrown overboard into the Mediterranean Sea and later found near the Syrian port city of Tartus. Overnight, the Klinghoffer sisters and their mother, Marilyn, became the focus of intense national and international media attention. The family was showered with expressions of sympathy from all over the world. They received heartfelt cards and gifts. Over the years I have benefited greatly from listening to the sisters describe what it was like to be subject to a horrible, violent, and public family tragedy. The sisters emphasized the importance of understanding the complications involved when a personal tragedy becomes part of public discourse, and our conversations helped me better understand the kind of sensitivity necessary to best carry out my work. Over the past decade, Max, thirteen at the time of the flag house discovery, and other family members have passed along valuable information on interesting photo opportunities.

Later that summer, on the way home from camp, Max and his mom stopped at the Flag House in Kent, Connecticut (Figure 2.42). The owner of the house, professional housepainter Kevin Sabia, while not unfriendly, was initially hesitant to speak

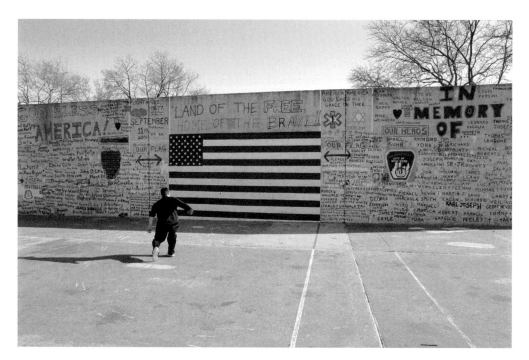

FIGURE 2.39. *Rockin' Ray's Handball Court*, Brooklyn, New York. Like the Vietnam Veterans Memorial in Washington, D.C., which carries the names of all those who died in the Vietnam War, this memorial handball court at one time listed the names of every person who died in the attacks. Every year since 2001, the neighbors have organized a memorial vigil at this community memorial and gathering place. Photograph by Jonathan Hyman, 2003.

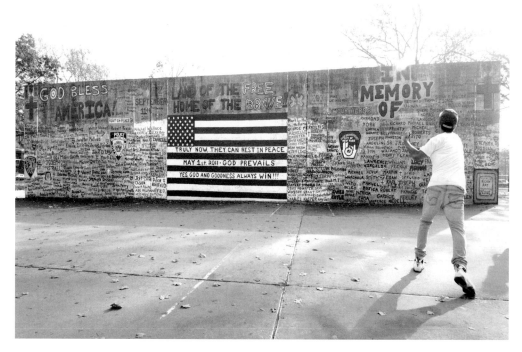

FIGURE 2.40. *They Can Rest in Peace*, Brooklyn, New York. Since September of 2001, muralist "Rockin' Ray" Fiore has returned intermittently to repaint various names, symbols, and phrases on this handball court wall. Immediately after the death of Osama bin Laden he commemorated this historic moment by adding the words on the American flag. Photograph by Jonathan Hyman, 2011.

FIGURE 2.41. Joe Indart and the actor Jon Voight share a light moment in front of Indart's recently completed ten-year anniversary mural. Brooklyn, New York. Photograph by Jonathan Hyman, 2011.

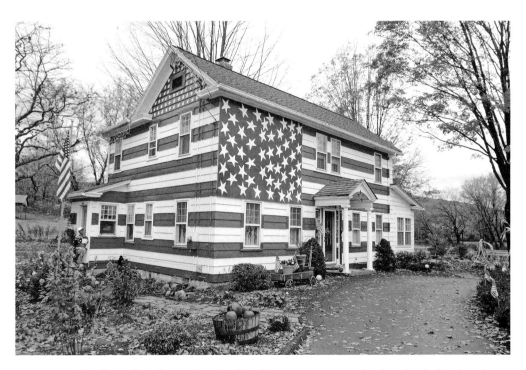

FIGURE 2.42. *Flag House*, Kent, Connecticut. The Flag House was later completely painted white in order to be sold. Photograph by Jonathan Hyman, 2003.

with Ilsa. After spending some time with her, Sabia told her he had painted the house shortly after the attacks. His work had been the subject of a torrent of criticism. Many, he said, felt the house was garish and bad for businesses in Kent. Ilsa spent more than an hour speaking with Sabia, got a tour of the inside of the house, and left with his agreement to accept a phone call from me. By the time I met Sabia and photographed the house, it had been painted as a flag for over two years. Sabia told me he transformed his house shortly after the attacks when he dreamed about his house as a flag. He was insistent about not repainting the house and felt that it was "a reasonable and patriotic response to the 9/11 attacks." He went on to say, "People are wrong. This is just the American flag.

It's just red, white, and blue, that's all. The flag is all of ours. There's nothing offensive about this." I spent several hours talking with him, photographing the house, and showing him my photographs. Sabia eventually moved to central Florida, and to his dismay could not find a purchaser of the house willing to keep it as a flag. Forced to paint over the stars and stripes, he said, "I deeply regret painting over the flag on the house. What a mistake. It should have stood as a monument to the way people felt right after the attacks."

Just before I left he told me that somewhere in a nearby town there existed a group of trees painted as a flag that he felt would be "perfect" for me. I spent the rest of the day in search of the trees, and along the way met and received informa-

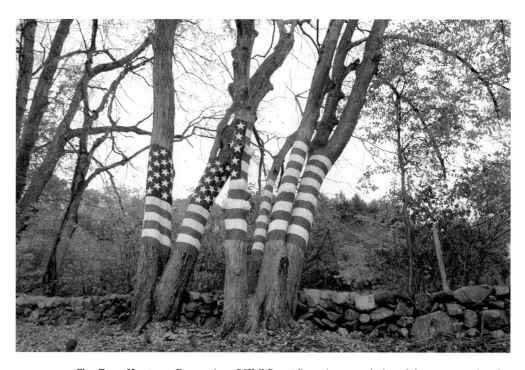

FIGURE 2.43. *Flag Trees*, Newtown, Connecticut. A Wall Street financier commissioned these trees painted in honor of nine of his friends, stockbrokers from the American Stock Exchange, who died in the 9/11 attacks. Photograph by Jonathan Hyman, 2003.

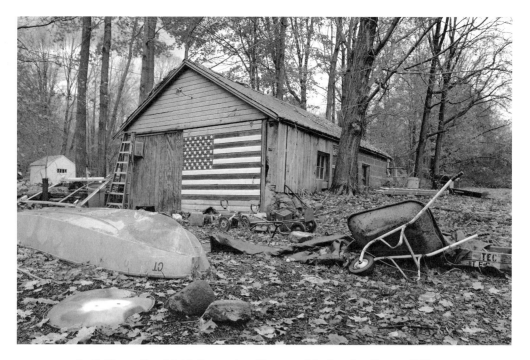

FIGURE 2.44. *Lori's Garage*, Brookfield, Connecticut. Photograph by Jonathan Hyman, 2003.

tion and directions from local shopkeepers, firefighters, police officers, mail carriers, and others. In addition to finally finding and photographing the trees, I also photographed two other pieces of local artwork made in response to the 9/11 attacks.

"This Helped"

I located the trees Kevin Sabia described to me (Figure 2.43) in Newtown, Connecticut, on the property of Howard Lasher, a Wall Street financier who lost nine colleagues and friends on 9/11; at the time of the attack, they were eating breakfast at Windows on the World, the restaurant atop the World Trade Center. In addition to facilitating a large memorial for his friends at St. Patrick's Cathedral, Lasher hired a well-known local muralist, David Merrill, to create a "living" memorial to his friends. The

only maker of 9/11 art I met to call himself a folk artist, Merrill had never painted a mural like this before. He said that he felt an "awesome responsibility" in taking on the task of making the Flag Trees. While working on this nature memorial, Merrill, like Sabia, became emotionally involved in the project and began to feel a spiritual connection to his work. "It's hard to describe," he said. "It was something spiritual. This wasn't just any old flag. This was a flag meant to remember nine lives that ended that day. It means a great deal to me because it was also a statement about a united country and feeling for the freedom we enjoy and [have for] some time taken for granted. This is a memorial to all Americans." The memorial meant a lot to Lasher also. He told me, "When 9/11 happened I couldn't sleep or rest for a long time. Getting the trees helped me out."

FIGURE 2.45. *Where Have All the Flowers Gone?*, Newtown, Connecticut. Photograph by Jonathan Hyman, 2003.

On a hill not far from Lasher's house, out of the corner of my eye I spotted a large flag painted on an old garage (Figure 2.44). This flag and my photograph of it became important to my collection because it functioned on many levels for me. Over the years and the many, many, thousands of miles I spent traveling in a car, I trained myself to become adept at noticing all forms of red, white, and blue while driving at high speeds. Staying alert led me to the Zarcones' flag and others. Lori Zarcone and her daughter Brittany painted the American flag in their backyard after the attacks, because as her daughter said, "We had to. And it brought us closer together." It was significant to me that they needed to make the flag, that they were mother and daughter, and that I found this artwork as a result of my encounter with the Flag House. When taking pictures and selecting images for my portfolio I often felt conflicted between what I saw as my job, if you will, as a documentarian and my need to make art. Often, the pictures I took that provided the best context and most information about an object were not images I considered representative of my artistry as a photographer. Not so with the Zarcone flag. All of the elements in the yard—from the beautifully realized flag on the rundown garage to the natural light and the assortment of random objects on the ground—allowed me to capture the flag at its best and still make a picture that went beyond simple reporting. When I noted that the flag was painted meticulously, in contrast to the upkeep of the rest of the yard, Lori Zarcone chuckled and said, "The flag deserved better."

"Of Course I'm a Patriot"

Newtown, Connecticut, resident Don Elmer is a retired wallpaper and fabric designer who now paints full time. Some of the paintings that hang in his house include American flags. "Of course I'm a patriot," Elmer says. "Maybe just a different kind of patriot. I don't believe that being a patriot means blindly following a leader into suppressing liberties. Sometimes being a patriot means saying 'no.'" The sign I photographed in front of Elmer's house is the third in a series he made after 9/11. The first sign, put up immediately after 9/11, declares "No War," but his wife, Barbara, felt it might scare the children riding by twice a day in school buses. She thought the kids might think that war was coming to Newtown. The next sign instead asked, "Got Peace?" in imitation of the famous "Got Milk?" commercials. Elmer, who like his wife believes strongly that going to war was not a wise response to the terrorist attacks, said: "Sure, 9/11 was horrible, but I didn't think going to war over it was the only solution. And, besides, what's Iraq got to do with 9/11?" In March of 2003, when the United States invaded Iraq, the wooden stakes of Elmer's third sign were pounded into the front lawn: "Where Have All the Flowers Gone?" (Figure 2.45). The sign, which includes peace symbols and flowers, reflects Elmer's affection for the sentiments expressed in the Pete Seeger song popularized by Peter, Paul, and Mary. Barbara Elmer was pleased that neighbors liked this third sign but lamented, "Unless they're old enough, they don't know what it means. They just think it's pretty. They don't associate the sign with Vietnam and Iraq."

FIGURE 2.46. *Roast Beef Dinner*, Hurleyville, New York. Photograph by Jonathan Hyman, 2001.

Asking Questions

As I began to organize pictures during the early stages of my project, I looked at flags, murals, tattoos, window displays, depictions of the towers, art on automobiles, and written texts as separate genres of visual expression. Eventually I divided these genres into subgroups. For example, I broke down the "flags" into store-bought and handmade. I divided written texts into religious comments, verbal clichés (Figure 2.46), and threats directed against Osama bin Laden (Figure 2.47, and also 3.7 and 7.13 in later chapters). The day in Connecticut was important for me not only because I photographed three different types of flags for my collection, but also because, as a result of this day, my best day, I began to think more deeply about both the subject matter and content of my

work. I also began to focus more closely on the ways artists described their work and their relationship to it. I started assigning subgroups that included flags painted on or attached to houses, motor vehicles (Figure 2.48), trees, highway overpasses, bodies, and so on. I also designated categories for flags appearing in murals, flags as weapons, flags with text on them, flags made by groups of people, and flags made by women. This kind of categorization provided the framework for a detailed analysis of what I was seeing and hearing from the people I interviewed.

The vast majority of people who made artwork—whether it was a simple memorial, a visual display with text on it, an elaborate homemade flag, or a patriotic flag display—all told me that they had not, up until they responded to the attacks, conceived of themselves as "artists" or as persons who

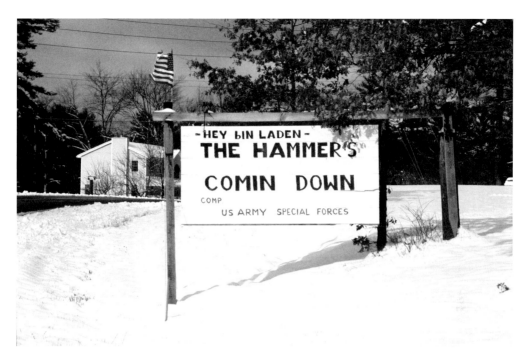

FIGURE 2.47. *Hey bin Laden*, Cochecton, New York. Photograph by Jonathan Hyman, 2002.

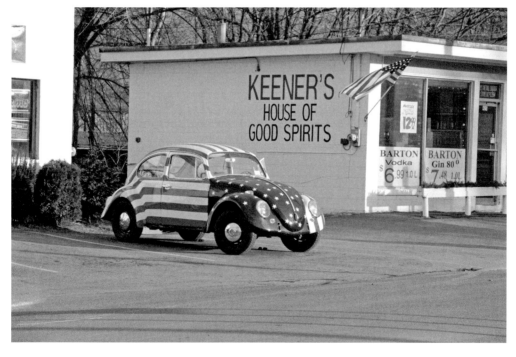

FIGURE 2.48. *Flag Beetle*, Middletown, New York. Photograph by Jonathan Hyman, 2002.

FIGURE 2.49. *Soundview Mural with Tito Puente*, Bronx, New York. Photograph by Jonathan Hyman, 2006.

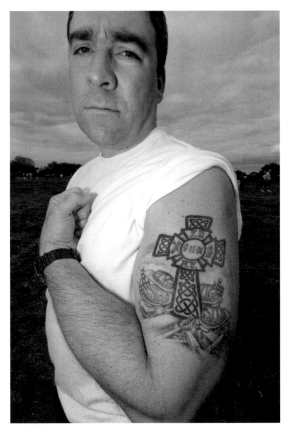

FIGURE 2.50. *Engine 201 Memorial Tattoo*, Brooklyn, New York. Crosses were a very common convention employed in response to the attacks. People used Christian, Celtic, and Maltese crosses as design elements in murals, tattoos, and sculptures. The Celtic cross was used frequently by New York City firefighters in their tattoos. Here, a firefighter honors his four lost station house brethren with a Celtic cross and helmets that function as tombstones. Photograph by Jonathan Hyman, 2005.

would express themselves publicly. The 9/11 muralists, some of whom were self-described artists or graffiti writers prior to the attacks, had either never made murals before or had never made art in a way that made them feel so self-consciously aware of a responsibility to communicate a message. Muralists told me that they felt challenged by the need to go beyond the intent of their pre-9/11 artwork and communicate certain ideas (commemorative, patriotic, etc.) in neighborhoods where, depending on their location, people were accustomed to blank public walls or else used to seeing wildstyle graffiti art. Bronx artist Wanda Ortiz, who had little experience painting murals, told me she considered very carefully what to include and not include in her mural in the Soundview neighborhood. She said: "Some people were being bad and thoughtless in my neighborhood and I didn't like how they were using the flag and the things they were doing in its name. There was violence and guys were picking on Indian people, Sikhs, I think. I wanted to say something thoughtful and show you can be thoughtful, patriotic, and still memorialize at the same time without being crazy. So I included red, white, and blue but no flag. I used poetry, heaven, and candles to give a certain feeling. Maybe that's because I'm a woman. I don't know" (Figure 2.49).

I began to ask myself questions that I still consider to this day. Does the frequent use of the American flag signify that Americans initiated a nationalistic response to 9/11? Does the use of the Christian cross, biblical phrases, and other religious objects (Figures 2.38, 2.49–2.54) signify that an important part of the response to the attacks was a religious one? Does the overwhelming number of personal memorials (Figures 2.54–2.57) to those who died in the attacks, including the thousands of "missing person" flyers, roadside memorials, and more formalized memorial parks in honor of the dead, suggest a change in American memorial culture? Do the murals reflect a rich or narrow artistic response? Are the murals as important for what is not shown in them as they are for what they do depict? What explains the recurring configuration of the American flag, bald eagle, and World Trade Center towers, particularly within murals (Figures 2.58 and 2.59, and also 4.7 in Chapter 4)? What happened to Uncle Sam and the Statue of Liberty (Figure 6.3 in Chapter 6)? What do the statements "God Bless America," "United We Stand," "Never Forget," and "Let's Roll" (Figure 2.60) try to convey? Do they mean the same thing for all people? Why do certain types of people make permanent and semipermanent artistic statements that are monumental in scale, such as enormous flags and murals, whereas others ink more private memorial tattoos of all sizes on their bodies? Yet, while some make ephemeral art, still others sing songs, hold hands, and light candles at peace or memorial vigils and leave little or no trace of the memorialized people or the commemorated event. Is this difference in expression related to political conviction, personal experience, or social class? Or all three? Why is only a very small portion of the public 9/11 art meticulously maintained while the rest of it has either been painted over, been placed in museum or home storage, or allowed to deteriorate outdoors? Does the lack of interest in maintaining and preserving the spontaneous and almost entirely non-government-sponsored artwork and mu-

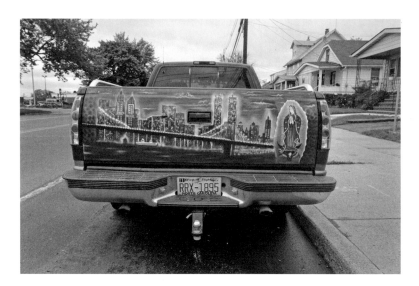

FIGURE 2.51. *Pickup Truck with Skyline and Towers*, New Brunswick, New Jersey. It was not uncommon to see automobiles and trucks adorned with art and slogans shortly after the 9/11 attacks. In addition to the recurring image of the Brooklyn Bridge looking into Manhattan, this pickup truck's tailgate offers a religious response to the attacks by depicting Our Lady of Guadalupe and a red cross atop one of the towers. Photograph by Jonathan Hyman, 2003.

FIGURE 2.52. *Honor the Day*, Manhattan, New York. Unlike most 9/11 murals that have been maintained or left to slowly decay, this "tagged" and multilayered mural displays a cross on top of a tower. The muralist quotes a Bob Marley lyric in calling for sharing the pain and burden of the 9/11 attacks. This vacant lot used to be very close to the former punk rock venue CBGB & OMFUG; it is now the site of an apartment building. Photograph by Jonathan Hyman, 2003.

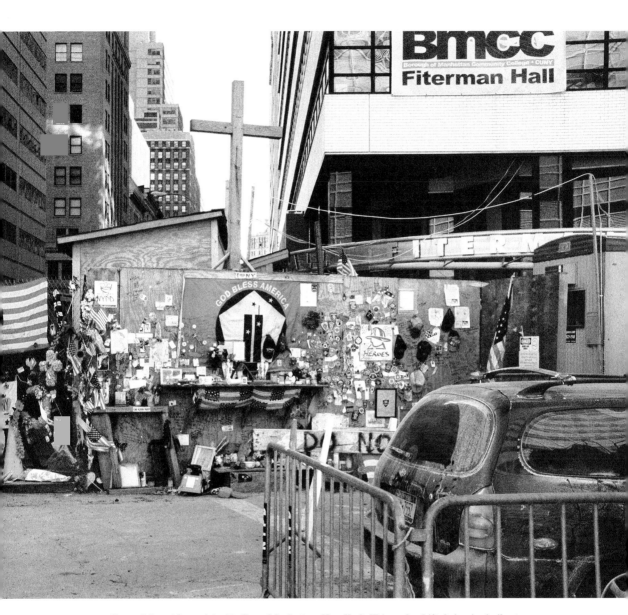

FIGURE 2.53. *Ground Zero Memorial with Cross*, Manhattan, New York. This makeshift shrine is similar to a number of other memorial displays that sprang up around the World Trade Center site after the attacks. Almost immediately, people came to lower Manhattan from all over the country to mourn, volunteer in the cleanup, and participate in the memorial process. This memorial was created in a secluded area by the people who worked at the "pit" cleaning up the wreckage from the towers. Photograph by Jonathan Hyman, 2002.

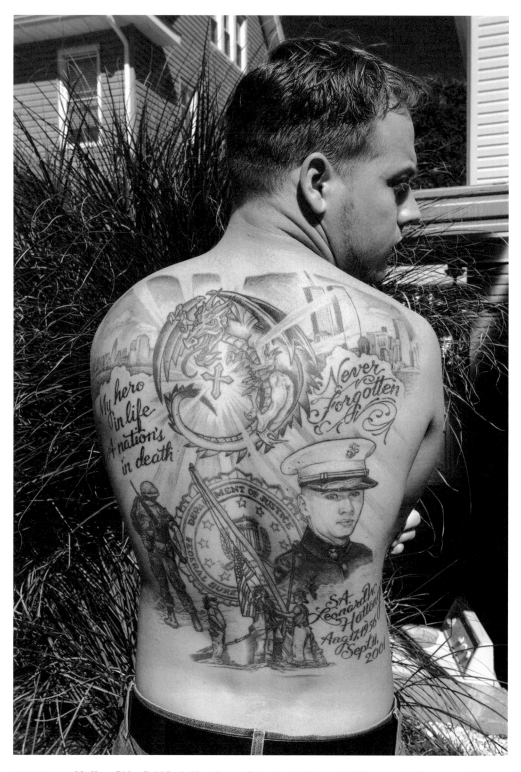

FIGURE 2.54. *My Hero*, Ridgefield Park, New Jersey. Saturated with iconic 9/11 memorial images and language specific to the attacks, this tattoo is a study in the folk art that emerged from the attacks. The son of FBI special agent Leonard Hatton Jr. not only memorializes his father as a hero but also shares his father and his father's portrait with the rest of America. Photograph by Jonathan Hyman, 2005.

rals reflect a cultural preference for more formalized, officially sponsored programs of public commemoration? If so, what will the eventual National September 11 Memorial & Museum in New York City look like? And in the future, will this museum and others present exhibitions and content that depict a public and visual conversation that generated and exchanged ideas and images through print media, television, the Internet, copy machines, cell phones, camcorders, and other forms of social media? Will the public memory of 9/11 reflect that Americans referenced icons from national history (Figure 4.5 in Chapter 4), in particular source material from World War II (Figures 2.6, 2.61, 2.62, and 2.63) and the Vietnam War era (Figures 2.1, 2.28, and 2.64)? Moreover, Americans culled and employed icons and imagery available to them from popular culture. This included the use of the colors red, white, and blue; comic book characters (Figures 2.65 and 2.66, and 3.6 in Chapter 3); and *Sesame Street*'s Big Bird (Figure 2.67).

A New Memorial Language

In my travels to different parts of the country and Europe talking about my work,[15] there is always someone (especially in academic settings) who characterizes the American response to 9/11 as shallow and nationalistic. People frequently ask me: "You have a lot of pictures. There's a lot of red, white, and blue and anger in your images. So where are the other voices?" In answering this question I have asked people to do two things: First, to try and conceive of the visual, vernacular response to the attacks as a genre or a kind of popular art movement that displays fairly proscriptive ele-

ments and ideas. I acknowledge that there was much red, white, and blue and that the American flag was everywhere. But people told me time and again that the use of the flag was deeply personal, that they loved their country, but that did not necessarily mean they agreed with much or sometimes anything that their government was doing. Second, I ask my audience to do its best to separate itself from personal politics and to look at and think about only what appears within the photographs. Granted, the body of work I have photographed contains more aggression than it does calls for peace. It is easy to point to the use of the American flag, comic book heroes like the Hulk and Captain America, and other vernacular art that calls for justice or revenge to support the argument that Americans reacted with a uniformly warlike, nationalistic response to the attacks. But a closer examination of the materials reveals that within conventional expressions of memorial language there were also calls for peace, love, unity, and inclusiveness. Undoubtedly, there were "other voices."

Globes, doves, butterflies, pink towers, cracked hearts, interlocked arms, and other pictorial conventions were used as a metaphorical means to express sentiments of world peace, unity, and healing (Figures 2.36, 2.45, 2.52, and 2.67–2.70). Flowers were used as well. For example, one mural presents a poignant call for peace (Figure 2.1). Here, the World Trade Center towers are painted as containing or being made of flowers of multiple colors—daisies, dandelions, and sunflowers—which suggest love, life, renewal, and peace. The mural also references "Flower Power" as employed politically and visually by the anti–Vietnam War movement of the 1960s and 1970s. As

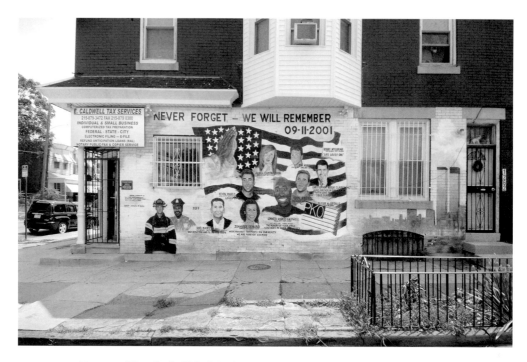

FIGURE 2.55. *Memory of Your Smile*, Philadelphia, Pennsylvania. This mural was commissioned to memorialize individuals from the Philadelphia, Pennsylvania, area who died in the attacks. Photograph by Jonathan Hyman, 2006.

FIGURE 2.56. *Memorial at Firehouse, Engine 74*, Manhattan, New York. This memorial to Firefighter Ruben Correa at the firehouse where he worked is typical of most street memorials in its inclusion of votive candles and flowers. Many of the spontaneous 9/11 firehouse memorials in New York City displayed other offerings as well, such as heartfelt poems and condolence letters. Some also included stuffed animals and children's drawings. Photograph by Jonathan Hyman, 2003.

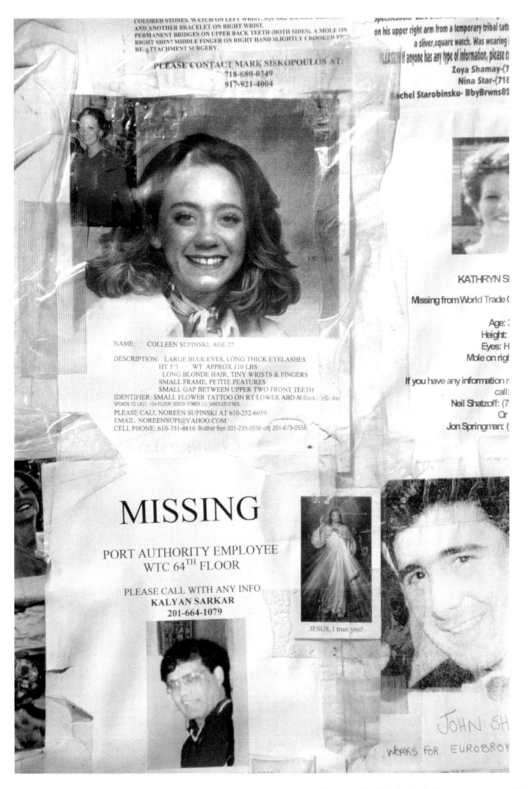

FIGURE 2.57. *Missing Flyer: Coleen Supinski*, Manhattan, New York. Thousands of "missing" flyers were posted in New York City and in surrounding towns after the attacks. Often heart-wrenching and containing personal information, these flyers ended up becoming memorials to those who perished. Photograph by Jonathan Hyman, 2002.

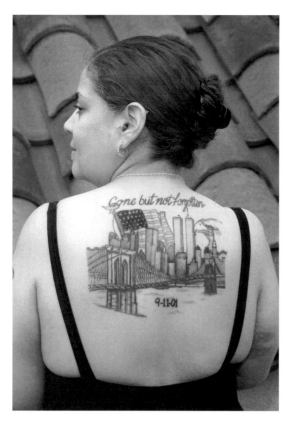

FIGURE 2.58. *Diana's Back*, Brooklyn, New York. The pairing of the American flag with the World Trade Center towers and the bald eagle was common to murals and other public artworks. It also appeared in tattoos as people passionately "inked" their bodies in ways that helped define and expand the visual and memorial language of the 9/11 attacks. Photograph by Jonathan Hyman, 2006.

FIGURE 2.59. *Flag, Eagle, Towers*, Brooklyn, New York. Photograph by Jonathan Hyman, 2003.

FIGURE 2.60. *Steamroller with Osama*, Damascus, Pennsylvania. Sculptor Forrest "Frosty" Meyers makes light of the now classic phrase "Let's roll," a call to brave action that emerged from the Flight 93 crash. Photograph by Jonathan Hyman, 2005.

FIGURE 2.61. *Date Mural*, Chicago, Illinois. Photograph by Jonathan Hyman, 2005.

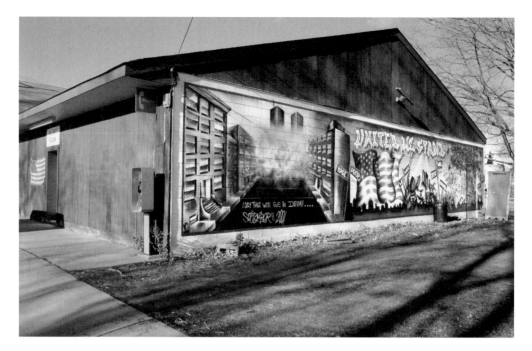

FIGURE 2.62. *Day of Infamy*, Pine Bush, New York. The 9/11 attacks have been compared, frequently, to the Japanese attack on Pearl Harbor. However, this mural goes a step further by quoting a passage from President Franklin Delano Roosevelt's 1941 speech to the nation in response to the surprise attack by the Japanese. Photograph by Jonathan Hyman, 2001.

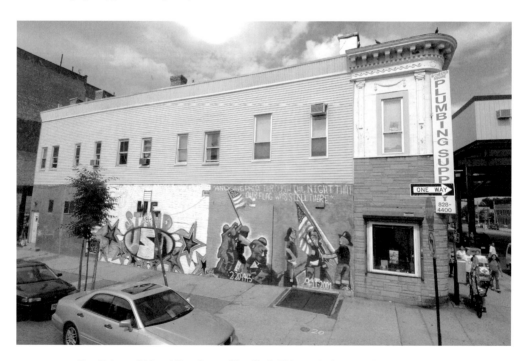

FIGURE 2.63. *Flag Raisers: Old and New*, Bronx, New York. This patriotic mural incorporates two iconic images: the WWII Iwo Jima flag raising and the 9/11 flag raising. The quotation above the flag raisings is excerpted from the American national anthem, "The Star-Spangled Banner," which was composed during the War of 1812. Photograph by Jonathan Hyman, 2005.

FIGURE 2.64. *Double Missing in Action Tattoo*, Queens, New York. The firefighters of New York City reworked the Vietnam War–era POW/MIA emblem as a means to express their emotional and persistent search to recover the remains of many of their fellow firefighters, many of whose bodies were never recovered after the collapse of the twin towers. Photograph by Jonathan Hyman, 2006.

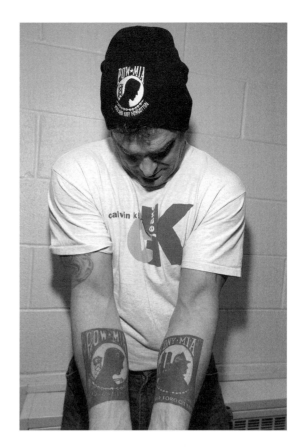

FIGURE 2.65. *City of Heroes*, Pine Bush, New York. Americans employed a variety of techniques to respond to the attacks. These ranged from using the colors red, white, and blue to referencing American history and recontextualizing objects and images from popular culture in more complex ways. With Captain America, the comic book superhero who came of age during World War II, the muralists make a connection between World War II and American strength and resolve in the aftermath of the 9/11 attacks. Photograph by Jonathan Hyman, 2002.

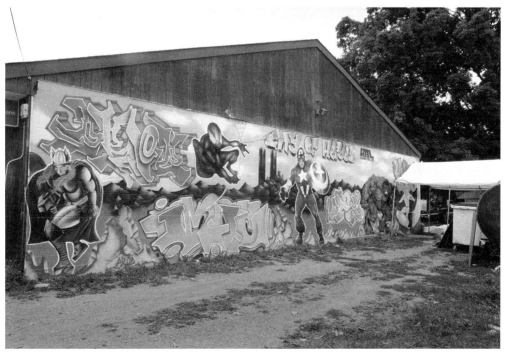

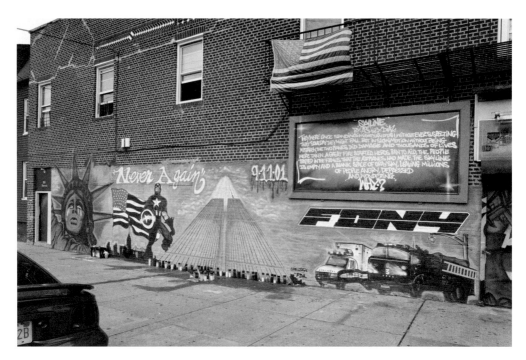

FIGURE 2.66. *Towers Go to Heaven*, Bronx, New York. With the blood of those who died still dripping, Captain America protects and observes the World Trade Center towers as they ascend to heaven, as if in apotheosis. Photograph by Jonathan Hyman, 2002.

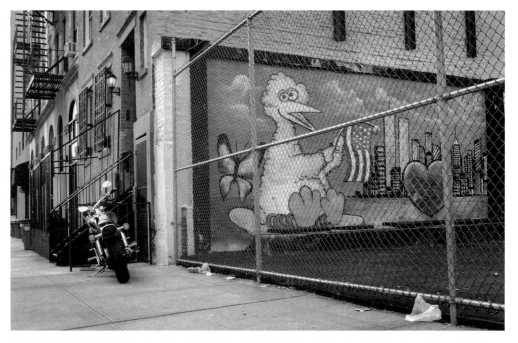

FIGURE 2.67. *Big Bird with Broken Heart*, Manhattan, New York. In addition to pink towers and a cracked heart, Big Bird is used in this schoolyard mural to connote childlike innocence. He is joined by a butterfly that has arrived in the world after a transformative journey. Despite the use of the American flag, this mural moves beyond a basic patriotic response with its emphasis on metamorphoses, the connotations of the color pink, and the emotions associated with a broken heart. Photograph by Jonathan Hyman, 2004.

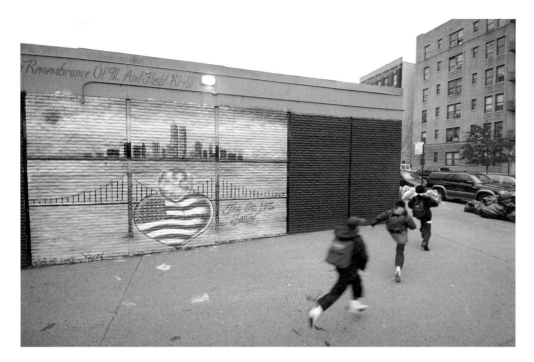

FIGURE 2.68. *Double Tribute with Children*, Manhattan, New York. This mural is painted on the side of a public school in the largely Dominican neighborhood of Washington Heights. It displays a globe and a reference to the deadly crash of a plane bound for the Dominican Republic in Queens, New York, shortly after the 9/11 attacks to suggest that New Yorkers and Americans are part of a larger global community. Photograph by Jonathan Hyman, 2004.

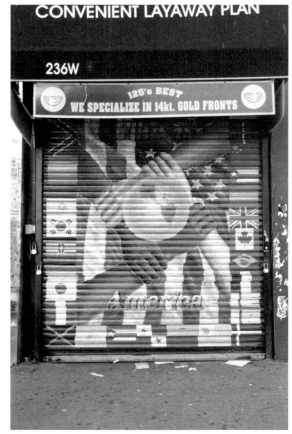

FIGURE 2.69. *Unity*, Manhattan, New York. Photograph by Jonathan Hyman, 2002.

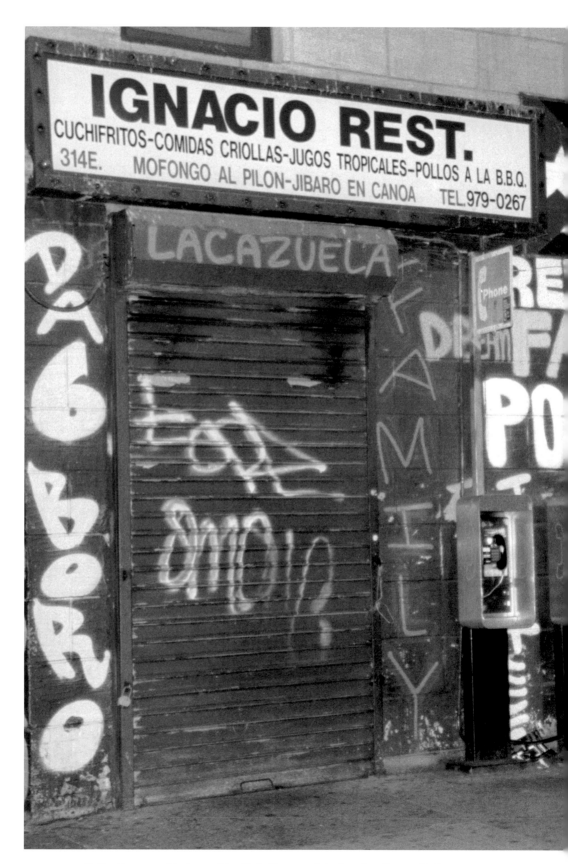

FIGURE 2.70. *To Our Tomorrow*, Manhattan, New York. Photograph by Jonathan Hyman, 2002.

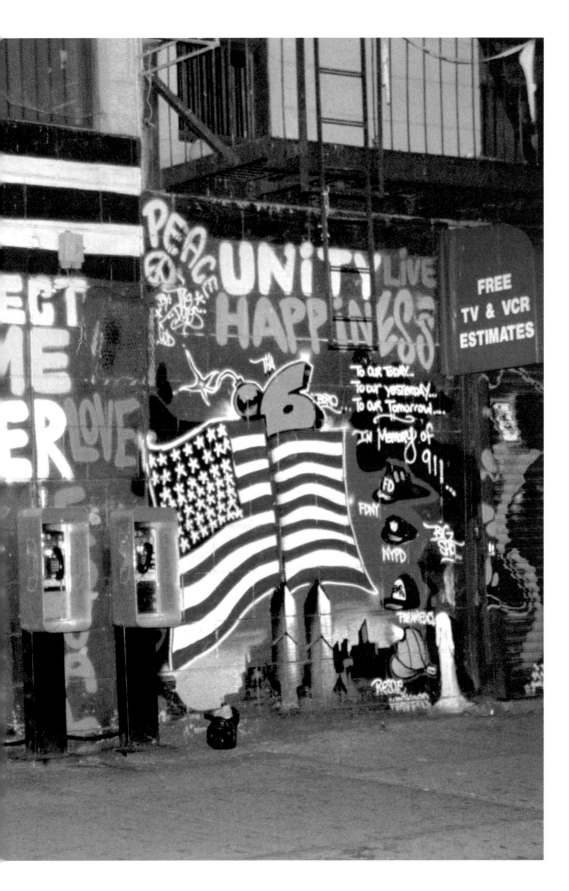

they rise up into an idealized glimmering sky composed of red, white, and blue stars, these towers reference American cultural history and speak to peace, suggesting that one can still embrace the red, white, and blue of being an American patriot while at the same time calling for one's country to follow the path of peace, not war.[16]

During the time I have been working on this documentary project I have encountered and spent time with a wide cross section of people who have made the artwork I photographed and documented. Knowing what I was working on, some people sought me out. Others I discovered accidentally by stumbling across them or else found them through personal contacts and references. Still others I found by actively seeking them out after having either seen or been made aware of their work. Some took me into their lives and insisted on telling me their personal histories and motivations for the art they made or paid others to produce. Others spoke to me reluctantly out of obligation once they understood my project's goals, and then only about the basic details of the work I photographed. And many others simply refused to talk at all. In short, everything was a negotiation and an effort on my part to be understood without being pushy or invasive.

The 9/11 artworks and memorials I photographed are part of a dynamic process of remembrance of the events of that fateful day and its immediate aftermath. So powerfully and abundantly present in public, they are now not only a part of the history of the public memory of 9/11 but also inextricably connected to the changing history and interpretations of the attacks and our collective future. I believe that a new generation of scholars and museum professionals, perhaps less burdened by personal and emotional connections to the attacks, will study and exhibit these materials with a vigor that will enable our society to interpret 9/11 in ways that balance our need to commemorate with the more complex and demanding task of understanding who we are as a nation and what freedom and never forgetting mean in a world remade by the 9/11 attacks. Both the complexity of our memorial culture and the memory of those who perished in the attacks demand nothing less.

Notes

1. The first ten thousand pictures I took with a Canon Elan auto focus camera using Fuji 35 mm negative film. In the summer of 2003 I made the switch to digital photography, first using a Fuji S1 Pro camera, then a Fuji S2 Pro, then a Nikon D200, and finally a Nikon D7000.

2. I was given a camera for my tenth birthday and continued to take pictures from that point on. I became more serious about photography my freshman year in college. Although I took photography classes as an undergraduate at Rutgers University and studied photography intensively in graduate school, I graduated from Hunter College in 1990 with an MFA in studio art with a concentration in painting. When I moved to New York City in 1983, my work focused largely on painting, supplemented with mixed-media collage and drawing.

3. I studied sculpture, painting, and mixed-media drawing with Orenstein at Rutgers for four years, and he was my advisor for a Henry Rutgers Honors project my senior year that paid me a small stipend and allowed me much time to work independently on my painting. The program required me to have an exhibit at the end of the year and write an accompanying thesis. I remain close to Orenstein. I studied painting with Golub in 1980 and 1981. We maintained a friendship that changed over time as I became a more mature working artist. It was his encouragement and urging that sent me back to graduate school. I studied photography with Feldstein (who was by then well known for his street photography after having been a painter himself) at Hunter College. He was largely responsible for my move away from painting and eventual focus on photography. We remained close friends until his death in 2001. I studied painting with Swain at Hunter College and although he is an abstract painter, as I was when I entered graduate school, he encouraged me to make the break from abstraction that eventually led to my move to photography. I was introduced to Close by my friend Jonathan Rose, who is Close's brother-in-law. I met Close at his studio twice. Our discussions centered around our mutual interest in photography, grids, and systems,

and my work at the time, which was made by cutting up my paintings and weaving them back together with store-bought black velvet paintings.

4. Manuel Peña immigrated from the Dominican Republic to New York City in the mid-1970s and settled in the Washington Heights neighborhood in northern Manhattan. I met him in 1991, the day I moved into his apartment building on 172nd Street between St. Nicholas and Audubon Avenues. As the "mayor" of the block, he eased my transition and acceptance into a neighborhood where very little English was spoken.

5. Under the auspices of the New York City Council, over four hundred people who died in the September 11th attacks have had streets named in their honor. (Information based on documents supplied to the author by the New York City Council. These documents were presented by New York City Council's Infrastructure Division between June 2002 and December 2010 to the New York City Council's Committee on Parks and Recreation.)

6. World Trade Center steel has found its way to many places, including 7.5 tons cast into the bow of a warship named the *U.S.S. New York.* As of February 2011, approximately two thousand requests have been made for the steel, housed by the Port Authority of New York and New Jersey at an 80,000-square-foot hanger at Kennedy Airport in Queens, New York, referred to as "Hanger 17." Half of the requests have been approved, but the Port Authority has stopped taking new requests due to lack of inventory. In addition to the small-sized beams and pieces of steel in the give-away program, the hanger is home to a number of large objects, such as a destroyed fire truck, a badly damaged Path train car, and enormous steel beams and core columns from the WTC towers. The Port Authority allows municipalities, uniformed agencies, and not-for-profit organizations to apply for and receive steel if they meet the criteria for memorial usage. Requests to use the beams for memorial purposes have come from all fifty states in the United States and from foreign countries including Canada, China, England, France, India, and Italy. (Information on the steel give-away program is based on the author's personal conversation and e-mail correspon-

dence in February 2011 with Norma L. Manigan, manager of external affairs, Public Safety Department at the Port Authority of New York and New Jersey. For steel used in the warship, see A. G. Sulzberger, "U.S.S. New York Reaches Manhattan," *New York Times*, November 2, 2009, http://www.newyorktimes.com/2009/11/03/nyregion/03ship.html.

7. At the time the flag was made, McBrien contacted the United Sates Department of State and received an accounting indicating that civilians from eighty-six nations had died in the attacks. Current research suggests that the actual number varies between 85 and 106. McBrien does not intend to alter the flag.

8. I have photographed images of Peggy Alario, sister of the lieutenant, and Angel's Circle, the Staten Island memorial, several times over the course of the last twelve years. Begun as a spontaneous memorial, Angel's Circle is located at the triangle formed by the intersection of Hylan Boulevard and Fingerboard Road in the Grasmere neighborhood, not far from the Verrazano-Narrows Bridge. Initially nothing but a simple traffic median, this very large memorial, which reflected the enormous number of people from the borough of Staten Island killed in the attacks, transformed over time from an informal gathering place and memorial site with candles, flags, "missing" flyers, and enlarged photographs of those dead or missing, to a formalized, manicured, and well-maintained memorial for over 150 people remembered in graphic detail with pictures, poetry, and collections of deeply personal memorabilia.

9. A number of phrases used by the New York City firefighter and others suggest that the Vietnam War has been a source for the way people have expressed their feelings about the attacks. "You Are Not Forgotten," "Never to Be Forgotten," and "All Gave Some, Some Gave All" are phrases that have traditionally been used by the POW/MIA movement and were used on 9/11 tattoos, memorials, and bumper stickers. The firefighters of New York City have also co-opted the POW/MIA flag and designed their own, almost identical, FDNY/MIA patch and flag, which honors and memorializes those firefighters whose bodies or

body parts were not recovered from the ruins of the twin towers. (I don't know who actually designed the FDNY-MIA flag and patch.)

10. Cassidy and I eventually became linked together forever when my photograph of his back tattoo was published on a full page in *Time* magazine. After *Time* published the photo on the five-year anniversary of the attacks, newspapers in the United States and Europe offered me money to publish a picture of Cassidy's face. I turned them down, but Cassidy told me that the *New York Post* photographed him, despite his wishes, as he turned the corner on the way to his firehouse. Shortly after that, a picture of Cassidy appeared in the *New York Post*, superimposed on the top left side of my photograph.

11. On the fifth anniversary of the 9/11 attacks I had a solo exhibition of one hundred photographs at the National Constitution Center in Philadelphia titled *9/11: A Nation Remembers*.

12. Some of Indart's early murals were commissioned by New York assemblywoman Helene E. Weinstein, who arranged six neighborhood commissions. She received permission from landlords to use their exterior walls and coordinated with Indart to have Youth DARES, a community group dedicated to keeping children out of gangs, prepare the walls. Indart's work was and still is subject to the various problems faced by all artists who make public work in urban settings. Work is vandalized or "tagged" by random people or competing street artists. Buildings get torn down or landlords sell their buildings, and the new owner either "scrubs" (paints over) the mural or uses the space for paid advertising.

13. In varying degrees of scale and representation, Indart's murals feature an undulating flag, an eagle, the World Trade Center towers, the New York City skyline, the Statue of Liberty, and inscriptions on a scroll that name the dead. The use of a scroll or tablet to name the dead and or make personal or civic proclamations was not unique to Indart's murals; as Christiane Gruber notes, the scroll evokes both biblical tradition and political tradition (the Declaration of Independence) (see Chapter 7 of this volume).

14. Danny Suhr, from Marine Park, Brooklyn, was the first firefighter to die in the September

11, 2001, attacks; he was killed when a falling body or "jumper" from the south tower of the World Trade Center landed on him.

15. In the fall of 2008, as part of a program organized by the American Embassy in Vienna and the University of Graz, Austria, I toured Europe as a cultural envoy, lecturing at universities in Berlin and Tübingen, Germany; Vienna and Graz, Austria; Brno, Czech Republic; and Zagreb, Croatia.

16. As a way to register their opposition to the American military response to the attacks, particularly the Iraq War, people involved in the antiwar movement in the United States have used the phrase "Peace Is Patriotic." The *Flower Power* mural echoes this statement visually.

COLLECTING THE NATIONAL CONVERSATION

Jan Seidler Ramirez

Between the writing and publication of this essay, the National September 11 Memorial opened as planned on the tenth anniversary of 9/11. As of December 2012, almost six million people had visited it. The companion museum will open in 2014.

The cataclysm of 9/11 has often been recast in analogies reliant on momentous events in American history when our collective consciousness and circumstances felt threatened by an inrushing, ominous change. The first shots fired between British troops and American colonists at Lexington and Concord, the Battle of Gettysburg, the attack on Pearl Harbor, and President Kennedy's assassination are some of these earlier turning points that are repeated in popular references to 9/11. Such events are also remembered as triggers that provoked rhythm-changing public response and reflection. The 2001 terrorist attacks on the United States were similarly convulsive, prompting emotional shock, spiritual soul-searching, and a show of patriotic solidarity that found diverse outlets. Notable among these repercussions was the groundswell of citizen volunteerism and charity mobilized to comfort the be-

reaved and to support the rescuers toiling at ground zero, the Pentagon, and the crash site near Shanksville, Pennsylvania. With an unplanned war in the making against an unfamiliar enemy, thousands abandoned the plows of their everyday pursuits to help counteract the nation's trauma. They were 9/11's "second responders," whose therapeutic contributions ranged from raising relief funds, crafting quilts, and donating blood (unfortunately, unneeded) to cutting tangled steel and feeding the search-and-recovery teams.

Jonathan Hyman is connected to this Army of Aftermath, yet distinct from it. His oversimplified biography shares many hallmarks of these recruits: an everyday taxpayer and family man from upstate New York whose moral universe was violated by the indiscriminate murder of nearly three thousand human beings at the start of an ordinary American workday. Like so many others who acted voluntarily in the wake of this tragedy, he sacrificed time, skills, and materials without expectation of compensation, spurred to do something purposeful and beneficial. In fact, Hyman holds an MFA degree in studio art, and prior to 9/11, as a working artist and photographer who continued to maintain a studio after moving out of New York City, he had been intrigued by vernacular roadside art, often traveling to photograph drive-by examples that caught his eye, sometimes exhibiting these images or incorporating them as source material into his mixed-media art.

Rather than channeling his adrenaline toward the hubs of the attacks, where a magnetic collectivism prevailed, Hyman's personal compass—a camera lens—led him to a more autonomous course in which he chronicled 9/11's reverberations within the neighborhoods and tri-state region collaterally scarred by the terrorist strikes. As his interest deepened, his geographic scope widened, and he traveled further afield in pursuit of pictorial ruminations about the events of 9/11.

The stimulus of Hyman's campaign finds parallels in the efforts of many other lay reporters motivated to investigate the cultural upheaval of 9/11 on their own terms, without waiting for the media or academia to parse its meaning. Nonetheless, his work diverges from much of that grassroots documentation by its exceptional breadth—an archive containing close to twenty thousand images—and the tenacity demonstrated by his multiyear engagement with this subject. Unquestionably, a seasoned perceptual facility enhanced the project, accompanied by no small measure of grit, sleuthing, and lucky breaks. But the constant buoy was Hyman's self-replenishing curiosity about the ubiquity and vigor of the unfiltered conversation he saw (or "eavesdropped on," as he sometimes termed it) on the walls, billboards, bodies, back roads, side yards, front stoops, and truck stops of America's common grounds.

I first met Jonathan Hyman in late 2002 when I was vice president and museum director at the New York Historical Society, which had steered into the storm of the 9/11 calamity by venturing to collect and present evidence of this cultural turning point—or what felt like one—without the assurance of knowing how historians would frame these terrorist crimes down the line. The candor of Hyman's work was intriguing. Already, there was an arc to the images he had gathered: a graphing of the diversity of lives reflected in the multiethnic, multiracial victim count; the depth of

national shock and sorrow over their common endpoint; the mood of unity consoling the country in the immediate aftermath; and the spread of competing meanings assigned to these attacks, unlocking divergent ideas about how to respond to them. They also generated suspense. Had this dynamic public chatter and lamentation over 9/11 peaked, or would it grow more rampant as political maneuverings around the attacks intensified, new information circulated, conspiracy theories amplified, and communities across the nation prepared to formalize memorials to the victims? Thereafter, we met periodically to review his maturing portfolio and discuss some of the remarkable stories and ideological patterns of expression he was excavating.

During this time, other museum curators were taking notice of the longitudinal nature of Hyman's work as well, including the

Smithsonian's National Museum of American History, which floated the idea of organizing a book and companion exhibition, although neither eventuated. Many of us had seen our share of exceptional site-specific pictures from this event. However, Hyman's roaming pictures, captured at a considerable remove from ground zero and the other crash sites, impressed in a different way. The actuality of response they were measuring felt wired more directly into the post-9/11 static electricity crackling across the country. Hyman, too, was earning respect for his tenaciousness as a hunter of this subject matter and for his conviction that the ''New Americana'' archive he was assembling was of historical importance. Moreover, I was coming to appreciate the rewards of his artistic patience, evidenced in pictures like *Boys Passing By* (Figure 3.1). Clearly having waited to capture a telling

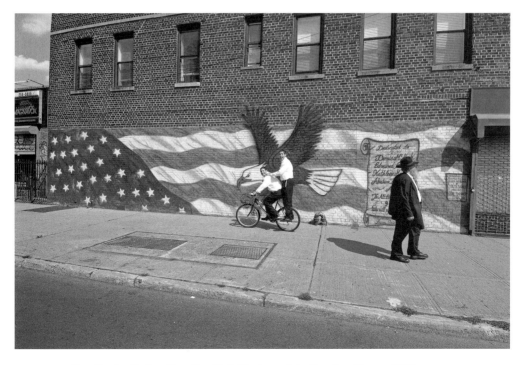

FIGURE 3.1. *Boys Passing By*, Brooklyn, New York. Photograph by Jonathan Hyman, 2005.

moment of public interaction with this 9/11 wall memorial in the Midwood neighborhood of Brooklyn, Hyman sensed the shot's opportunistic arrival as two Orthodox Jewish boys suddenly rode past him on a bike, mugging for the camera as they crossed in front of the uplifted wings of an American bald eagle centering the composition behind them. Hyman's choices in making this picture are revealing and define the way he approached his work. Knowing this mural lacked the World Trade Center towers, he took care to ensure that the scroll on the right side of the mural listing the names of those who died in the attacks was visible. The resulting image playfully coordinates the fusion of aerial and foot-propelled motion, depicts a moment in time in a Brooklyn neighborhood, and also preserves the mural's integrity as a 9/11 memorial.

When I assumed the chief curator position for the nascent World Trade Center Memorial Foundation in 2006, Hyman's photographs often served as focal points for our start-up project team as we debated how to portray the cultural aftershocks of 9/11 within the narrative museum that would complement the 9/11 Memorial at ground zero. Like Hyman, we recognized that these effects had no end bracket in sight. The impact of 9/11 was still uncoiling in response to local, national, and international events and to theatrics of remembrance that were becoming increasingly politicized. For the fifth anniversary observances, the foundation collaborated with Hyman to mount an exhibition of his 9/11 photography at the newly rebuilt 7 World Trade Center, overlooking the cheerless construction hole of our future memorial.[1] We also began to acquire his images for the museum's collection. Curatorially, that

process of incremental selection—which has evolved into an annual pattern of partial purchase, partial gift—underscored the malleability of Hyman's archive. For almost every topic weighting our interpretive discussions at particular junctures, his picture library could be relied on to offer visual correlatives addressing these same issues or arguments, often at their formative stages.

There are countless ways to recruit Hyman's photographs as springboards for investigating the content moorings of the National September 11 Memorial & Museum. The following survey skims only four nodes of images that I have had occasion to reconsider for refreshed perspectives as the complementary programs of the museum and memorial approach their final form. Each resonates with a sensitive storytelling strand that must be woven into the presentation of this history—but not blatantly so. These range from the appalling nature of deaths witnessed on 9/11 and the stress inflicted on survivors of the attacks to the exertions of the National September 11 Memorial & Museum to arrive at a paradigm for conveying the scope of this mass murder without depriving its multiple victims of their individuality.

The Jumper

While traveling through North Philadelphia in 2003, Hyman chanced upon an exceptional image for the roadside 9/11 murals he had been recording to date (Figure 3.2).[2] A component of a larger painted tableau that commanded the side of a repair shop specializing in automobile alarms, it freezes the free fall of a businessman plummeting to certain death from one of

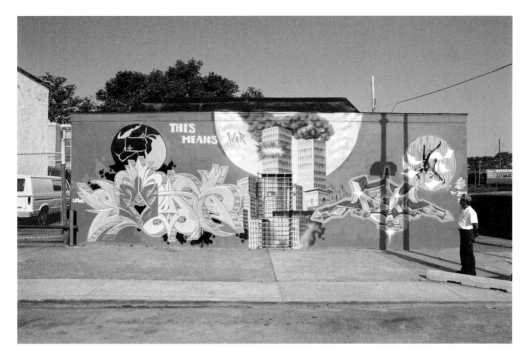

FIGURE 3.2. *This Means War*, Philadelphia, Pennsylvania. Of the many thousands of photographs taken by Jonathan Hyman, this mural includes the only depiction of a "jumper" he saw that was painted or drawn by an adult. Photograph by Jonathan Hyman, 2003.

the wounded towers, which spew smoke at the center of the composition. Fluttering office papers expelled from the stricken buildings orbit the "jumper." At the scene's far left, a map spotlights the New York and western Pennsylvania crash sites of three of the four hijacked aircraft. Although the Pentagon hasn't been situated as a target, its retaliatory presence is implied in the mural's putative title: *This Means War*.

That Hyman confronted this falling man at some geographic distance from New York is probably significant. Within the New York metropolitan area, real-time witness of the World Trade Center attacks was so recent and raw that any exploitation of this spectacle risked public censure.[3] Bystanders as well as occupants inside the towers looking out windows that morning recall

the inconceivable shock of realizing that such tumbling forms were human beings, not building debris, caught in gravity's pitiless pull. The effigy rendered by this local graffiti collaborative likely derived from Internet sources, a newspaper, or graphic novels appropriating sensationalist images captured on 9/11. Although the jumper's comic-book rendering mutes some of its visceral impact, the moment immobilized for our contemplation is nonetheless disturbing, forecasting important tensions that have accompanied the National September 11 Memorial & Museum's efforts to craft a way to document this awful aerial sight within its core exhibition.

Choice is a theme interwoven through 9/11's dramatic progression, distilled by the deliberate actions taken by nineteen ter-

rorists that deprived nearly three thousand innocent people of any plausible choice. At the World Trade Center, as many as two hundred individuals trapped above the impact zones are estimated to have exercised a measure of drastic agency over their destinies when they chose to breathe fresh air rather than suffocate, attempting inconceivable self-rescue over incineration.[4] Their desperate and daring choices stunned those watching. Onlookers, too, had choices: to look, or to look away. Etiquette from below varied greatly that morning, tapping into intimate personal and spiritual beliefs. Firefighter Maureen McArdle-Schulman, whose gaze moved skyward after responding to the fire department's command station on West Street, felt like a voyeur upon recognizing that it was people, not desks, plummeting from on high. "I was intruding on a sacrament," she recalled. "They were choosing to die and I was watching them and shouldn't have been."[5] Conversely, Victor Colontonio, a visitor from Boston who saw the same phenomenon on the street outside the World Financial Center, considered it his moral duty to observe. "I felt an overwhelming obligation to witness the poor souls jumping to their death," he later wrote. "Watching, it was the only thing we could do, it was the least we could do, and in the same breath, it was all that we could do."[6] Shaken by his first sight of this unbearable, repeating performance, Mayor Rudoph Giuliani, a steeled crisis manager, confided to his police commissioner, "We're in uncharted waters now."[7]

Questions inevitably arose among certain religiously affiliated groups of victims' relatives and clergy stemming from the volition they perceived in the act of jumping. Were these suicides? However unplanned, were they fundamentally a sinful equivalent to the self-annihilation sought by the terrorists? New York City's medical examiner, Dr. Charles S. Hirsch, immediately ruled all deaths suffered in the attacks to be homicides except those of the hijackers. Still, spiritual unease nagged those who could not accept exiting a burning building from a window thousands of feet above ground as a willful choice made by their loved ones.

Photographers at the scene, too, exercised a range of judgments about recording those falling to earth. Some averted their camera lenses, too dismayed to click. However, many haunting pictures were taken capturing the supreme isolation and physics of their descent—epitomized by Associated Press photojournalist Richard Drew's often-reproduced *Falling Man*.[8] Videotape acquired by news agencies and the FBI reveals couples and small groups of co-workers clasping hands as they leaped from broken window apertures into immaterial air. Hyman's choice to eternalize the content of this mural parallels the rationalizations and instincts influencing those who opted to preserve visual witness of these ineffable final moments.

Interestingly, by the next day, media outlets were already weighing the newsworthiness of running such unprecedented images against the risks of offending readers' sensibilities and trespassing on the privacy of the unknown victims depicted. (Over time, some identifications did emerge based on magnification, the study of clothing worn, and locations from which they fell.) Papers electing to publish such images—including the *New York Times*, which situated Richard Drew's picture on page 7 of its September 12 issue—often

found themselves on the defensive to explain their editorial ethics. Quickly, photographs and film footage of the ''jumpers'' evaporated from national mainstream coverage of the 9/11 attacks in rare collective deference to restraint over optical novelty. Nonetheless, their telegraphic impact persisted through circulation on the World Wide Web, in international journals, and in filmed replays of the savage assault on the World Trade Center. However briefly exposed to these images in mass media formats or as direct witnesses, children relentlessly drew figures cartwheeling from the towers in their response art, sometimes inserting Superman or rescuers on elongated ladders attempting to catch them.

In a museum nested inside the archeological void of the World Trade Center where these terrorist atrocities occurred, how does the institution negotiate the emotional caretaking of visitors and bereaved families in appropriate balance with its educational commitment to historical veracity? Do these images of people falling to death seared into our public consciousness on 9/11 have evidentiary value surpassing spoken and written accounts of such scenes extracted from interview footage and retrospective oral histories? In laying out an exhibition about the events of the day, should visitors be introduced to this element of the narrative on a main path, like the man standing on the sidewalk in Hyman's photograph, perpetually absorbing the mural's totality? Or is this troubling content better cloistered within an alcove that is optional to enter, pre-signaling the topic it addresses? Modalities of presentation within such a space also provoke questions. Is one picture too few to solemnize the number of ''jumpers'' whose falls

were part of that morning's prolonged horror? If spare editing prevails, which images best perform in the eyes of visitors as truth-telling documents instead of compositions inclining toward artfulness because of their cropping? Will truth be compromised by confining the day's cruelty to frozen frames of optical witness, excising the stunning sounds of the helpless making impact with roof canopies and pavements outside the World Trade Center?[9] As deadlines approach, these tough, even profound, questions have kindled ongoing debate, concern, and differing expositions among the museum staff and consultants tasked with resolving this design quandary.

The rarity of Hyman's encounter with explicit jumper pictures—the Philadelphia mural representing the only figure of a jumper created by an adult that he came across while compiling his archive—may suggest that vernacular memorial makers, too, deliberated the traumatic weight that these charged images would likely carry in an open landscape, especially within areas harboring populations likely to have directly intersected with 9/11.[10] Ultimately, the museum elected to remove this particular content from the central visitor pathway to an alcove that one may opt to enter after first confronting images of shocked eye-witnesses. Rather than relying on oblique depiction of what has stirred those emotions—such as featuring an enlarged version of Hyman's photograph of the jumper mural picture—the alcove will present a spare selection of projected still photographs of individuals falling to their deaths sufficient to confirm that these choiceless choices were not isolated occurrences.

Survivor

The magnitude of 9/11's death toll, although less than initially estimated, cast a pall over the nation for months. As Mayor Rudolph Guiliani reflected on the afternoon of September 11 when urged to project casualty numbers, the human cost of the attacks would prove "more than any of us can bear ultimately," regardless of the final tally.[11] In the weeks that followed, sympathy flowed to relatives whose loved ones had been killed or were still missing. For almost a year, public grief was rekindled by the ritualistic publication of individual obituaries endearing the victims and martyred rescuers to *New York Times* readers, who recognized something of themselves in these profiles of hard work, family devotion, and dreams—abruptly severed.

Survivors of the catastrophe fared differently as subjects of popular concern. In the immediate wake of 9/11, reporters rushed to broadcast their dramatic escape stories while investigators courted their witness testimonies to reconstruct the timeline of the disaster. (In New York City alone the source pool for such accounts was vast: an estimated 16,400 to 18,800 occupants were inside the twin towers that morning, with as many as 25,000 people evacuated from buildings and streets adjacent to the World Trade Center.[12]) However, the press spotlight on survivors retreated as the U.S. War on Terror commenced and relief efforts accelerated to support the bereaved, the displaced, and recovery personnel at ground zero. Taking the pulse of those spared death and gruesome injury seemed of minor significance to the breaking developments of this outspreading global event. An assumption

prevailed that survivors—thankful to have eluded the fate suffered by less fortunate co-workers—would recover from their ordeal by cherishing and re-engaging with the normalcy of their September 10th lives. Posttraumatic stress, of course, resists such tidy closure, as chronicled in a small trove of Hyman's photographs.

Survivor, for example, forecasts the emergent voice of those who found safety on 9/11, if not protection from its horrific memories (Figure 3.3). In a countryside setting far removed from the devastation of ground zero, a bedsheet draped over a wooden fence outside a farmstead proclaims the improbable status of one of its occupants as a survivor of the World Trade Center attacks. Hyman encountered this *plein air* statement near the village of Warwick, New York, sometime after the trees had shed their foliage in late autumn of 2001. He tried and eventually succeeded in interviewing the property owner but learned only that "he got out" of the towers and later moved out of the house.

Like thousands of others whose personal information mattered little once the hijacked planes torpedoed into the towers, the improviser of this sign has divulged the only fact that counted that morning: his place locator, 2WTC 69, alphanumeric shorthand for the 69th floor of the south tower, accompanied by the patriotic identifier of several American flags. It was realized only some days after the attacks that floor positions, access to passable emergency stairwells, and physical mobility were the inflexible determinants of outcomes for tenants and others within the buildings when American Airlines Flight 11 struck the north tower (officially, 1WTC) at 8:46 a.m., followed by United Airlines

Flight 175, which plunged into the south tower (2WTC) at 9:03 am. Due to the angle of aircraft impact, egress options were eliminated instantly for everyone above floor 91 in tower 1. In tower 2, conflicting evacuation scenarios unfolded over a critical seventeen-minute interval in response to the "accident" affecting the other building. Although a majority of occupants were already below the direct strike zone by 9:03, approximately 620 people in higher offices (some of whom had earlier reached the lobby by elevator but obeyed instructions to return to their respective company quarters, which, it was thought, would shelter them from the falling debris and people outdoors) were either doomed or killed instantly when the plane diagonally ripped through floors 77 to 84. Ironically, one debris-strewn stairwell, stairwell A, remained navigable in the south tower's impact area, but only eighteen individuals managed to locate and escape down it.

Among tower occupants able to descend, an abbreviated numerological code quickly developed to reference locations within the buildings as an explanation for and assertion of life. Hindsight has imposed added meanings on these spatial coordinates. In the case of the bedsheet datum, it can be inferred that 2WTC 69 is traceable to an employee of or visitor to the investment firm Morgan Stanley Dean Witter & Co., which occupied twenty-two floors (spanning 74 to 43, not all consecutive) of the south tower, as well as the lower-rise Building 5. Having adopted and stringently rehearsed a disaster contingency plan after the 1993 terrorist bombing of the World Trade Center, the company claimed an extraordinary statistic on 9/11: 3,700 of its resident workforce walked away from

obliteration to the local shelter of predesignated backup facilities. Only thirteen (seven employees and six professional service contractors) failed to exit alive, among them Rick Rescorla, Morgan Stanley's security chief, who had long anticipated a renewed targeting of the towers by terrorists and who instituted a corporate culture of preparedness for emergency situations. Remembered that morning by many colleagues as singing "God Bless America" and favorite military songs over a bullhorn to encourage evacuees during their anxious descent, Rescorla was seen minutes before the building toppled at 9:59 a.m. reclimbing stairs with several of his deputies to sweep Morgan Stanley's offices again for any stragglers.[13]

It is tempting to interpret Hyman's *Survivor* as a redemptive ending—a harrowing personal journey resolved when 2WTC 69 reached the streets, retreating sometime thereafter to bucolic Orange County, New York, possibly to a weekend home or the comfort of a family compound.[14] However, abundant documentation now confirms that the psychological anguish experienced by many survivors deepened rather than subsided after 9/11, when the adrenaline of relief yielded to an onslaught of delayed emotions ranging from guilt and anger to depression and mourning over lost friends, colleagues, workplaces, and personal security. Feeling isolated from one another and peripheral to the spate of resources available to victims' relatives, dislodged residents, and members of large companies with proactive counseling programs, survivors often recall these early post-incident years as lonely, confusing, and intensely introspective. In 2006, almost five years after the attacks, while passing through a

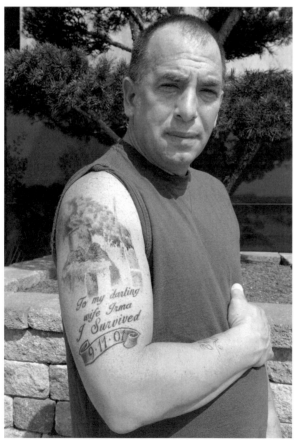

FIGURE 3.3. *Survivor*, Warwick, New York. People who worked in the World Trade Center towers or in nearby buildings on the day of the attacks and "got out" refer to themselves as "survivors." At this farm outside the limits of New York City, a "survivor" identifies himself and then goes a step further by specifying the number of the tower and floor from which he escaped. Photograph by Jonathan Hyman, 2001.

FIGURE 3.4. *To My Darling Wife*, West Nyack, New York. Photograph by Jonathan Hyman, 2007.

shopping mall in Rockland County, New York, Hyman spotted an upper-arm tattoo bearing tell-tale images of an angry fireball and smoke erupting from the towers (Figure 3.4). Assuming it would be a variation of homage to fallen uniformed services heroes or a loved one killed on 9/11, he approached the man sporting the piece to ask for permission to photograph it. On closer inspection, the design surprised Hyman by revealing itself as a survivor's souvenir, in this case indelibly dedicated to the motivator of the man's deliverance: "My darling wife, Irma." A trader in the towers on 9/11, he lived daily with the disaster seared into his body as it must have been

seared into his mind. Alternatively, one did not have to be a "survivor" to find inventive and personal ways to use his or her body to commemorate or state a connection to the attacks, memorialize a loved one, or broadly pay tribute to the towers of New York City (Figures 2.15, 2.16, and 2.54 in previous chapter, and Figure 3.5).

Acquiring tattoos represented one literal form of processing the pain of these events. Other survivors turned to the Internet as a way to validate their experiences. Two years after the attacks, a small eclectic group coalesced to launch the WTC Survivors Network as a grassroots forum for discussion and mutual healing support.[15]

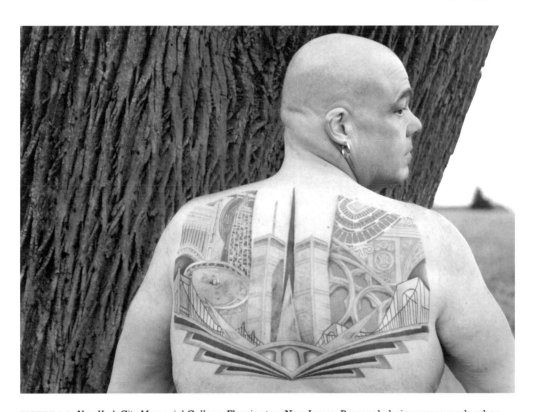

FIGURE 3.5. *New York City Memorial Collage*, Flemington, New Jersey. Personal choices were made when people constructed artwork or adorned their bodies with tattoos. This native New Yorker and now longtime New Jersey resident made a conscious decision to honor the city of his youth by depicting landmarks important to him. However, he omitted the American flag and other overtly patriotic icons. Photograph by Jonathan Hyman, 2012.

Over time, participation in the network grew through word of mouth and media outreach. Preceding it was a comparable online organization dedicated to reconnecting guests, conference goers, and staff who survived the brutalization of the Marriott Hotel (3WTC) when cascading debris from the adjacent towers fell on it twice, killing several guests, employees, and a number of firefighters using the hotel as an emergency command center.[16]

Ten years after 9/11, it would be unthinkable to marginalize survivors when evaluating the long-run collateral damage of the terrorist attacks, just as it is impossible to overlook the lessons of resilience and determination reflected in their progressive recovery. Time has bridged their separation and empowered their influence at the table of reconstructing the history and impact of this disaster. When the 9/11 Memorial Museum opens, it will owe the preservation of one of its most resonant artifacts, the Vesey Street stairway, to the impassioned efforts of survivors to safeguard this last remaining above-ground vestige of the World Trade Center as a testament to their experiences. Used by hundreds who fled north from the plaza level after going down uncountable flights of steps inside the imperiled towers, this final passage toward safety incarnated the fate interconnecting those who lived: like the person whose destiny was divulged on the bedsheet seen in Hyman's photo, they reached and descended stairs, often passing the upwardly moving traffic of firefighters, police officers, and other civilian rescuers who ultimately met their deaths. By chance, the Vesey Street stairway itself survived the day's devastation, as well as the subsequent cleanup efforts at ground zero. Within the chasm of the site anchoring the 9/11 Memorial Museum, visitors will descend past this relocated 58-ton relic to bedrock, where the primary exhibition recounting the events of the day and their consequences will draw, in part, on the powerful testimony of those who got out. Opposite the final tread of the stairway, a vast expanse of wall will confront those arriving at the museum's interpreted spaces bearing words from Virgil's *Aeneid*: "No day shall erase you from the memory of time." The wall also will carry a discreet inset panel explaining that just beyond it, sequestered in a facility controlled by the city's medical examiner, are reposed the unidentified and unclaimed remains of many hundreds of World Trade Center victims denied the possibility of "getting out."

The Uneasy Emotions of September 12

Despite its defining date and mission to honor those killed as a result of the day's atrocities, the National September 11 Memorial & Museum is just as much about the world we awoke to on September 12, 2001, and the reactions that have characterized our nation as it has moved forward since that resetting event. An essential message of the museum is that 9/11 happened to all of us in varying degrees, and that we are all individual and collective stakeholders in determining the event's global legacy. One of the three sections composing the 9/11 Memorial Museum's primary historical exhibition has been assigned to exploring that continuing epilogue.

With complexities that have often strained efforts at distillation, the account constructed for visitors has been parsed

into topics supported by expository artifacts. These have been aligned to a general chronology moving from the immediate vigils of mourning through the nine months of rescue, recovery, and cleanup work at ground zero, advancing to the death of Osama bin Laden nine and a half years later, with side journeys into protracted government investigations (9/11 Commission; N.I.S.T.), the War on Terror, ongoing efforts to identify the dead, emerging health-care repercussions among ailing responders (now viewed as collateral victims of the attacks), and societal efforts to heal and construct positive meaning through memorialization and humanitarian endeavors, to cite only some of the territory covered.

Absent from the arsenal of objects recruited for duty here is the immense subsoil of emotion that still underlies this recent history, which unsettles the foundations of conclusions and directives contributing to the catharsis that many expect from the visitor experience at a memorial site. Herein resides a quandary for a hybrid memorial-history museum like ours. On the one hand, an institution born from a recent act of mass violence needs to provide therapeutic messages for those feeling anxious or aggrieved. Through strategic exhibition choices, corroborating the ties of decency, courage, kindness, and generosity that bind human beings is stressed over humanity's capacity for evil. Gestures of tolerance are emphasized over extremism. Opportunities to derive moral and spiritual uplift are also threaded through the 9/11 Memorial Museum's interpretive plans and memorial consciousness. On the other hand, visitors often seek validation or recognition of their own feelings as normative within the context of a ''national'' museum of history.

With democracy and the exercise of its associated freedoms under symbolic attack on 9/11, the National September 11 Memorial & Museum should have license to present the panoply of public responses unleashed in the aftermath, extending to outlier expressions distasteful to the mainstream but still understood as reasonable within the circumstances of the terrorist attacks, including anger, xenophobia, and cries for military retaliation. Their presence, it could be argued, would affirm the undiminished health of freedom of speech as a human right and as a cornerstone of the United States Constitution in defiance of those hostile to such principles. However, with the sensitivities intrinsic to an official mourning place for nearly three thousand people murdered just over a decade ago, the museum must tread cautiously as it demarcates its inaugural content, weighing the benefits of unencumbered analysis against the aims of commemoration and restorative social experience.

Investing for the day when deeper soundings of the public's ''September 12th'' psyche feels justified, the 9/11 Memorial Museum's curatorial team nonetheless has been busy collecting evidence of these more unregulated, emotional responses to 9/11, including news footage and propaganda imagery recording the eruptions of anti-American protests and ''victory celebrations'' overseas within Pakistan, Lebanon, and El Salvador shortly after the attacks. (The Museum's exhibit designers proposed a spare treatment of such negative material in the form of projected images or text, like a memory suddenly recaptured then quickly receding, never staying fixed in the gallery real estate.)

Predictably, given Hyman's populist cu-

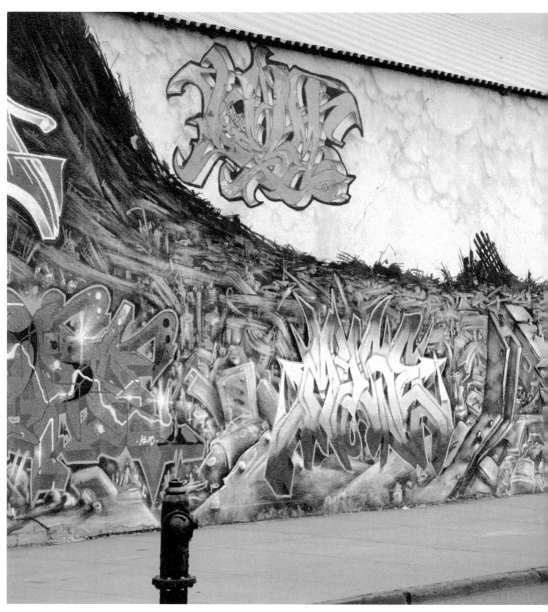

FIGURE 3.6. *Angry Hulk in the Pit*, Queens, New York. Photograph by Jonathan Hyman, 2002.

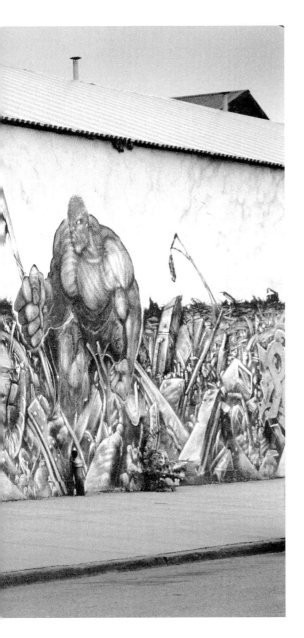

riosity, his archive contains many instructive examples produced on the homefront. The majority take form as pictorial commentary posted on commissioned or appropriated walls in the cityscape, or as statements made on private property, but positioned for intake by neighbors and strangers. Acquired as part of the museum's starter-survey of works by Hyman, *Angry Hulk in the Pit* (Figure 3.6) forebodes the torrent of emotions that fueled popular discourse about the 9/11 attacks for months and years after the initial shock. On a sweeping mural painted in Queens by the Wallnuts Crew of graffiti artists, the legendary Marvel Comics superhero stands upright—a solitary tower unto himself—in a sea of World Trade Center wreckage. Known for deriving force from anger, which strengthened in proportion to his wrath, the Hulk grasps an American flag in his green-toned fist, preparing for action. He will seek a target for his vengeance, unswayed by the world's rhetoric of forbearance and dialogue building, or so the mural's sentiment implies.[17]

Around this same time period, Hyman documented several other murals of more explicit, if fantasized, aggression. A choice example is *We The People* (Figure 3.7), in which its creators hurled vulgarities at the terrorists along with a bomb torpedoing toward Osama bin Laden's turbaned head, which has sprouted a pair of devil's horns. The pugnacious tenor of these works would disturb the decorum of a memorial space. Nonetheless, Hyman's photographs of them—and of other roadside declarations in the same vein—help to authenticate the contentious, uncensored voices (Figure 3.8) lending noise to the chorus of attitudes sounding through post-9/11 America.

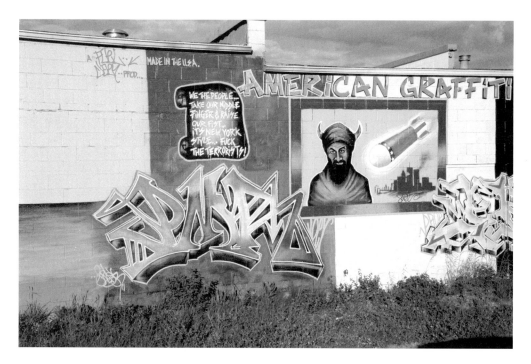

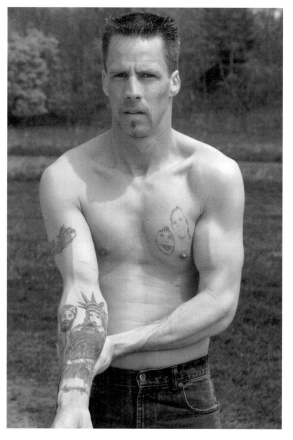

FIGURE 3.7. *We the People*, Middletown, New York. Visual and verbal threats against Osama bin Laden compose a particular genre of the vernacular response to the attacks. People employed missiles, comic book superheroes, and profane language as they vented their private emotions in public by displaying fantasized aggression toward Osama bin Laden in particular and terrorists in general. Photograph by Jonathan Hyman, 2002.

FIGURE 3.8. *Bin Laden Beheaded*, Pinehurst, Massachusetts. Photograph by Jonathan Hyman, 2006.

Within scrolled images designed to reveal the nation's September 12th mood without obliging visitors to examine any one as key to or more important than the others, high-speed legibility is essential. The 9/11 Memorial Museum intends to draw on a number of Hyman's photographs for this component of its primary exhibition, appreciating their easy visual accessibility, which is linked to his efficiency as a story captor. (Hyman points to necessity as honing that skill, as he often hunts his subjects while driving, and has also learned to advance plot his shots on edgier urban turf, with fast work and faster escape in mind.) Two of more than a dozen images collected for this assignment include *God Forgives* (Figure 3.9) and *Flag House* (Figure 3.10), the latter of which is among the best known of Hyman's pictures of vernacular memorials. On a quick take, a satisfying comparison is achieved in this pairing of suburban or ex-urban residences, the first located in the Delaware County crossroads of Delhi, New York, and the second in the upscale Litchfield County town of Kent in northwestern Connecticut.

Don Jones, owner of the Delhi property, has extemporized a 9/11 testimonial with two fabric American flags and a can of red paint, dipping into it to rescript the Christian precept of forgiveness on his mildewed clapboards: "God Forgives But We Don't." In contrast, Kevin Sabia, owner of the Kent property, has orchestrated a meticulous metamorphosis of his full residence into a technicolor show of patriotism. (Camouflaged at far left, Sabia can be spotted posing near a flagpole wearing a compatibly themed American flag shirt.) Without need for explanation, each speaks to the emotions informing the respective

households. Each is a First Amendment exercise. Each may trigger visitors to recall their own impulses to act on deeply held beliefs and feelings spurred by the 9/11 tragedy and to reflect on those gestures of public response that comforted, inspired, or troubled them.

One drawback of a rotating slide show is its limitations as a format for analyzing these spontaneous memorials in greater depth, including their performance of life cycles and the shifting perceptions attached to them with the lapse of time. In the habit of retracing his footsteps to see how certain memorable works had fared, Hyman discovered some years later that Sabia's Old Glory had reverted back to an ordinary neocolonial house. From eccentric but harmless affidavit of national loyalty (the project's idea reportedly came to Sabia in a dream), it had become an objectionable eyesore to the community. Prior to decamping for Florida with his family, Sabia was obliged to repaint the house status-quo white in order to sell the property. Presumably, the court of local opinion had judged the era for ebullient demonstrations of patriotism by individual citizens to be over, no longer viewing them as urgent or innocent acts of self-expression.[18]

Repeat inspection is required to absorb the layered emotions inhabiting some of Hyman's more subtle "roadside chatter" pictures, making them less well suited for transient projection. An example is *Queens Carpet Store Mural* (Figure 3.11), one of several photographs he took of 9/11 response murals commissioned by Muslim carpet store owners in New York City's outer boroughs, bustling with immigrant populations from Egypt, Morocco, Lebanon, Syria, Pakistan, Yemen, Afghanistan, and

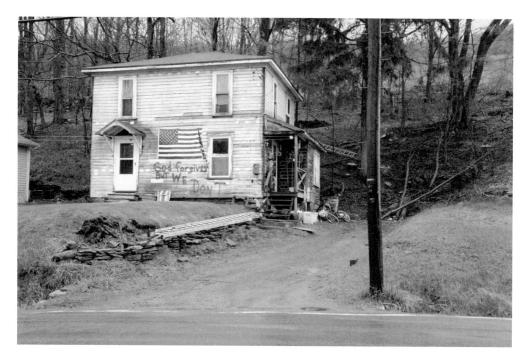

FIGURE 3.9. *God Forgives*, Delhi, New York. Photograph by Jonathan Hyman, 2002.

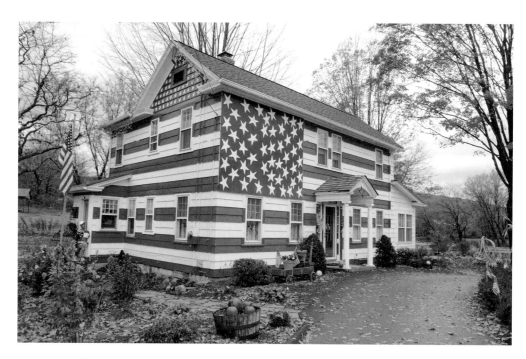

FIGURE 3.10. *Flag House*, Kent, Connecticut. By painting his entire house as an American flag, homeowner Kevin Sabia in effect created a huge roadside billboard. A collector of Americana who got the idea to paint his house from a dream he had shortly after the attacks, Sabia appears in this photograph wearing a flag shirt. Photograph by Jonathan Hyman, 2003.

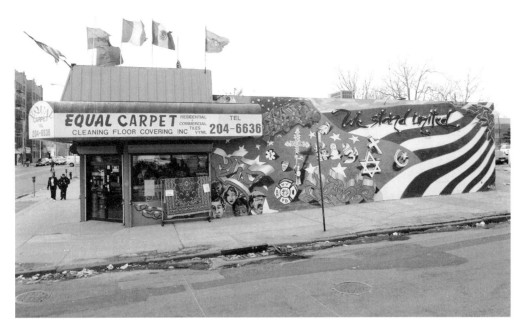

FIGURE 3.11. *Queens Carpet Store Mural*, Queens, New York. Just as the World Trade Center was conceived of as a place where people from all over the world could coexist and prosper in the name of commerce, the impression given by this carpet store, with its assortment of world flags and religious symbols placed side by side, is that it too is a harmonious place where people from everyplace can come and do business. Photograph by Jonathan Hyman, 2004.

South Asia. For such proprietors, recruiting neighborhood graffiti crews to decorate the exteriors of their establishments with imagery advertising sympathies and sentiments understood by longer-settled New Yorkers was a smart business tactic. By affirming allegiance to the United States (like a sentinel, an American flag on a pole raked to maximize its visibility from the street welcomes shoppers to the Queens carpet store) and showing respect for those killed, the owners also lowered the susceptibility of their stores and clientele to vandalism and backlash.[19]

For this particular Astoria-based floor covering shop and cleaning establishment, which occupied a corner plot at 4707 Broadway, the single-story facade stretching along one access sidewalk has been revamped as an immense, undulating American flag. Superimposed on this colorful canvas are spray-painted symbols depicting the world's three dominant religions (Christian cross, Star of David, crescent and star of Islam), a papal figure carrying a Coptic cross, a nod to the different badges or insignias of New York City's first-responder agencies, and (at lower far left) a gallery of multicultural portraits, probably stand-ins for the store's working-class patrons, who are both subscribers to and beneficiaries of the mural's catch-line, "We Stand United," written on the upper right. Signatures of the creators are also interwoven into the piece.

The choice of message is noteworthy

since it detours phrases more prevalent in 9/11-tribute murals, such as "God Bless America" and "Never Forget." Perhaps the store's owner reckoned that on the heels of a deadly assault on America by perpetrators of Middle Eastern and Muslim backgrounds, neighborhood solidarity was a virtue worth accentuating on its own, or perhaps the motto's strategy was to reassure outsiders that this ethnically diverse patch of Astoria was a seamless part of the larger American quilt. The name of the venture, Equal Carpet, which Hyman took care to register twice in choosing his camera vantage point, invites some ironic reflection as well. While the prospect of securing equality of opportunity has been integral to the immigrant dream of settlement in the United States, achieving those benefits has usually proved more elusive for newcomers, entailing unrelenting work and psychological stamina. No magic carpet exists to transport the aspirant to pain-free success. That Islamist extremists had masterminded the 9/11 attacks discharged new unease through stepping-stone neighborhoods like Astoria, home to growing numbers of Muslim residents, where the ideal of equality hovered to motivate but was not yet a societal given.

Although its customers would be unaware of the connection, Equal Carpet actually shares similarities, at a very humble scale, with the late World Trade Center. Both feature/featured a show of international flags to convey their world outlook. In Astoria, a few flap in the wind on the store's roof; at the World Trade Center, an extensive display greeted tenants and visitors inside the mezzanine lobbies of the towers, each of which rotated a selection of them, signaling the universal reaches of com-

merce the complex was built to facilitate. In the 1960s, Minoro Yamasaki, architect of the behemoth buildings, and his client, the Port Authority of New York and New Jersey, believed in the power of global trade to promote world peace through the expeditious and equitable distribution of modern goods, information, and ideas to all partaker nations. The demise of the World Trade Center on 9/11 was a catastrophic perversion of the promise invested in it by its planners. But the mission—and optimism—of the World Trade Center also endures, in decentralized fashion, through countless micro enterprises like Equal Carpet, many run by immigrants in globally diverse neighborhoods, which continue to bring goods, ideas, and a stabilizing presence to the areas they serve.

The unpacking of such images requires time, just as Hyman himself devoted time to tracking down, researching, and framing their capture. When the National September 11 Memorial & Museum activates a special exhibition program several years after the launch of its core galleries, it will be rewarding to arrange a reunion of these "September 12th" images to see where our understanding and emotional reading of them has traveled.

Remembering the Victims

In early 2004, after evaluating 5,201 designs reflecting submissions from sixty-three nations and forty-nine of the fifty United States, a jury appointed by the Lower Manhattan Development Corporation (LMDC) awarded Michael Arad and Peter Walker Partners with the commission to implement their hybrid concept, Reflecting Absence, for the official World Trade Cen-

FIGURE 3.12. *Angel's Circle*, Staten Island, New York. This enormous roadside memorial began spontaneously as an informal gathering place for friends, family, and others mourning the dead and the collapse of the towers. Over time it became a more formal, landscaped, and well-known site that memorializes approximately 150 people. It continues to function as a memorial to this day. Photograph by Jonathan Hyman, 2003.

ter Memorial. Long before that announcement, however, efforts to pay public tribute to the victims of 9/11 were already prolific. With roaming camera, Hyman began to inventory that phenomenon of improvised, democratic commemoration.

Correctly anticipating a prolonged process of managing the art competition at ground zero, let alone implementing whatever choice resulted, the creators of these expedited memorials satisfied an emotional urgency to immediately ingrain remembrances of the dead in our communal consciousness. These ubiquitous grassroots tributes, especially apparent in outer-borough neighborhoods, suburbs, and job-related outposts connected to the

victims or their mourning families, prodded passersby to bear in mind that regardless of how these hostile attacks against America might be synopsized in the future, those killed on the frontlines must never be forgotten as the ordinary but precious individuals they were. Sometimes grafted onto them was an appeal to remember the human networks these victims epitomized, linkages not telegraphed by their names or numbers alone. Located at the intersection of Hylan Boulevard and Fingerboard Road in Staten Island is Angel's Circle (Figure 3.12), the subject of multiple photographs by Hyman taken in 2002 and 2003. It exemplifies this latter genre of homage. Sprouting on a barren traffic circle reborn as a

miniaturized suburban subdivision in the wake of 9/11, this spontaneously generated people's memorial park commemorates upward of 150 World Trade Center victims of varied occupations who were local to Staten Island on tightly packed and landscaped "residential" plots. Although each plot accommodated stations for individualized picture shrines and other differentiating votive offerings, the compact, undulating layout of Angel's Circle accentuates, above all, the neighborly ties that had cemented this population of decedents.[20]

An extensive press trail has chronicled the controversies ignited by the LMDC's selection of Reflecting Absence as the scheme anchoring the eight acres reserved for memorialization at the World Trade Center site. Certain project stakeholders, including subsets of aggrieved relatives and uniformed rescue unions, berated the design for its consecration of emptiness. Consisting of a solemn horizontal plaza punctuated by tree plantings but stripped of other honorific symbols or vertical homage to the twin towers, Arad's abstract conceit privileged the footprints of the missing buildings but repurposed them as inverted receptacles for two cascading waterfalls designed to weep into deeper voids at the epicenter of each granite-clad pool, symbolizing the immeasurability of human loss suffered on 9/11. According to this coalition of critics, the notion of "absence" was insufficient for evoking the valor, resolve, and patriotism associated with ground zero.

Further opposition centered on the architect's plan to list the names of the murdered. Initially, these were to be inscribed in galleries located within the cavity of the site. As a result of design adjustments made to the overall plan in late 2006, the names were subsequently elevated to appear above ground, bordering the memorial's two sunken pools. However, anger remained over the continuing plan to randomly order the victims' names and intermix civilians with rescuers, justified by the designer as dramatizing the haphazard brutality of terrorism by resisting the imposition of "order" on this suffering. (A degree of narrative allowance had been conceded to trained emergency responders through inclusion of their departmental insignia. In the revised scheme, these names would be paired with their respective dispatching agencies.) This fortuitous arrangement, its supporters noted, underscored the role of wild-card fate that day: individuals perished not because of who they were or the particular jobs they held but because of where they happened to be when catastrophe struck and the buildings fell.

Complications grew when the renamed National September 11 Memorial & Museum focused more attention on the mandate to honor Pentagon, Flight 77, and Flight 93 fatalities as well as the six victims of the 1993 terrorist bombing of the World Trade Center. Groups became more emboldened in advocating, variously, for more interpretive explanation of 9/11's narrative scope on the outdoor memorial plaza, demanding the alphabetizing of victims' names, citing of their ages, distinguishing of the flight passengers and active military service members and/or the referencing of affected companies within the towers, including (or not including) ranks for line-of-duty deaths, and recognizing unborn children among the victims, a precedent established in the 1993 bombing memo-

rial commissioned by the Port Authority for the World Trade Center's Tobin Plaza, which was destroyed on 9/11.

Despite the discontent voiced by its detractors, Reflecting Absence progressed into construction, retaining the stark simplicity of its master plan and undergoing only slight modifications required by evolving engineering, budgetary, and security variables.[21] What did shift markedly, however, was the approach to situating victims' names around the bronzed parapets of the tower pools. This revision ensued from consultative sessions held over several years between the memorial foundation, the architect, and other professionals listening to the opinions of 9/11 families, first responders, and tenant firms bent on correcting the principles guiding the disposition of names. Although all critics of the project were not satisfied on all points, a compromise was reached that validated many sentiments proclaimed years earlier in the makeshift memorials photographed by Hyman.

Hundreds of his images contain seeds of the ideas reflected in this resolution. In Paterson, New Jersey's, Cedar Lawn Cemetery, for instance, Hyman spotted an elaborate family tree etched into a headstone for twenty-eight-year-old Cindy Ann Deuel, an executive assistant employed by Carr Futures on the ninety-second floor of the north tower (Figures 3.13, 3.14). This choice of motif, which featured Cindy's cat sitting underneath its foundational branches, honored her success as an amateur genealogist, including the discovery of her great-great grandfather's unmarked grave near this same spot. Surprising in this placid setting was the stone's reverse face: an explicit delineation of the twin towers with the antenna atop tower 1 portending the scene of her murder and forever connecting Deuel to where she worked on September 11. Overt references to the venues where loved ones perished were not universally present in the grassroots tributes Hyman encountered. But they recurred enough to suggest the primacy of place, especially the potent icon of the twin towers, that was interjected into the ritual of commemorating lives terminated there.

In the evolving 9/11 Memorial design, victims' names also would be codified according to their respective aircraft flight numbers or target sites where death occurred. To do so, however, required that Michael Arad and allies of his vision relinquish the original concept of random distribution of names around the memorial pools. Mathematically, there were layout challenges in absorbing the full national roster of 9/11 fatalities along with the earlier 1993 victims, further compounded by the need to factor adequate space for any newly identified victims' names that might be issued by the New York City medical examiner. Eventually, however, nine discrete groupings would inform that expanded program.[22]

Eight of these bracketed locales are specific to the human storytelling of these events. The north tower pool would list names of the crew and passengers of American Airlines Flight 11, which exploded above it, workers and visitors killed inside that building, and the six fatalities of the bomb detonated below it in 1993. The south tower pool would contain the names of its known casualties together with those killed in proximity to the World Trade Center and aboard United Airlines Flight 175, augmented by the names of Pentagon

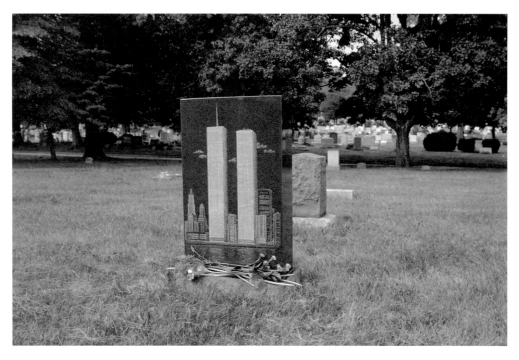

FIGURE 3.13. *Cindy Ann Deuel Tombstone*, Patterson, New Jersey. Photograph by Jonathan Hyman, 2004.

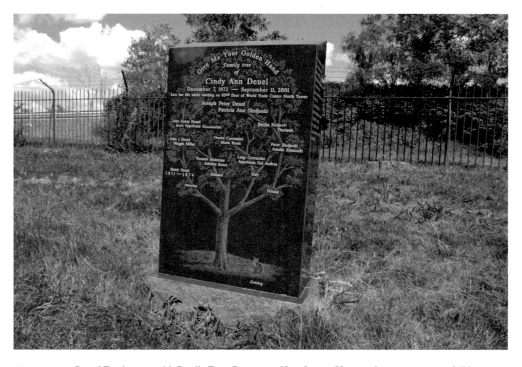

FIGURE 3.14. *Deuel Tombstone with Family Tree*, Patterson, New Jersey. Vernacular responses to 9/11 include personal accounts of the attack's victims. Victims are memorialized in various ways, from depictions of their faces and personal information about their bodies and hobbies to details about their family members and jobs. In addition to a detailed family tree, this tombstone depicts Cindy Ann Deuel's pet cat, Sammy. Photograph by Jonathan Hyman, 2004.

victims and the passengers and working crews aboard Flights 77 and 93.

The ninth major grouping, reserved for first responders and assigned to the south tower pool, posed many design problems. A number of Hyman's pictures of early shrines to these fallen rescuers presage some of the germinating disputes that would slow progress on this component of the memorial. Such is the case for the depiction of a tidy white house emblazoned with a proud cursive *B* under its gable, referencing the owners, Ernest and Hilde Bielfeld (Figure 2.31, previous chapter). A locally made sign affixed to its front fence, erected six months after the attacks, implores onlookers, "Never Forget the Three Hundred and Forty Three Who Were Murdered in the Rescue of over 25,000 People, September 11, 2001," alluding to the number of active-duty New York City Fire Department members killed when the towers fell.[23]

The placard—electrified for nighttime display—is dedicated to "our son, our hero," the forty-four-year-old firefighter Peter A. Bielfeld, whose name, birth and death dates, and portrait photo are woven into its design. On a day of mounting perils, the supreme sacrifice made by career civil servants in their efforts to save others certainly merited this honorific, including Peter Bielfeld, a veteran member of the FDNY's Ladder 42. Out on sick leave on September 11 from injuries sustained while fighting a fire three days earlier, he insisted on being placed back on duty to respond to the call and was last seen rushing toward the burning south tower.[24]

The proximity of the sign to the open road traveled by Hyman seems to enact the push-and-pull involved in transitioning personally controlled memories of 9/11 victims to the public realm. On private property, the parents of firefighter Bielfeld could dictate their preferred vocabulary and numbers of significance. However, when thousands of fellow victims must be remembered through an egalitarian process of the sort required of the 9/11 Memorial, individual epitaphs are subsumed by the language and hierarchies controlling that larger memorial's accounting system.

Despite appeals by some groups of next-of-kin to order victims' names on the memorial telegraphically, according to bold numerical subdivisions like the FDNY's 343 (Figure 3.15) casualties or the 658 civilian deaths sustained by the north tower financial firm of Cantor Fitzgerald, a more subtle placement procedure emerged for the national memorial. This approach allowed names to be gathered within appropriate affiliations but deleted headers indicative of employing companies (except for first responder agencies) and omitted specific casualty counts: it was people, not corporations or statistics, who perished.[25]

Overt heroic wording was also absent from the first responders' grouping on the premise that all 9/11 victims' deaths were commensurately lamentable and with the knowledge that brave civilians, too, had died while selflessly aiding their companions, fellow evacuees, and passengers. Especially vexing to families of uniformed officers killed in the line of duty was the memorial's rejection of rank and title designations. The sudden loss of the immense, cumulative expertise of chiefs, captains, lieutenants, and others with years of training to their credit was an especially shocking blow to the New York City Fire Department. The design team, however, stood its

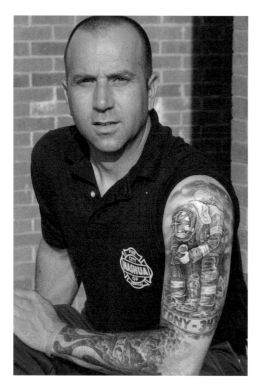

FIGURE 3.15. *343 Tribute*, Nashua, New Hampshire. Iconic images and generic phrases emerged as part of the memorial language of the attacks. Important numbers emerged as well, such as 343, which represents the number of New York City firefighters who perished in the attacks. Photograph by Jonathan Hyman, 2006.

ground in rejecting the ordering of names by any implied or literal hierarchy.

Ultimately, two principles would govern the arranging and labeling of first responders' names around the south tower pool: citation of official New York City dispatching agencies, within which names would be leagued or clustered under the individual units from which the rescuers had responded to the scene, such as fire company, squad, or battalion unit, police command station or precinct, and ambulance corps. While not mollifying those who continued to insist that chain of command be privileged, this solution not only reinforced the history of a September workday gone dramatically wrong (fire, police, and emergency medical response agencies were sending employees to a "job," in this context) but also acknowledged the renowned camaraderie of the New York City firehouse and other tightly knit crisis response teams who trained, patrolled, and often were housed together—and were prepared to die together if duty demanded that extreme sacrifice. Under this convention, Peter Bielfeld would be associated with Ladder 42, the habitual posting glued to his identity and practice as a New York City firefighter.

In addition to where they were or what agency they worked for, a crucial aspect of people's experience on September 11 is who they were with. Many victims that Tuesday morning were in the company of co-workers when the attacks occurred. Some were with relatives, friends, guests, fellow travelers, and strangers with whom acute connections were forged as a result of their shared predicament. As understanding grew of the extent and importance of the day's deeper human af-

filiations, the memorial's designer strove to accommodate placement of names that would perpetuate those special alliances. As Hyman discovered when researching the stories motivating many of the 9/11 murals, tattoos, and neighborhood shrines he encountered, names were rarely linked capriciously within these compositions. However, it was the insiders who created them or viewed them daily who supplied their narrative linkages. Reflecting Absence followed this modality by offering next-of-kin or legal partners the choice of situating their loved ones' names adjacent to others with whom they had or were believed to have had meaningful relationships, whether forged over a lifetime (in the case of families, spouses, siblings, and best friends who co-perished), a span of collegial interaction, or a matter of minutes. Not apparent to the casual visitor, the significance of these juxtapositions would have resonance to those already intimate with the victims' biographies.

Logically, one would expect such meaningful adjacencies to populate the groupings of victims who were traveling together as families and couples aboard the four hijacked flights. However, a number of corporate firms in the World Trade Center—most notably, Cantor Fitzgerald—also suffered multiple losses of relatives within their employee ranks, including siblings, cousins, in-laws, spouses, and parents and children. Traditions of families gravitating to the same civil service niches over successive generations created overlapping relative losses within the fire and police departments, too. In his tracking of 9/11 memorials, Hyman began to recognize the recurrent motif of two colossal uniformed figures rendered as the pillars of the twin towers, one often attired as a firefighter, the other as a police officer (Figures 1.1, 3.16–3.18, and 7.12 in Chapter 7). This brotherly pairing is generally read as a gesture of respect to the bravery and martyrdom of those first-responder branches, but Hyman soon appreciated the reality rooted in this configuration: the deaths of the FDNY's John T. Vigiano II, age thirty-six, and his thirty-four-year-old brother Joseph Vigiano, a detective with the NYPD's Emergency Service Unit, both sons of John Vigiano, a retired FDNY captain and former Marine. Another fraternal association crossing rescuer lines was that of the Langone brothers, Peter with FDNY Squad 252 and Thomas with NYPD Emergency Service Squad 10.[26] To make allowances for blood ties that transcended common agency and employment groupings, the Memorial Foundation commissioned a media design firm to devise an algorithm enabling Michael Arad and others to study such emotional kinship connections and situate them to enjoy physical proximity on the memorial's names parapets.[27] With this option, each Vigiano and Langone brother would remain clustered within his correct agency and company with the seam between fire and police personnel joined in a way that allows their names to be read contiguously, on the same line.

When the National September 11 Memorial & Museum is dedicated, the stories flowing imperceptibly through its names arrangements will be made available to curious visitors through supplementary content delivery systems and a robust exhibition about the lives of the victims presented within the museum's south tower footprint. The memorial's primary emotional energy, however, will generate from

FIGURE 3.16. *Flag, Eagle, Towers: Levittown Mural*, Levittown, New York. The World Trade Center towers have been depicted repeatedly in post-9/11 paintings, drawings, and sculptures. The towers are sometimes depicted as a firefighter and policeman standing together or else as a pair of firefighters. These pairings honor and memorialize the sacrifice made by the first responders who lost their lives in the attack. They also anthropomorphize the towers. Sometimes these folk art figures stand alongside, or in place of, the World Trade Center towers in the New York City skyline. (Also see Figure 1.1.) Photograph by Jonathan Hyman, 2002.

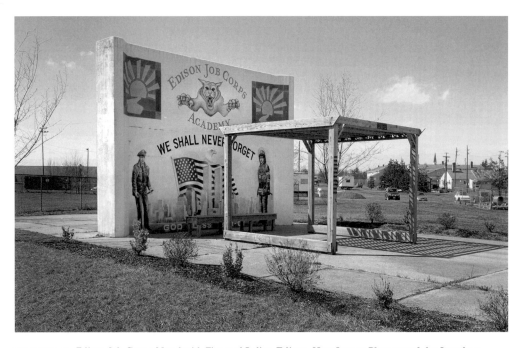

FIGURE 3.17. *Edison Job Corps Mural with Fire and Police*, Edison, New Jersey. Photograph by Jonathan Hyman, 2006.

FIGURE 3.18. *Johnny Perna's Hot Dog Truck*, Staten Island, New York. Photograph by Jonathan Hyman, 2003.

the viewer's sensory absorption of the colossal dual voids with cascading waterfalls commanding the ground once occupied by 10 million square feet of the World Trade Center, and processing of the magnitude of loss solemnized by the unremitting, un-alphabetized inscriptions of 2,983 distinct personal names[28] around the two pools. The memorial will likely continue to serve as a lightning rod for criticism because it has braved an aesthetic solution to the challenge of how to remember the victims of these terrorist acts, provoking further questions about the meaning and civic values assigned to the events of and responses to 9/11.

Jonathan Hyman's photographs are invaluable because they preserve a baseline of the nation's memorial fervor before a professionalized design process began to coalesce around the permanent National September 11 Memorial & Museum. Hyman would be the first to agree that as widespread as these uninhibited expressions were, no clear blueprint emerges from them about how to eternalize the victims of 9/11. Instead, his work demonstrates the need to safeguard the unique names of the nearly three thousand individuals murdered—an aggregate representing more than ninety nationalities—and to ensure that their collective freedoms, vitality, sacrifice, and human interdependencies be perpetuated as a positive legacy of this dark day.

Notes

1. The exhibition, titled *9/11 and the American Landscape, Photographs by Jonathan Hyman*, ran from September 8 to October 7, 2006. The project's curator was Clifford Chanin, senior program advisor to the World Trade Center Memorial Foundation, the official name of which was changed to the National September 11 Memorial & Museum in August 2007. The forty-seven-story skyscraper known as 7 World Trade Center, located on Vesey Street immediately north of the original World Trade Center campus, collapsed under the ravages of fire in the late afternoon of September 11. Its rebuilding was undertaken by Larry Silverstein Properties, which had acquired the ground leases for the World Trade Center from the Port Authority of New York and New Jersey in July 2001.

2. The venue for this wall mural, Polam, Inc., Auto Service and Repair, is located at 4518 North Fifth Street in Philadelphia, near where Hyman's sister lived. According to Hyman, a trio of graffiti artists with the street names of Dan 1, Pastor, and Lotus approached the proprietor: if the owner would pay for the paint and provide the surface on the street side of his shop, the muralists would not charge for creating the piece.

3. Because of its troubling connotations for relatives of World Trade Center victims, the term "jumper" is not used by the Memorial Museum, which instead adopts the straightforward expression "people who fell." Hyman noted that he encountered mural depictions of flying papers in the New York City area, but not of falling people. Interestingly, some latitude existed to enable the insertion of commercialism into these commissioned memorial walls. In *Milo Printing Company* (2003) (Figure 2.34, previous chapter), painted by the graffiti master Chico, for instance, three curled papers float in a skyline featuring the twin towers, bowed but intact, each carrying text advertising the product line of this business on Avenue A, such as labels, invoices, and letterhead. Similarly, prolific muralist Joe Indart painted a mural that included an advertisement for a coffee shop in which the Statue of Liberty drinks a cup of coffee (Figure 2.35, previous chapter).

4. *USA Today* reporters Dennis Cauchen and Martha Moore published one of the earliest and most detailed accounts of people plunging to their deaths at the World Trade Center. See "Desperation Forced a Horrific Decision," September 2, 2002, http://www.usatoday.com /news/sept11/2002-09-02-jumper_x.htm. According to their investigation, the people falling from heights of between 1,100 and 1,300 feet would have struck ground at 150 miles per hour, "not fast enough to cause unconsciousness while falling, but fast enough to cause instant death on impact." The *New York Times* could not verify with confidence Cauchen and Moore's estimate of around two hundred fatalities attributable to falls from the higher floors of the north and south towers when its reporters studied collected videotapes and news footage of the towers engulfed in smoke and flames. *USA Today* used a more expansive method that included eyewitness accounts, through which its reporters arrived at a number of "probably greater than two hundred," as explained to me by Jim Dwyer of the *New York Times*.

5. Maureen McArdle-Schulman, Fire Department of New York (FDNY) oral history printed transcript, interview taped October 17, 2001, 3. In 2005, the *New York Times* published over 12,000 pages of previously restricted oral histories recorded with City of New York personnel who responded to the World Trade Center attacks, including interviews conducted with 503 firefighters, paramedics, and emergency medical technicians. See http://www.nytimes.com/packages /html/nyregion/20050812_WTC_GRAPHIC/met_ WTC_histories_01.html.

6. From Victor Colontonio, "Day-at-a-Glance, September 11, 2001, 200 Liberty Street," unpublished 33-page memoir, collection of the National September 11 Memorial & Museum. Colontonio prepared this detailed account of his sensory collision with the World Trade Center attacks on 9/11 as part of a writing therapy program suggested by mental health professionals he consulted after returning to the Boston area. He had flown to the World Financial Center out of Logan Airport for a business meeting that morning.

7. Retrospectively, Guiliani's comment was widely circulated and quoted in printed accounts of the leadership and human vulnerability he demonstrated on September 11, 2001. See, as

one example, Bill Sammon, *Meet the Next President* (New York: Simon & Schuster, 2007), 102.

8. Drew's photograph, which appeared on page 7 of the *New York Times* September 12, 2001, issue covering the previous day's terrorist attacks, also ran on the front pages of several newspapers outside of the New York metropolitan region. The despair it embodied disturbed readers throughout the country. This particular frame, taken by Drew outside the north tower at 9:41:15 a.m., captured an unknown man plunging through the air in what appeared to be a straight drop. Additional frames shot by the photographer, which were not published at the time, reveal the same individual tumbling out of control. The shocking power and suicidal connotations of Drew's photograph prompted several journalists to attempt to identify the man pictured. The most influential of these efforts resulted in the September 2003 article entitled "The Falling Man," written by Tom Junod for *Esquire Magazine*, http://www.esquire.com/features/ESQ0903-SEP_FALLINGMAN. Junod's speculations were pursued subsequently in several television documentaries airing in Great Britain (British TV Channel 4, March, 2006), Canada (CBB *Newsworld*, September, 2006), and ultimately the United States (Discovery Times Channel, September 2007), but none yielded conclusive proof of the jumper's identity. Most agreed that he probably fell from Windows on the World, the restaurant and catering venue located on floors 106 and 107 in the north tower, and that, based on his attire, he may have been an employee.

9. That sensory sound reality is preserved in audio and film tapes taken at the outset of the calamity, perhaps most unforgettably in footage recorded inside the north tower's fire command station by Jules Naudet, who with his brother Gédéon had been preparing a documentary chronicling the experiences of a probationary firefighter whose Battalion 1 unit responded to the north tower immediately after seeing Flight 11 strike while he was on a call to investigate a gas leak a few blocks away. The sequence recording the plane's explosive impact was televised nationally shortly before midnight on September 11, 2001. The Naudet brothers subsequently assembled *9/11: A Documentary* from the collective film footage they shot, which was first broadcast on CBS in March 2002 to mark the sixth-month anniversary of the attacks.

10. The degree to which makers and commissioning parties censored intentionally disturbing subject matter from the content of 9/11-specific street art remains a matter of speculation. Hyman has observed that apart from the solitary example of a falling man depicted in a mural in North Philadelphia, he counted only two outdoor memorial walls that incorporated airplanes, and only one depicted a jarring scene of a hijacked aircraft knifing into its target. This image, depicting the rear of a jet being swallowed into a puncture hole painted on masonry wall in Merrick, Long Island (see *Plane Crash* 2005, Figure 7.3, Chapter 7), was discovered to be an image recycled from a preexisting wall mural.

11. Guiliani, whose own safety was endangered when the south tower collapsed unexpectedly, uttered these remarks at his first formal press conference about the attacks, which convened at 2:49 p.m. that same afternoon.

12. These are the average survivor estimates cited in the published report of the 9/11 Commission and N.I.S.T.; see *Final Report of the National Commission on Terrorist Attacks on the United States* (July 22, 2004) and National Institute of Standards and Technology, *Final Report on the Collapse of the World Trade Center Towers* (September 2005). At the height of a typical workday, each tower usually had twenty thousand occupants. On September 11, 2001, the count inside the buildings was lower than usual before 9 a.m. due to a local primary election that was underway, causing workers to run late. The academic year was also beginning in many area school districts, with parents escorting children to their new schools and classrooms. These contingencies spared many tower occupants from death or direct engagement in the horrors that began to unfold beginning with the first hijacked plane strike on the north tower at 8:46 a.m.

13. A retired U.S. Army officer of British birth who had served in Vietnam, Rescorla was the subject of a number of posthumous biographies, documentaries, and tributes. See, for example, James B. Stewart, *Heart of a Soldier: A Story of Love, Heroism and September 11th* (New York: Si-

mon & Schuster, 2002), and *The Man Who Predicted 9/11*, a documentary television film premiered on The History Channel in 2002 and broadcast on Channel 4 in Great Britain. For a corroboration of Morgan Stanley's survivor outcome as a result of the firm's emergency preparedness drills, see *Morgan Stanley Annual Report* (2001).

14. Hyman later confirmed that the property was the survivor's primary residence, suggesting the wide geographic pull of the World Trade Center as a magnet for commerce and work opportunities.

15. The organization's website offers a history of its gradual development. See http://www.survivorsnet.org/aboutus.html.

16. A profile of the Marriott survivors' network is found at http://www.sept11marriottsurvivors.org/.

17. An alternate identity for the Hulk has been proposed by at least one viewer of this mural: "the Abomination," another humanoid supervillain populating Marvel comics. Possessed of webbed ears, a ridged brow, and a green hue, the Abomination was created by writer Stan Lee and artist Gil Kane as a stronger and more evil and savage version of the Hulk but lacking the latter's capacity to modulate anger in proportion to circumstances.

18. *Flag House* is among the images featured in an online exhibition of Hyman's work curated for Duke University by Pedro Lasch, an assistant research professor in the Department of Art, Art History, and Visual Studies at Duke. Contextualizing *Flag House* as part of the conspicuous enlistment of heroic-scaled American flags for building construction projects, sites of public assembly, and other structures after 9/11, Lasch reflects: "While those who associate the use of monumental flags with 20th century Fascism and Nazism may find these flag buildings troubling, and others simply find them to be tasteless—Sabia's neighbors did, one can also see these flag buildings as the natural outcome of the common use of facades for corporate advertising. It seems to me that what we get when we dress a private home with the American flag is the icon par excellence of the American Dream." See http://exhibits.library.duke.edu/exhibits/show/hyman/gallery part 6/.

19. When the 9/11 hijackers were identified as Islamist fundamentalists, Arab New Yorkers feared retaliation despite pleas made to the general public by Mayor Rudolph Guiliani and other officials to avoid ethnic and religious scapegoating. New York City police agents were dispatched to safeguard local mosques, numerous stores selling Middle Eastern products shuttered themselves, and Muslim women wearing the traditional hijab requested protective escorts when they shopped and took their children to school. In Brooklyn, Arab business owners fearing reprisals canceled their annual Atlantic Avenue festival, scheduled later in September. Documented cases of actual violence against Muslims and Arabs in Greater New York never obtained the numbers initially feared, but personal safety anxiety and economic uncertainties persisted in these immigrant neighborhoods, compounded by the escalation of federal detention programs that resulted in the roundup of more than five thousand Arab-American and Muslim men for questioning, some of whom were subsequently deported from the country.

20. A living piece of folk art changing decor with the seasons, Angel's Circle was the brainchild of nearby resident Wendy Pellegrino. Shocked at hearing about the deaths of so many neighbors at the World Trade Center, she crafted a handmade sign—"God Bless Our Heroes"—to adorn a traffic island opposite her residence. Within a few days, other Staten Island residents began leaving candles and American flags on the island, followed by the arrival of laminated "missing" posters and enlarged portrait photos of the missing and confirmed dead. Mementoes—including many angel figurines, mass cards, and ruby-colored candle lanterns—began to proliferate. A garden center owner stepped forward to donate plants, trees, and flowers as well as an artificial waterfall. A local fencing company provided a wrought-iron enclosure for the new memorial park. Benches arrived for the comfort of visitors, and a mailbox appeared as a repository for letters penned to the deceased. Over time, Angel's Circle has evolved both in size and ambition, with the number of victims remembered at this enduring community memorial fluctuating depending on the participation of family members and friends of the de-

ceased. Since 2003, the baseline of around 150 has been augmented.

21. The history of the evolving memorial and museum master plan at ground zero was the subject of a survey exhibition featuring various generations of project renderings, *A Space Within: The National September 11 Memorial and Museum*, mounted at AIA's New York Center for Architecture, June 25 to September 14, 2009.

22. The rationales for these nine groupings are articulated on the website of the National September 11 Memorial and Museum. See http://www.national911memorial.org/site/Page Server?pagename=New_Memorial_NA. The names of the nineteen suicide-terrorists are excluded. Since 2007, three deceased New Yorkers unaccounted for in earlier versions of the confirmed victims list for the World Trade Center have been identified as 9/11-related deaths meriting inscription rights on the memorial.

23. The number 343 was a standout among the unforgettable statistics of first-responder fatalities claimed by this catastrophe, along with the thirty-seven deaths sustained by the Port Authority Police Department and twenty-three fallen officers tallied by the New York City Police Department.

24. In addition to his family's posthumous receipt from President George W. Bush of the 9/11 Heroes Medal of Valor, which recognized 442 public safety officers killed while on duty on September 11, 2001, Bielfeld was immortalized in two memorial murals. One was painted around the block from his firehouse in the East Morrisania section of the Bronx, and the other, not far from his Bronx apartment. Bielfeld was also memorialized along with another firefighter on the tattooed leg of a fellow Bronx-based firefighter (see Figure 2.32, previous chapter). The murals and the tattoo were all photographed by Hyman.

25. As a matter of policy, any first-responder name put forward for inscription on the memorial has required verification of active employment status with the victim's respective agency and cross-checking against the list of recipients of the 9/11 Heroes Medal of Valor awarded by the White House in September 2005. As the passage of time has confirmed, the precision of numbers like "343" attracted inevitable challenges. Rela-

tives of certain first responders have lobbied for reassigning the names of loved ones killed while performing private-sector security jobs on 9/11 to the uniformed departments from which they had earlier retired. Other civilian families have challenged the exclusion of their loved ones' names from the revered first-responder grouping, arguing for recognition of the skills these victims would have contributed, by habit, to the crisis under way based on years logged with local volunteer fire and ambulance rescue corps outside New York City government.

26. The double fatalities and sacrifices of Joseph and John Vigiano at the World Trade Center inspired the documentary film *Twin Towers*, which earned an Oscar award for best short documentary subject in 2003. The film presents the brothers as civic role models who incarnated the professionalism and heroism of the more than four hundred first responders who perished on 9/11.

27. More than one thousand adjacency requests in total were received from victims' relatives, creating a complicated web of connections that all had to be addressed in the final design of the Memorial's names arrangement. In mathematical terms, the layout scheme represented a monumental optimization problem of finding the best solution among a myriad of possible ones. To help resolve the challenge, the Memorial Foundation's media design firm, Local Projects, built a software tool in two parts: first, an arrangement algorithm that could optimize adjacency requests to find the best possible design solution; and second, an interactive tool that allowed for human adjustment of the computer-generated layout.

28. In June 2011, the New York City Medical Examiner's Office ruled Jerry Borg, a sixty-three-year-old accountant who worked in lower Manhattan's financial district, a victim of the September 11, 2001, attacks. Although Borg died in December 2010, nine years after the event, his death was linked to pulmonary sarcoidosis, an inflammatory disease of the lungs that in his case was caused by inhalation of toxic substances thrown up by the dust clouds created when the towers collapsed.

FROM THE STREET TO THE MUSEUM
JONATHAN HYMAN'S PHOTOGRAPHS

Charles Brock

When Jonathan Hyman first showed me his photographs in September 2002 I was impressed by his passionate commitment to documenting how Americans were responding in myriad ways through a wide variety of creative works to the events of 9/11. Hyman was clearly a man on a mission who believed that he was witnessing something remarkable and that it was his calling to seek it out and record it regardless of any difficulties he might encounter along the way. As an art historian I was especially struck by the fact that, as much as a documentary impulse, there was an intriguing artistic sensibility at play in Hyman's photographs. How Hyman decided to frame and render his subjects was in many ways as interesting to me as the subjects themselves, especially since he had been trained primarily as a painter and fine artist.

Over the years, as I saw more and more of his work and Hyman's project grew to encompass twenty thousand images of about seven thousand distinct subjects from nineteen states and the District of Columbia, I became increasingly intrigued with how his compendium joined artistic

FIGURE 4.1. Charles Willson Peale, *The Artist in His Museum*, 1822, oil on canvas, 103³/₄ x 79⁷/₈ in. Courtesy of the Pennsylvania Academy of the Fine Arts, Philadelphia. Gift of Mrs. Sarah Harrison (The Joseph Harrison, Jr. Collection).

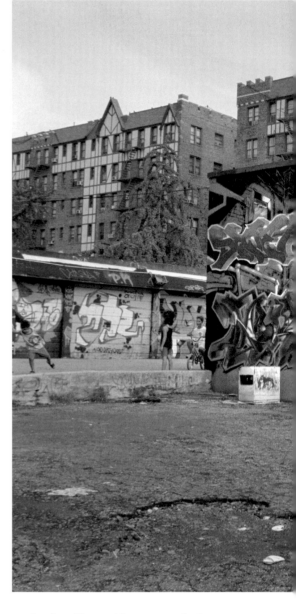

FIGURE 4.2. *Bronx Muscleman*, Bronx, New York. Hyman's photographs owe a debt to photographers Jacob Riis and Berenice Abbott, who documented the underbelly of New York tenement life and fleeting moments of the modern urban landscape. Photograph by Jonathan Hyman, 2002.

methods with a wide range of other concerns, including cultural, sociological, political, and anthropological issues. Finally, when Jonathan approached me in 2010 to write something about his now vast body of work, it seemed useful to try to show how its scale and scope and hybrid nature could be related to earlier interdisciplinary projects undertaken by American art-

ists/explorers, projects that in similar ways aspired to cover vast terrains of national experience. I also thought it might be helpful to begin to grapple with how, more than being just objective documents of other artists' works, Hyman's photographs could themselves be considered as part of the evolving chain of subjective artistic responses to 9/11.

The mixing of artistic pursuits with the more scientific, academic accumulation and organization of knowledge has been part and parcel of American culture since at least the time of Charles Willson Peale (1741–1827). Peale's multitalented, creative persona is epitomized in his famous self-portrait, *The Artist in His Museum* (Figure 4.1), which, with its depictions of birds

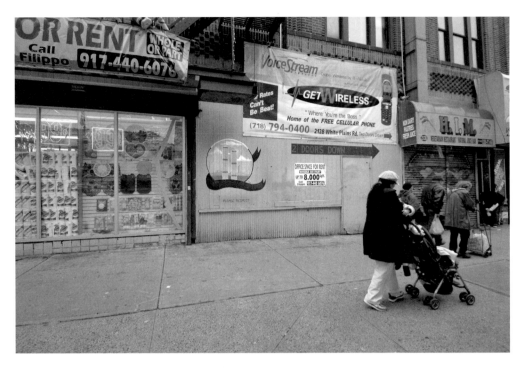

FIGURE 4.3. *Please Respect*, Bronx, New York. Photograph by Jonathan Hyman, 2005.

and dinosaur bones, evinces Peale's interest not only in portraiture but also in a variety of other fields, such as museology, ornithology, and paleontology.[1] In 1820 John James Audubon (1785–1851) set out to depict every species of bird in the United States for *The Birds of America*. The publication was printed over a period of twelve years on 2- x 3-foot double-elephant folio sheets and included 435 life-size engravings.[2] Ostensibly an ornithological census, Audubon's renderings are in many ways insightful "portraits" of his bird sitters, a portrait gallery of nature. And George Catlin, beginning with a trip up the Mississippi River with General William Clark in 1830, devoted his career to depicting the Indians of the Americas. His Indian Gallery came to include over six hundred paintings, and in 1841 he published *Manners, Customs, and Conditions of the North American Indi-*ans in two volumes with three hundred engravings.[3] Here again a supposedly objective compilation of knowledge elided into the more subjective realm of art.

Later artistic/documentary projects, often employing photography, can be related more specifically to the political, urban, and cultural dimensions of Hyman's enterprise. The sense of capturing the immediate aftermath of a national cataclysm is evident in Alexander Gardner's images of the Civil War battlefields of Antietam, Fredericksburg, Gettysburg, and Petersburg, and in his 1866 two-volume compilation, *Gardner's Photographic Sketch Book of the Civil War*.[4] The plight of a forgotten urban underclass that is sometimes seen in Hyman's images echoes Jacob Riis's harrowing photographs of tenement life, published in 1890 in *How the Other Half Lives: Studies among the Tenements of New York*.[5]

Hyman's portrayal of the fleeting aspects of the modern urban landscape (Figures 4.2 and 4.3) owes a debt to Berenice Abbott, who, after struggling for a decade to cobble together sufficient financial and institutional support, in 1939 completed her remarkable *Changing New York*. Abbott's opus consisted of a publication and a collection of over three hundred photographs that she deposited with the Museum of the City of New York.[6] That same decade, American folk culture, seen in Hyman's works in its more modern, urban forms like graffiti, murals, and tattoos, was systematically surveyed and catalogued by the Works Progress Administration's Federal Art Project as part of the Index of American Design, a compilation of eighteen thousand meticulous watercolor renderings of American decorative arts of the eighteenth and nineteenth centuries.[7] Finally, Hyman's photographs of neglected, overlooked aspects of national life share some of the haunted, nuclear-age atmosphere and revelatory qualities of Robert Frank's *The Americans* (1959), with its eighty-three images culled from over twenty-five thousand photographs taken by Frank in his travels across the United States in 1955 and 1956[8] (Figure 4.4).

Hyman's experience in compiling, exhibiting, and seeking an appropriate repository for his photographic survey has much in common with that of his predecessors. Driven by a sense of urgency that, if not for their efforts, something profoundly significant would be unrecognized and forgotten, they all set out to document distinct

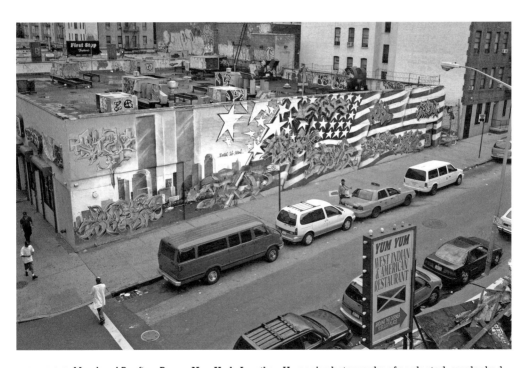

FIGURE 4.4. *Mural and Rooftop*, Bronx, New York. Jonathan Hyman's photographs of neglected, overlooked aspects of national life shed light on our culture in much the same way that Robert Frank's photographs from his 1950s project *The Americans* captured the haunted, nuclear-age atmosphere and revelatory qualities of the post-WWII era. Photograph by Jonathan Hyman, 2003.

aspects of national life and to create definitive frameworks that would allow the phenomena they captured to be classified and analyzed, remembered and understood. Whether in the wilderness, on the western frontier, across the killing fields of the Civil War, in blighted cities, or along America's endless streets and highways, in various ways they risked their lives and livelihoods to explore, physically, emotionally, and intellectually, difficult and sometimes controversial terrain. They frequently had to overcome daunting practical and financial challenges and, because they inevitably transgressed at times the proprieties and boundaries of their subjects as well as the concerns and sensibilities of their audiences, were censured and neglected as often as they were understood and praised. Quixotic projects that were always aspiring and in progress but never finished, they resisted any kind of easy classification or closure and may always rest a bit uneasily within the institutions in which they are housed, be they library, archive, history museum, or art gallery. Ostensibly designed to be synoptic and encyclopedic, in many instances they have come to be appreciated as much, if not more, for their more elusive aesthetic qualities.

Beyond broad similarities in structure and purpose, what most distinguishes Hyman's project in comparison to its antecedents is the way in which it captures such an early, if not immediate, artistic response to a very specific historical event. Many of the creative acts that Hyman documented are so inherently ephemeral that there would be no lasting record of them if not for his efforts. Spontaneous public murals and graffiti, in part because they are often not lawful, sanctioned activities, are soon removed

or painted over. Tattoos are often hidden from view, their messages subject to the mortality of the bodies that carry them. These types of art, while no doubt striking and remarkable, function effectively in large part because they are designed to be fleeting; part of the anonymous, informal, pedestrian lives of thousands of people who, depending equally on routine and serendipity, either pass by them or bypass them. Indeed one way murals, graffiti, and tattoos can be categorized as folk art is the degree to which they are successfully integrated and seamlessly participate, appear, and then disappear amid the flux of life as opposed to being radically distinguished or permanently preserved and set apart from it as objects in a museum generally are. The primary theme of the works documented by Hyman is in fact transience and metamorphosis: buildings, bodies, flags, and eagles constantly meld and shift their identities; steel, flesh, and fabric flow into each other across alternating bands of sky, land, and water; forms beget more forms. Accompanying these transformations are cascading shifts in scale, with walls enveloping skyscrapers that are in turn encompassed by flags, eagles, or the figures of firefighters and police officers.

Hyman's photographs amplify and at the same time mark a new phase of the ongoing metamorphic process initiated by the 9/11 street artists. By presenting the quotidian context of the 9/11 imagery, they dramatize how what is around the art—the enveloping body or streetscape—is itself in an unstable and fluid state. Telltale signs of transience—shadows, debris, passersby, clouds, and sky—abound and reinforce the metamorphic message of constant change and transformation seen in the imagery

of the murals, graffiti, and tattoos. As photographs they also present a specific time and space in the midst of the unceasing flow of events. By capturing a cultural moment they demarcate a subtle shift in the artistic response to 9/11, a point where the initial works generated by the event are not as overwhelmed by flux and become more situated and less disoriented within the still provisional, but nonetheless relatively stable, photographic framework provided by Hyman. They suggest how a society's creative response to traumatic historical events might evolve through different stages over years, decades, and even centuries, with the initial volatility of certain motifs, after being continuously layered and taken up and refined by artist after artist, becoming incrementally more constant, still, and cohesive until they eventually encode a culture's memory within more stable, deep structures of perception that defy easy analysis or explanation.

These more traditional, stable forms of artistic expression, such as paintings, sculptures, photographs, and drawings, are often explicitly designed to be viewed in museums. While historically grounded, they also more self-consciously seek to engage timeless, universal qualities. Seen within the more formal spaces of a museum, these types of objects reflect a culture's complex, ongoing relationship to the past. They enact a paradoxical interplay between society's need to remember specific events and the need to reconcile them with more abstract, meditative, eternal notions of time and space.

One way to begin to think of how Hyman's vast photographic archive marks the passage from the art of the street to the art of the museum is to consider its most ubiquitous motif: the flag. The flag is a particularly effective visual response and counterpoint to the twin tower icons. The juxtaposition of its linear horizontality to the towers' dramatic verticality encapsulates the terrible narrative of 9/11, in which something designed to stand forever fell. The basic constituent element of the flag diagram, the horizontal line, is a concise graphic device for representing the ground level or horizon line that the towers disintegrated into. Running parallel to each other at regular intervals, the flag's horizontals suggest the death and destruction, the flatlining if you will, that attended the obliteration of the fallen towers while simultaneously constituting stripes. In Hyman's archive these stripes are often found further transformed and enlivened into waving bands of color (Figure 3.16 in Chapter 3, and Figures 4.5–4.7). In the context of 9/11 the flag represents (or stands for) the fallen towers and enacts a constructive response to a destructive event. Its parallel lines recall the essential design of the towers and evoke a mixture of emotions, both terrifying and reassuring, that make an already powerful symbol even more resonant.

The murals, like the flags they often include, are also insistently horizontal and flag-like, as are the formats of the majority of Hyman's photographs. These different flag forms ripple and echo out from flag to mural to photograph, with each new permutation successively reframing the previous one. Though from a very different historical moment, the enveloping of one flag shape by another is a clear analogue for one of the most famous museum icons of postwar American art: Jasper Johns's flag paintings (Figure 4.8). It is rather startling to find Johns's pop art imagery directly ref-

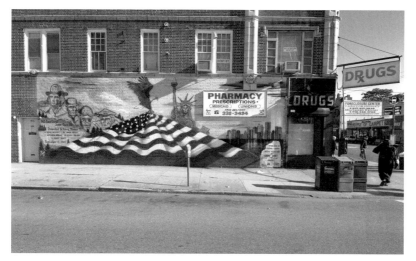

FIGURE 4.5. *Mt. Rushmore in Brooklyn*, Brooklyn, New York. Wildstyle graffiti artists and muralists such as Joe Indart depict the American flag as a vital and active object. In doing so, they offered a productively creative response to an otherwise destructive event. Photograph by Jonathan Hyman, 2005.

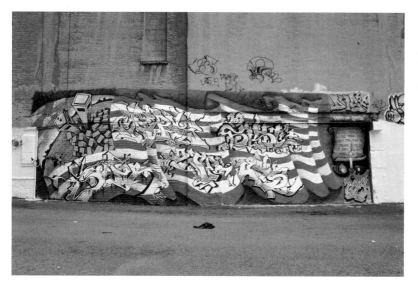

FIGURE 4.6. *Wildstyle Flag with Towers from Above*, Manhattan, New York. Photograph by Jonathan Hyman, 2002.

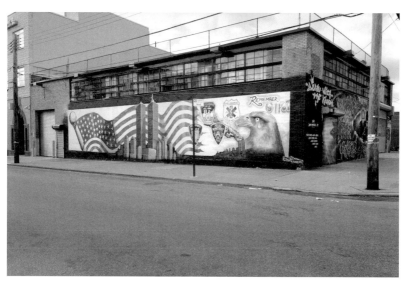

FIGURE 4.7. *Weeping Eagle with Patches, Towers, and Flag*, Queens, New York. Photograph by Jonathan Hyman, 2004.

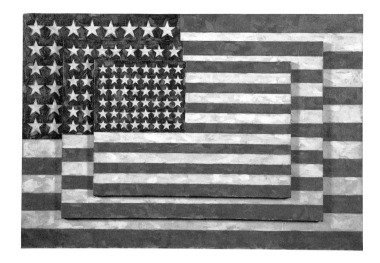

FIGURE 4.8. Jasper Johns, *Three Flags*, 1958, encaustic on canvas, $30^7/8 \times 45^1/2 \times 5$ in. Whitney Museum of American Art. Copyright Jasper Johns/Licensed by VAGA, New York, NY.

FIGURE 4.9. *Three Flags: Proud of America*, Pine Bush, New York. This direct reference to Jasper Johns's iconic *Three Flags* painting from the 1950s, which features a flag within a flag, suggests an interplay between vernacular art made and exhibited in the street and "fine" art institutionalized in a museum context. Photograph by Jonathan Hyman, 2002.

erenced in the Hyman archive in an image where a re-creation of the flag-inside-the-flag motif is shown hanging off the side of a red brick school building in Pine Bush, New York (Figure 4.9).[9] These associations suggest how a long trail of myriad inflections of meaning might in theory be precipitated by events like 9/11; the way they might potentially move from the calligraphy of the graffiti artist in the street to the cool, ironic paintings of Jasper Johns found in museums, and even back again to clearly patriotic sentiments such as the flag seen against the brick facade (punctuated tellingly by the introduction of a vertical element proclaiming "proud of America" and framed in an anomalous vertical format by Hyman).[10]

Hyman's photographs, then, both document and participate in the collective enterprise of building a visual culture and help to illuminate how it is constantly being formed and re-formed. His vivid images of works of art knitted into the fabric of their surroundings show a world creatively addressing pressing emotional and intellectual needs in the aftermath of 9/11. Compelling works of art in their own right, they constitute a memorial about memorials and suggest how creative acts, often rooted in destruction and suffering, lead to further creative acts that gradually, bit by bit, layer upon layer, may help to provisionally bind together fractured worlds. With their expansive, collage-like structure and insistent flag motifs and formats, they can be thought of as provisional banners for a country that we are constantly trying to see more clearly and better understand.

Notes

1. On Peale, see David C. Ward and Charles Willson Peale, *Charles Willson Peale: Art and Selfhood in the Early Republic* (Berkeley: University of California Press, 2004); David R. Brigham, *Public Culture in the Early Republic: Peale's Museum and Its Audience* (Washington, D.C.: Smithsonian Institution Press, 1995); Charles Willson Peale, Lillian B. Miller, Sidney Hart, Toby A. Appel, and National Portrait Gallery (Smithsonian Institution), *The Selected Papers of Charles Willson Peale and His Family* (New Haven, Conn.: Published for the National Portrait Gallery, Smithsonian Institution by Yale University Press, 1983).

2. On Audubon see Lee A. Vedder, *John James Audubon and "The Birds of America": A Visionary Achievement in Ornithological Illustration* (San Marino, Calif.: Huntington Library, 2006); Richard Rhodes, *John James Audubon: The Making of an American* (New York: Alfred A. Knopf, 2004); Duff Hart-Davis, *Audubon's Elephant: America's Greatest Naturalist and the Making of "The Birds of America"* (New York: Holt, 2004); Shirley Streshinsky, *Audubon: Life and Art in the American Wilderness* (Athens: University of Georgia Press, 1998); John James Audubon, Annette Blaugrund, Theodore E. Stebbins, Carole Anne Slatkin, Holly Hotchner, and New-York Historical Society, *The Watercolors for "The Birds of America"* (New York: Villard Books, New-York Historical Society, 1993).

3. On Catlin see George Catlin and Peter Matthiessen, *North American Indians* (New York: Penguin Books, 2004); George Catlin, Therese Thau Heyman, George Gurney, Brian W. Dippie, and Renwick Gallery, *George Catlin and His Indian Gallery* (New York: W. W. Norton, 2002); Brian W. Dippie, *Catlin and His Contemporaries: The Politics of Patronage* (Lincoln: University of Nebraska Press, 1990); William H. Truettner, *The Natural Man Observed: A Study of Catlin's Indian Gallery* (Washington, D.C.: Smithsonian Institution Press, 1979).

4. On Gardner see Theodore P. Savas, *Brady's Civil War Journal: Photographing the War, 1861–65* (New York: Skyhorse, 2008); Anthony W. Lee, Elizabeth Young, and Getty Foundation, *On Alexander Gardner's Photographic Sketch Book of the Civil War: Defining Moments in American Photography*

(Berkeley: University of California Press, 2007); D. Mark Katz and Alexander Gardner, *Witness to an Era: The Life and Photographs of Alexander Gardner: The Civil War, Lincoln, and the West* (New York: Viking, 1991).

5. On Jacob Riis see Tom Buk-Swienty, *The Other Half: The Life of Jacob Riis and the World of Immigrant America* (New York: W. W. Norton, 2008); Bonnie Yochelson, Jacob A. Riis, and Daniel J. Czitrom, *Rediscovering Jacob Riis: Exposure Journalism and Photography in Turn-of-the-Century New York* (New York: New Press, distributed by W. W. Norton, 2007); Jacob A. Riis and Museum of the City of New York, *The Complete Photographs of Jacob Riis*, microform (New York: Macmillan, 1981); Jacob A. Riis, *The Making of an American* (New York: Macmillan, 1901).

6. On Berenice Abbott see Douglas Levere, Bonnie Yochelson, Berenice Abbott, and Museum of the City of New York, *New York Changing: Revisiting Berenice Abbott's New York* (New York: Princeton Architectural Press, Museum of the City of New York, 2005); Bonnie Yochelson and Berenice Abbott, *Berenice Abbott: "Changing New York"* (New York: New Press, Museum of the City of New York, distributed by W. W. Norton, 1997); Terri Weissman, *The Realisms of Berenice Abbott: Documentary Photography and Political Action* (Berkeley: University of California Press, 2010); Sharon Corwin, Jessica May, Terri Weissman, and Amon Carter Museum of Western Art, *American Modern: Documentary Photography by Abbott, Evans, and Bourke-White* (Berkeley: University of California Press, 2010).

7. On the Index of American Design see Virginia Tuttle Clayton, Elizabeth Stillinger, Erika Lee Doss, and National Gallery of Art (U.S.), *Drawing on America's Past: Folk Art, Modernism, and the Index of American Design* (Washington, D.C.: National Gallery of Art, 2002); Index of American Design, *The Index of American Design*, microform (Cambridge, England: Somerset House, 1979); Clarence Pearson Hornung and Index of American Design, *Treasury of American Design: A Pictorial Survey of Popular Folk Arts Based upon Watercolor Renderings in the Index of American Design, at the National Gallery of Art* (New York: H. N. Abrams, 1972).

8. On Robert Frank see Sarah Greenough, Stuart Alexander, and National Gallery of Art (U.S.), *Looking In: Robert Frank's "The Americans"* (Washington, D.C.: National Gallery of Art, distributed in North America by D.A.P./Distributed Art Publishers, 2009); Robert Frank, Ute Eskildsen, Museum Folkwang Essen, Museo Nacional Centro de Arte Reina Sofía, and Centro Cultural de Belém, *Robert Frank: Hold Still—Keep Going: Museum Folkwang, Essen, Museo Nacional Centro de Arte Reina Sofía, Madrid* (Essen: Museum Folkwang, 2000); Sarah Greenough, Philip Brookman, Robert Frank, and National Gallery of Art (U.S.), *Robert Frank* (Washington, D.C.: National Gallery of Art, 1994).

9. The flag was constructed from scrap metal by a local schoolteacher who was only vaguely aware of the Jasper Johns flag pieces. Johns has also taken his motifs from passing street imagery; his famous flagstone motif was inspired by a painted wall he saw in Harlem.

10. Perhaps not surprisingly the inflections of meaning that ebb and flow through Hyman's images are often related to pop and other types of modern popular art movements that self-consciously seek to bridge "low" and "high" art and negotiate the gap between the commercial, mundane, everyday world and the museum. These range from objects that can be compared to Marcel Duchamp's ready-mades to Hyman's nod to Ben Shahn's famous painting, *Handball* (Museum of Modern Art, 1939) (see Figure 2.39).

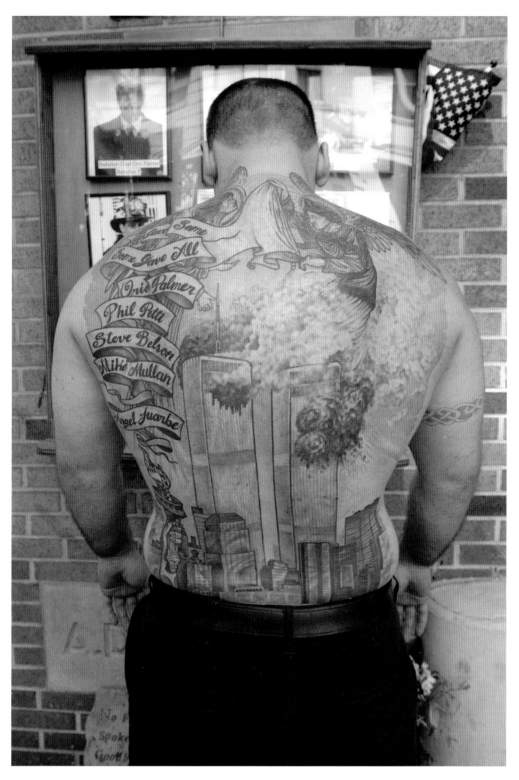

All Gave Some, Some Gave All, Manhattan, New York. Photograph by Jonathan Hyman, 2003.

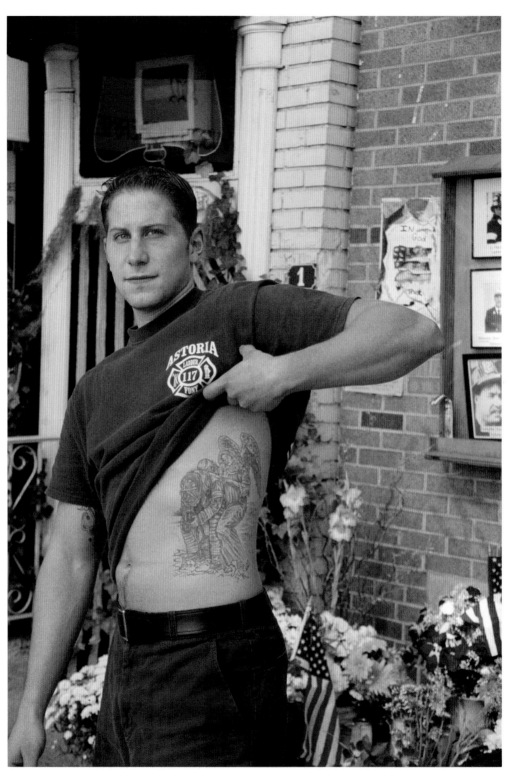

One Angel, Manhattan, New York. Photograph by Jonathan Hyman, 2003.

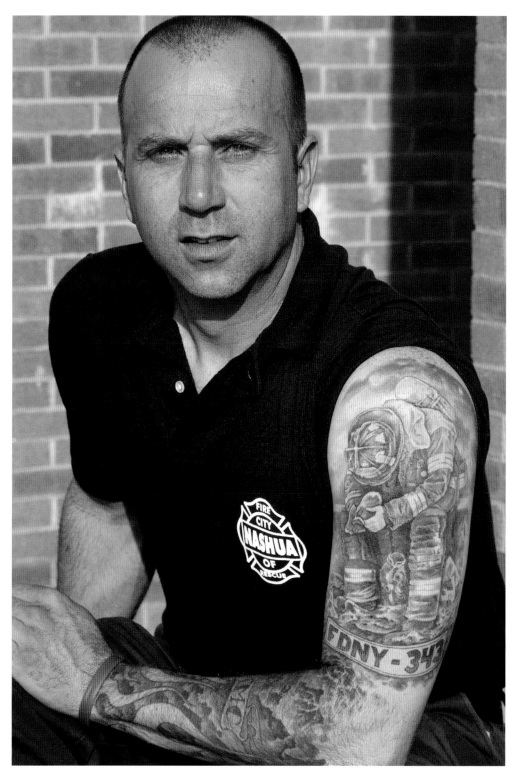

343 Tribute, Nashua, New Hampshire. Iconic images and generic phrases emerged as part of the memorial language of the attacks. Important numbers emerged as well, such as 343, which represents the number of New York City firefighters who perished in the attacks. Photograph by Jonathan Hyman, 2006.

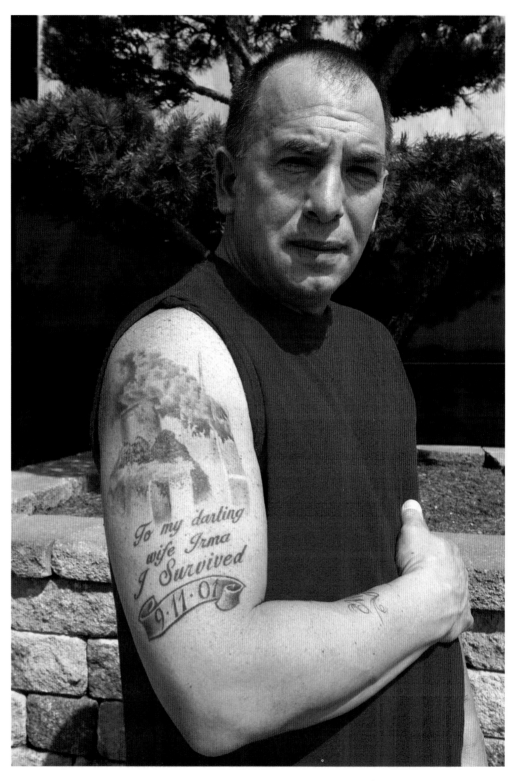

To My Darling Wife, West Nyack, New York. Photograph by Jonathan Hyman, 2007.

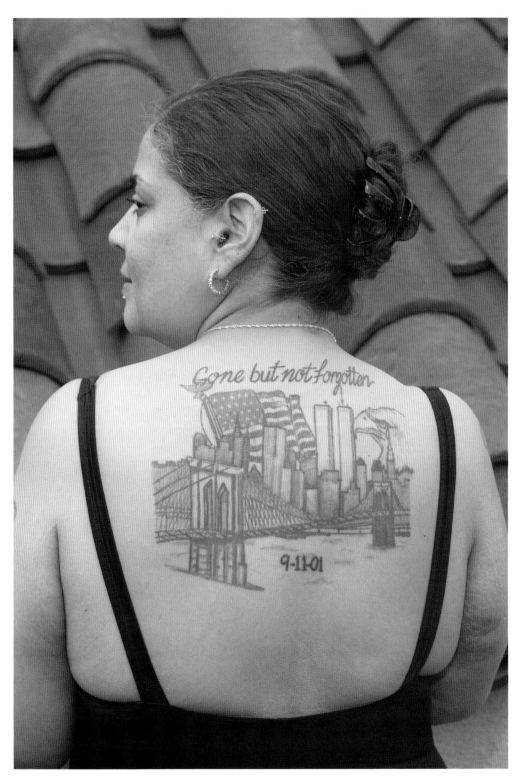

Diana's Back, Brooklyn, New York. Photograph by Jonathan Hyman, 2006.

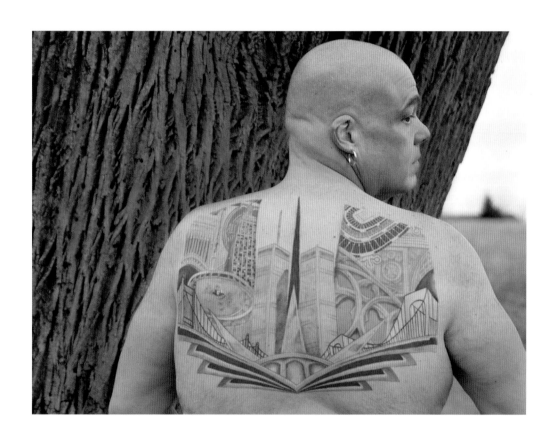

New York City Memorial Collage, Flemington, New Jersey. Photograph by Jonathan Hyman, 2012.

Looking into Long Island City, group mural by various muralists, Queens, New York. Photograph by Jonathan Hyman, 2005.

Honor the Day, Manhattan, New York. Photograph by Jonathan Hyman, 2003.

Mural with Silos, Warwick, New York. Photograph by Jonathan Hyman, 2001.

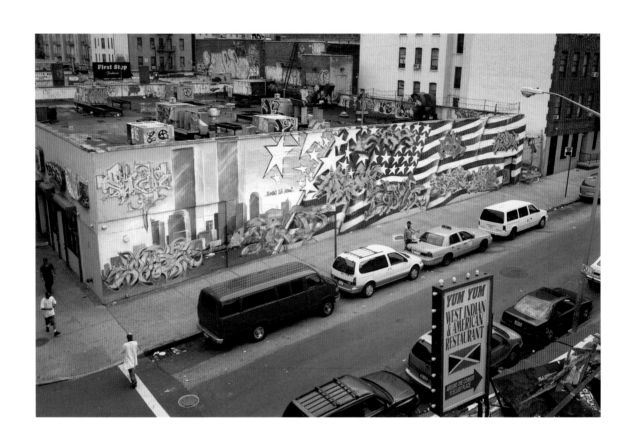

Mural and Rooftop, Bronx, New York. Photograph by Jonathan Hyman, 2003.

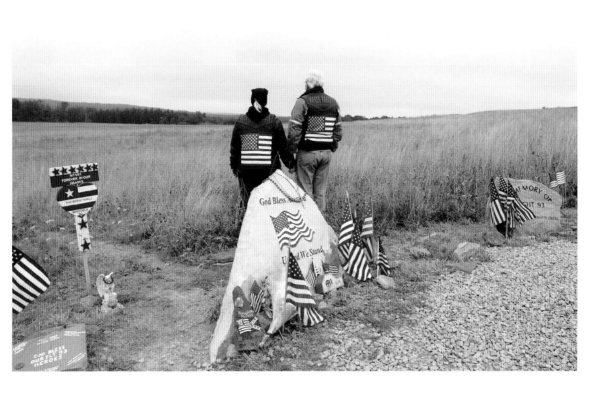

Shanksville Handholders, Flight 93 crash site, near Shanksville, Pennsylvania. Photograph by Jonathan Hyman, 2003.

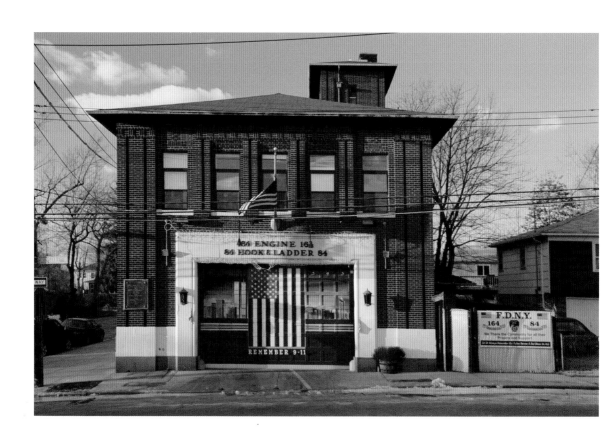

Drumgoole Road West Firehouse, Staten Island, New York. Photograph by Jonathan Hyman, 2003.

Flag Trees, Newtown, Connecticut. Photograph by Jonathan Hyman, 2003.

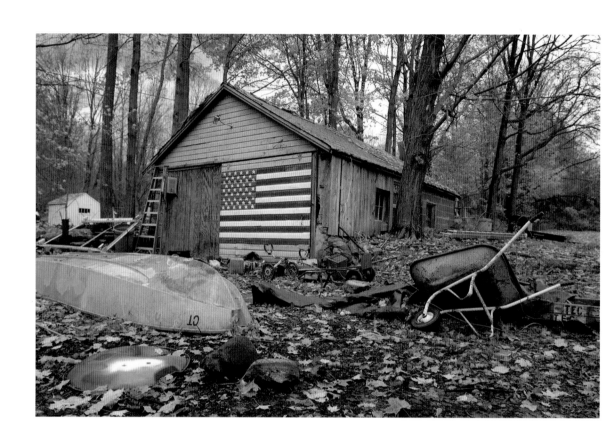

Lori's Garage, Brookfield, Connecticut. Photograph by Jonathan Hyman, 2003.

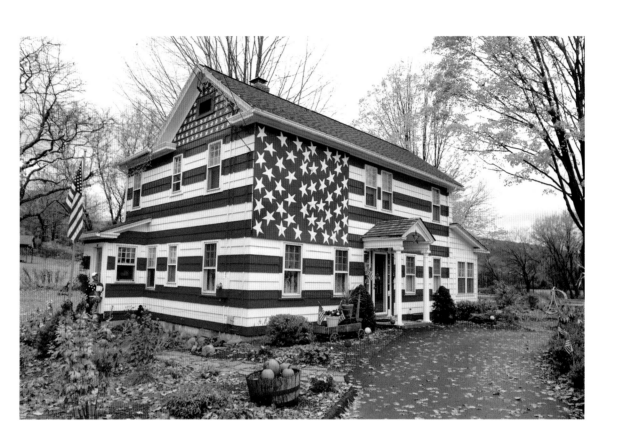

Flag House, Kent, Connecticut. Photograph by Jonathan Hyman, 2003.

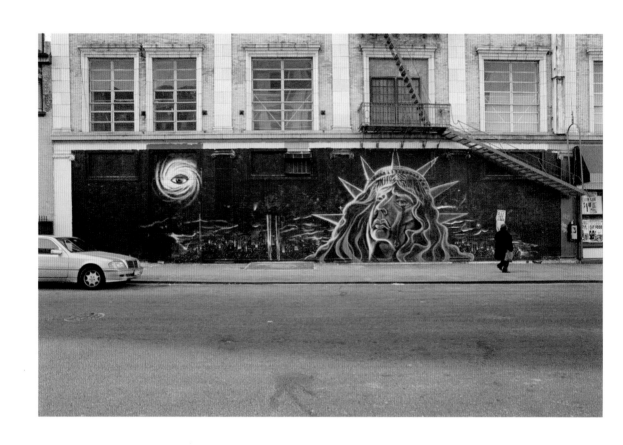

Bleeding Statue of Liberty, Manhattan, New York. Photograph by Jonathan Hyman, 2002.

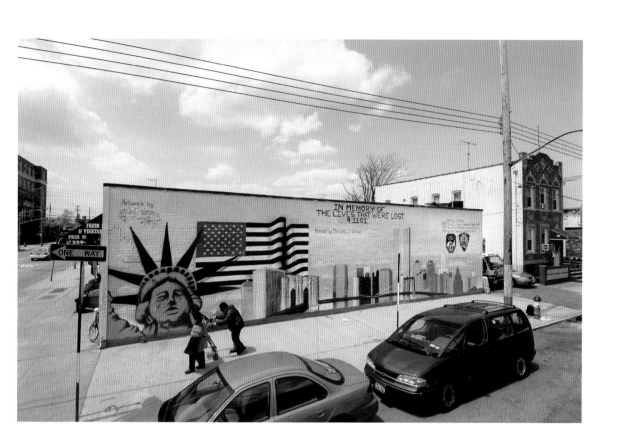

Weeping Statue of Liberty, Brooklyn, New York. Photograph by Jonathan Hyman, 2005.

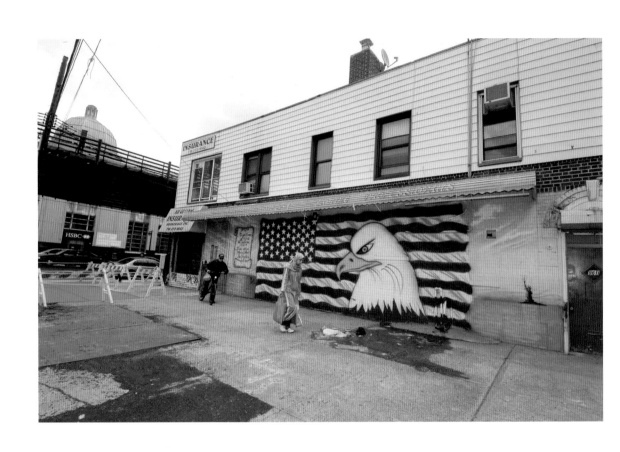

Muslim Woman with Eagle, Brooklyn, New York. Photograph by Jonathan Hyman, 2005.

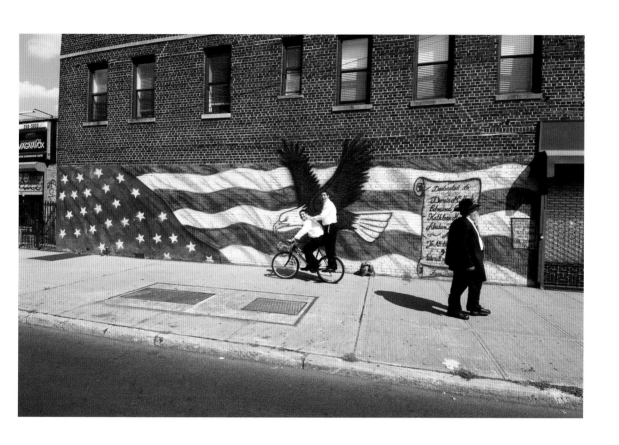

Boys Passing By, Brooklyn, New York. Photograph by Jonathan Hyman, 2005.

We the People, Middletown, New York. Photograph by Jonathan Hyman, 2002.

Big Bird with Broken Heart, Manhattan, New York. Photograph by Jonathan Hyman, 2004.

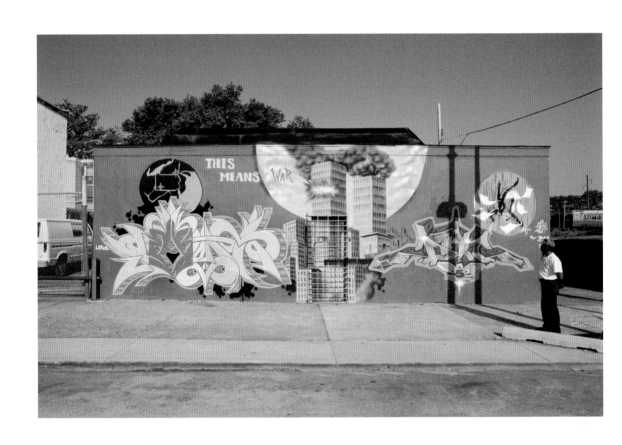

This Means War, Philadelphia, Pennsylvania. Photograph by Jonathan Hyman, 2003.

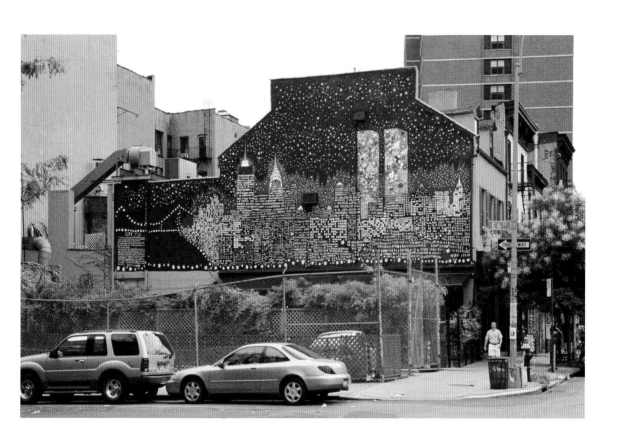

Flower Power Mural, Manhattan, New York. Photograph by Jonathan Hyman, 2002.

Memorial at Firehouse, Engine 74, Manhattan, New York. Photograph by Jonathan Hyman, 2003.

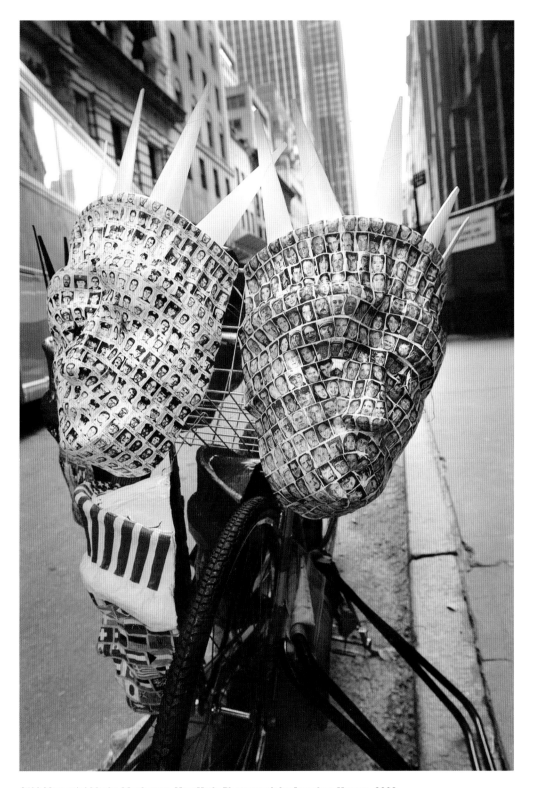

9/11 Memorial Masks, Manhattan, New York. Photograph by Jonathan Hyman, 2003.

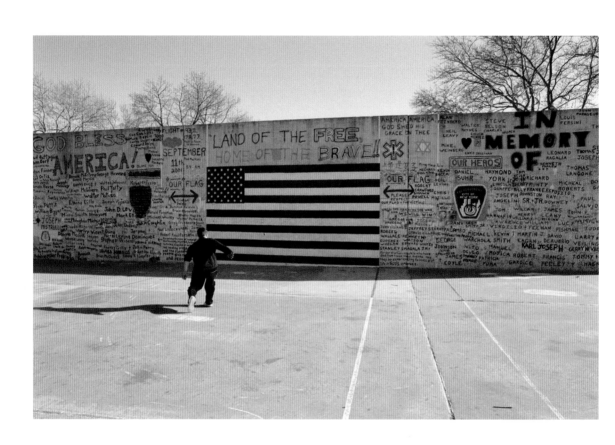

Rockin' Ray's Handball Court, Brooklyn, New York. Photograph by Jonathan Hyman, 2003.

Angel's Circle Memorial, Staten Island, New York. Photograph by Jonathan Hyman, 2003.

Flag, Eagle, Towers, Brooklyn, New York. Photograph by Jonathan Hyman, 2003.

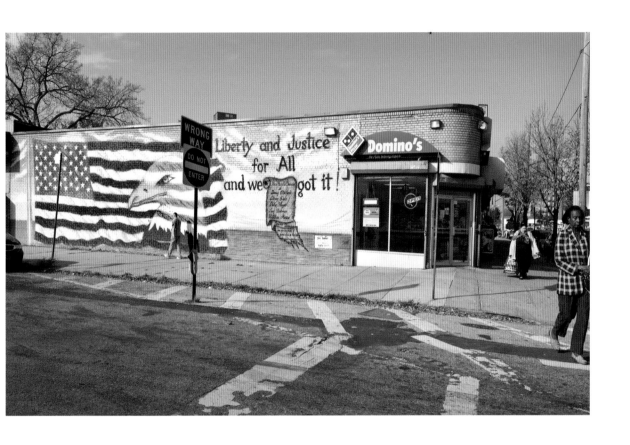

And We Got It, Brooklyn, New York. Photograph by Jonathan Hyman, 2011.

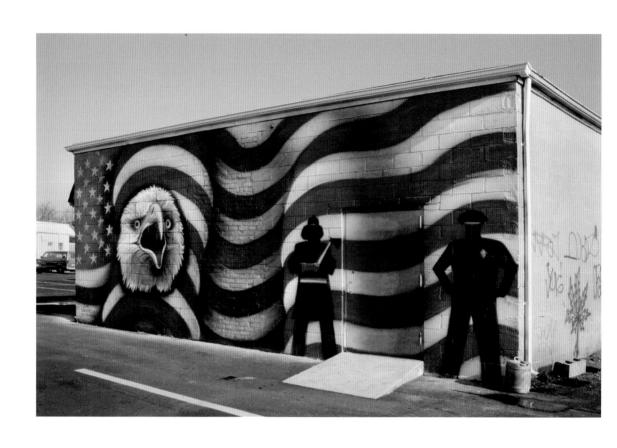

Flag, Eagle, Towers: Levittown Mural, Levittown, New York. Photograph by Jonathan Hyman, 2002.

Johnny Perna's Hot Dog Truck, Staten Island, New York. Photograph by Jonathan Hyman, 2003.

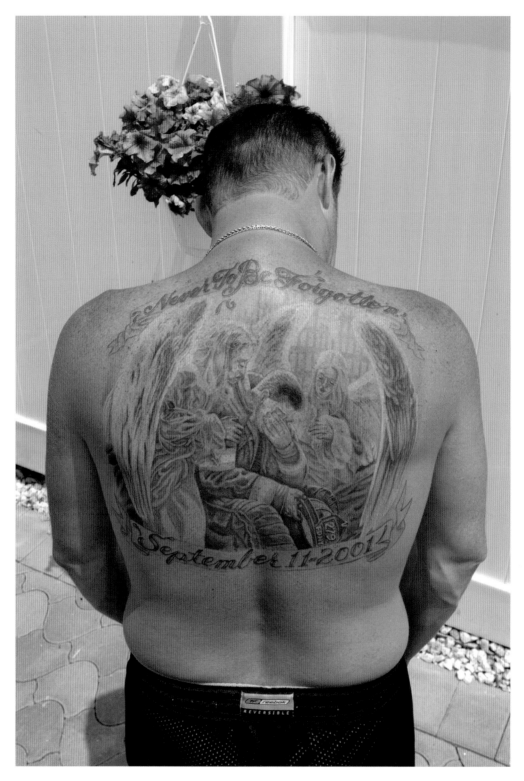

Comfort from Angels, Staten Island, New York. Photograph by Jonathan Hyman, 2004.

VERNACULAR MEMORIALS AND CIVIC DECLINE

*Robert Hariman and
John Louis Lucaites*

"Never forget." We will never forget September 11, 2001. We shall never forget. We will remember. Gone, but not forgotten. Never to be forgotten. We must never forget.

And so we forget. Not those of us who lost family or friends—that pain is forever—nor those who lost comrades and co-workers, for those memories will always resurface unexpectedly. And surely not those who inscribed the memory onto their skin, nor those who created the memorials. But the rest of us, we forget. The fading newsprint flags in the windows have long since been taken down. Other deaths and other disasters have intervened, and life goes on, here as everywhere. Roughly 70 million people died in World War II, which is now a history lesson soon to be read only by those who were not yet alive at the time. Seventy million, including roughly 418,500 Americans. How often did you think of them last week? Or of the 2,976 who were murdered on September 11, 2001?

Such is the pathos of collective memory. To put it bluntly, if memory could be trusted, there would be no need for the imperatives to remember. But my loss is not the same as

your loss, solidarity is riven with difference and self-interest, and amnesia seems to be part of the life force itself. Thus, the realization dawns that remembrance is least of all about preserving the past and much more about negotiating the present. The public memorial is more about working through grief and fear in order to regain one's hold on life, and about using public grieving and other civic emotions to reconstitute a viable community. Yet even this perspective depends on a distance from the traumatic event similar to the process of forgetting. Once again, powerful, disorienting, world-cracking pain has been neutralized, and the emotional commitments so prominently displayed in the mural, the tattoo, or the street-side memorial have been reduced to artifacts awaiting analysis.

The authors of this essay believe that full appreciation of and respect for vernacular memorials needs to confront their limitations, even their futility. In creating the collection of images in this volume, Jonathan Hyman has taken great care to document the memorials as they are in their own spaces and contexts. If there is any idealization, it comes in his verbal interpretation of the memorials as Americans "talking to each other."[1] They certainly are that, but to appreciate fully the character of such public talk, one needs to recognize its specific and often sad qualities. In these images of ordinary Americans memorializing 9/11, we need to see how they are speaking with a limited vocabulary and from compromised circumstances to an audience that often is not listening. Nor are these the consequences of using the "visual speech" of murals, tattoos, photographs, and the like; instead, the turn to a visual rhetoric both reveals the constraints on ordinary civic discourse and offers one strategy for overcoming them.

This essay considers such vernacular memorials as a mode of public address that is caught in the low-grade but persistent traumas of civic speech by ordinary citizens in local communities. Because we look across all of the photographs in the volume rather than focusing on one image, our argument necessarily admits to some exceptions at each point in its development. That said, we hope to show how the artworks reflect not only the wounds caused by the attack of September 11 but also the persistent erosion of civic life in America. Thus, the images are pathetic in two senses of the term: they are a determined effort to draw people together on the basis of shared emotions, and they are sadly inadequate to their intention.

Of course, the selection of images in this volume is intended to reflect a nuanced range of visual articulations, and some images will likely lie outside of any one categorization. That said, many of the memorials reflect a combination of means, circumstance, and response that makes their limitations all too obvious. These constraints include a limited repertoire of signs, marginal spaces, processes of decay, and a lack of cultural resonance. Because of such constraints, the civic memorials seen here are inevitably shadowed by betrayal—as surfaces decay, the society forgets, and slower catastrophes continue their glacial destructiveness. Such constrictions on civic speech are not the whole story, however, as the memorials draw on specific strategies for persuasive effect. One obvious strategy involves direct

emotional appeals via such techniques as vivid colors and putting a tear in the eye of the American eagle. Another strategy, which both includes and complicates such stock appeals, is the creation of allegorical tableaus that provide models for collective memory and citizen participation. By casting the memorials in this light, one might be better prepared to address the question of whether they are examples of a vital public art.

Poverty and Pathos

Imagine a school assignment where students are required to write a memorial essay using only five nouns. This restriction would be ridiculous, yet it is a common feature of the 9/11 memorials. The drama of the attack, the grief over lives destroyed, the commitments to remembrance and solidarity are all communicated through the same, rudimentary iconography. These images include most prominently the flag, the American eagle, the Statue of Liberty, and the twin towers of the World Trade Center—in short, the most familiar markers of national identity and the attack itself. These symbolic markers are buttressed by others, such as the New York skyline, firefighters and police, the iconic photograph of the flag raising at ground zero, comic book superheroes, and Uncle Sam, along with memorial conventions such as angels and lighted candles. Most of the designs used two, three, or four of these stock images along with a few scraps of text to cue the basic intention of the work ("Remember 9/11/01"). In fact, the scope of vernacular display is so narrow that use of all of these figures in one artwork would seem cluttered or otherwise unnecessary. Simple signage appears to be enough. When one sees them in this collection, however, the effect is like looking at birthday cakes in a grocery store display case: whether the frosted balloon on the cake is on the right or the left doesn't really matter after all, and apparently all family rituals are alike.

This small repertoire of widely circulated signs obviously insures maximum intelligibility, albeit at the cost of not being able to say much that is in any way nuanced or distinctive. Of course, the memorials do not intend to "say" much at all, and it is equally a testament to the power of visual media that a few images can provide sufficient means for communicating powerful emotions on behalf of collective bonding. Nor is the small palette a sign of the times, as civic statuary has historically been highly conventional—in the nineteenth century, for example, there apparently was always room for another soldier on a horse. Even so, there is something pathetic about having to rely so much on the flag, the eagle, and similarly generic figures. For all their value, the displays are not indicative of a rich culture of public arts. Instead, the more likely condition is one of minimal cultural literacy, limited opportunities and resources for expression, and viewers who are indifferent and never really together otherwise.

Thus, the vernacular iconography inadvertently signifies a community that was in some way degraded before the attack. This hidden past is then reflected in the subsequent temporal decline of the display itself. The surfaces of some of the murals started out badly (corrugated metal or cracked walls), and many already have become

weathered and worn—faded, scratched, stained, graffiti laden—just as the tattoos will come to hang on blotched and sagging skin; the street-side memorials will become soaked, dirty, and vandalized; and the red, white, and blue building will seem ever more out of synch with the neighborhood and the times. What haunts all memorials becomes most evident when there is no state institution maintaining the site: the appeal to remembrance is itself doomed to decay.

This pathos need not deny that the memorials can tap deep reservoirs of local knowledge and personal feeling. (They may, but the outside viewer wouldn't know that.) The memorials are poignant, but not only because each is a chronicle of loss; there is also the sadness that comes from seeing how many of them testify to some erosion of civic life. There are two problems that are most obvious: relative poverty and empty public spaces.

Not to put too fine a point on it, but these vernacular memorials demonstrate America's stratification by class. From the designs for the reconstruction of the WTC site to the spray paint on an alley wall, both means and materials follow a clear declension in capital. The few murals that exhibit higher quality paint and more formally elegant designs are each in more middle-class settings. Those with the clotted signage and wildstyle graffiti lettering are well down the street. Those with the crude lettering and calls for vengeance are near the bottom. And many of these sites are obvious examples of the substandard infrastructure, maintenance, and general quality of life in lower class neighborhoods. Cracked sidewalks, deteriorated buildings, graffiti,

weeds, trash, junk, crappy signage—the unavoidable background of urban life becomes concentrated in places neglected, passed over, or forgotten. The point is not to demand that everyone adhere to a middle-class aesthetic, but to note that celebrations of national unity are being placed, again and again, next to stores that have chain-link window screens, doors that have three locks, fences topped with razor wire, buildings with rotting window frames and decaying brickwork, and on cars and vans and a mailbox that are rusted—in sum, the murals are in places that are strapped for cash.

Even when the scene is obviously more affluent, the images reveal a disturbing emptiness. And note that, contrary to myth, the poorer neighborhoods are not teeming with the vibrant throngs of a common life. Some of the vacancy will be an artifact of the photographic process; obviously, you can't photograph a mural if it is obscured by a crowd. Even so, many of the vernacular sites are used because they have no other communicative value: the back side of a building or cracked wall of an alley is easily overlooked, while civic memorials are placed in parks and fields that are usually empty spaces. The irony of individuals moving past the memorials without pause only reinforces this pervasive disconnect between the many small but demanding preoccupations of private life and the large but inert backdrop of collective symbols. That disconnect is signified repeatedly in the photographs by the contrasts between the memorials and the surrounding signage: auto supplies, batting cages, beer, carpet, plumbing, sandwiches, tax services, for rent, for sale—it is clear that life

goes on, by people having to make a living. In principle, the vernacular memorial should exemplify how public and private identities can be woven together in the scenes of everyday life: "Do as you do, be who you are, but never forget our common heritage." In practice, however, the murals become merely the odd complement to the very different concerns of the moment, and their mute isolation is testimony to how empty the public square can be much of the time.

Of course, the memorials are pushing back against that fate. Their pathos also comes from their anonymous, brave, unrewarded assertion that a community is here, in this neighborhood or along this road, despite being otherwise unheralded. But one absence ultimately leads to another. The pathos of the memorials is signaled most poignantly by the betrayal of the injunction to "never forget." Those memorials to individuals are particularly telling, as the public is asked never to forget someone they never knew. Perhaps the tattoos are close behind. Parallel tattoos linking those lost at ground zero with the mythical POW/MIA survivors suggest that memory has already become hostage to paranoia, and yet that connection is another symptom of how betrayal haunts collective memory. The public is being asked to remember strangers as if they were loved ones, while those who have suffered personal loss are asked to believe that the anonymity of collective remembrance by and about strangers is somehow really about those they love. This is too much of a load for most memorials to bear. The carefully crafted individual tributes among the firefighters and other friends and relatives of the dead

surely will always be meaningful to those bearing them, but they are automatically too personal for collective remembrance, while the figures of Uncle Sam and the American eagle apply to everyone and so to no one. And at some point all of the ceremonies are concluded, the fallen replaced, the memorials dismantled or abandoned, and other disasters claim the front page.

The inevitability of forgetting is already implicit in the memorials: why else do we have to be told to remember? Likewise, the written injunctions already are disconnected from the images surrounding them: either a small banner is dwarfed by the conventional iconography that cues primarily generic associations, or too many words are crowded into a place where they will be ignored by those who have their reasons to walk by, drive by, or do anything else but stop and read anonymous writing on a wall. It becomes clear after seeing so many examples of the call to remembrance that it is as conventional as the stock images of the flag, the Statue of Liberty, and the rest of the 9/11 iconography. And so, "remember" need not mean "don't forget," but rather "recognize," "see me," "support us," "be patriotic," "care about who we are, who I am, in this place, here, now." The question remains, what else has to be present for that to happen?

For public art to have powerful effects, there has to be a shared culture that allows spectators to connect their individual experiences with the representations of a common life. That culture is created in part by public art, and so the relationship is circular, but that is no problem so long as the circle is not too tight (and thus open to only the most immediate residents)

or too wide (and thus so general that the symbols are merely generic). Vernacular memorials can be either: a tattoo might be rich in personal references and individualized designs that are obscure to others, while use of the American flag is diluted by endless reproduction across athletic uniforms, beach towels, and thousands of other products. For the most part, the memorials in this collection are limited by having only distant resonance with other important means of identification in American life. The scenes, for example, do not connect with vital centers of urban space or national identity, whether Times Square or the Mall in Washington. The artworks themselves don't have the rich articulation of everyday life that is found in a movie—or a TV ad. The American eagle is an image of an abstraction, the twin towers no longer exist, and the angels refer to a heaven never to be seen while one is alive.

Thus, vernacular memorials are caught in the problem of finding resonance in the public culture. Unfortunately, the standard for such resonance is set by heavily engineered spaces such as Disney World or the Mall of America, which take kitsch to the highest levels of intertextuality at the expense of foreclosing on any potential for authentically open and synergistic pluralism. At their best, the memorials provide an alternative to such designs for commercial domination of civic space, but generally they suffer from being too cut off from the plenitude of civic interaction. The murals and other fixed memorials have limited connectivity because they don't circulate—instead, people have to circulate past them, and that too often involves routine passages that reduce the mural to mere background.

The tattoos and decorated vehicles do move through other scenes, but too incidentally or too quickly. And none of them have the repetitiveness of billboard/poster advertising or use the interactive media, both of which are quickly becoming an expectation for civic engagement. Instead, all the weight of engagement is put back on the symbolism, which may be one reason why it is so formulaic. The one minor deviation is emblematic of the problem: the use of popular culture superheroes and wildstyle graffiti lettering suggests a more actively artistic attempt at evoking cultural resonance and perhaps some resistance to dominant norms of civic representation. Of course, one result of such invention is to reinforce subcultural consumption rather than political participation. The question remains whether that need be the only result.

Vernacular Rhetoric

The artistic commemorations of 9/11 reflect diverse motivations, but by virtue of becoming works of public art they acquire political significance. Thus, one can ask how these memorial practices contribute to public identity, thought, and action. Jonathan Hyman sets out a very attractive answer: "Americans were talking to each other. They were speaking out loud in public on their cars, houses, and places of business, on their bodies, and anywhere else they could find the space."[2] This is certainly true, at least as a measure of intention and orientation. They were motivated to communicate something to a public audience. But serious questions remain: What were they saying? Was it what they meant to say?

Why didn't they just speak instead of paint? Was anybody listening?

One should not be too quick to use this collection to reaffirm a myth of democratic speech. The people do strive to speak to one another, but that noble intention is fraught with problems—indeed, it often is pathetic in every sense of the word. One reason the murals exist is precisely because people cannot easily avail themselves of opportunities to speak out loud in public. Ordinary Americans too often lack the time, the skills, and the forums for public speech. There are too few places with real audiences that in turn can influence actual decisions, and too many material, social, and cultural obstacles to speaking effectively. Consider, for example, what would happen if one were to stand in front of any of the murals and give a speech. You might as well expect to get rich by dropping your money down a well.

One of the advantages offered by the vernacular arts is that they provide an opportunity to level the playing field. Actual speech would be lost on the open air, but a mural can be seen for years. Many people would not be taken seriously if they spoke up, but a tattoo is an obvious commitment that commands some respect. Young adults who are flunking out of school can put up remarkably skilled visual declarations that they, too, care and are capable of being part of the civic space. As John Bodnar argues, public commemoration is continually negotiating the tension between official and vernacular assertions of collective life.[3] Thus, some of the vernacular memorials can be seen as attempts at local self-assertion on behalf of the richly textured lives of those directly affected by the events of 9/11.[4] Instead of the War on Terror, we see family, church, school, jobs, teams, and neighbors articulated together in ritual restoration of the local community. Instead of accepting state action coupled with individual isolation, we see collective affirmations that grief can be shared and trauma overcome.

As Bodnar warns, however, the promoters of official culture are adept at capturing vernacular motifs; as those more explicitly attentive to the operations of hegemony would point out, it's not only a matter of appropriation but also of providing key elements of the cultural repertoire in the first place. As much as one might want to celebrate the memorials depicted in this book, there is comprehensive evidence that the means of persuasion have been supplied from the top. The iconography comes almost entirely from the state or the entertainment industry, and the political sentiments run the gamut from A to B—more specifically, from patriotism to vengeance. Opportunities for contestation were limited drastically in the immediate aftermath of 9/11, and there is little need for it in the 9/11 memorials anyway, so the point is not that they should have been more resistant. What is apparent, however, is that the memorials come to constitute a public "language" for framing the historical event in collective memory, and the framework is so limited to an iconography of dominant interests that it provides few resources for richer or more adaptive public communication.

That said, the memorials may contain underappreciated resources for civic life. Two come to mind. One is their obviously emotional nature. Artistically, many of the works could be denigrated for their ap-

peal to the lowest common denominator of emotional identification, but that is beside the point. A key feature of the memorials, and one reason they can be so simplistic otherwise, is that they channel powerful, often traumatic feelings. The attack was vicious, the losses terrible, the reasons opaque—and all because of collective associations and geopolitical forces that exceed the dimensions of private life. And thus the hearts, tears, candles, cityscapes, fires, ruins, and those photographs of the victims that will tear your heart out if you really look at them. The murals remind us not of an historical event, but rather of how the political community is an emotional community—bound together by deep currents of identification, anger, guilt, aspiration, awe, fear, pride, and all the other reactions that make up a common life. Needless to say, these emotions are easily manipulated; they also can be rendered inert, which can be just as bad.

The second resource for public "talk" evident in the collection is the use of allegorical composition. Allegories are stories retold using figural language about a vital belief, and their composition must be obviously artificial in order to organize multiple perspectives regarding collective experience. Allegorical works typically combine fragments taken from diverse media, arts, and styles; through unusual juxtapositions, distortions in time, and other devices they encourage active interpretation suited to periods of cultural change. The 9/11 vernacular memorials don't reflect all of the characteristics of mature allegory, but many of them do rely on these techniques. Text and image side by side; politics, entertainment, religion, and local landmarks thrown together; virtually everything out of scale; signage everywhere, both within (badges, for example) and all around the work (storefront advertising); time scrambled (the towers and ground zero side by side); diverse fonts combined (wildstyle, block lettering, or text set in a scroll); figural characters such as Uncle Sam and angels forever out of time watching over an event being retold again and again—these and other conventions of allegory are the stock in trade of the vernacular mural. This unchecked copying and mixing is commonly marked as kitsch, which gets it half right. It is kitsch—that is, cheap imitation of stock images for sentimental appeal—but it is also a compositional practice that extends to significant works of popular culture and to some of the finest works of art. More important, it serves distinctively democratic interests at the moment.[5] At the least, vernacular allegories encourage an active audience, one that will look at and think with the diverse materials in the work, often taking up diverse points of view (say, from both the Brooklyn Bridge and heaven). They also represent the manner in which much civic speech today is a provisional weaving together of the disparate signs, discourses, and media arts saturating the lifeworld.

That is not to say that they do it well. Even if so, however, it is important to remember that these vernacular memorials are not the summit of civic speech, but rather a very real attempt to deal with some of its deep problems. Those problems include—perhaps more than ever—contending with catastrophe and finding the resources for civic renewal. One temptation is to let the first condition prompt the second: surely

the community will rise to the occasion again, and so we need not worry too much about the weathering of the current memorial or of the beaten-down infrastructure surrounding it. But that would be another betrayal. There is need not simply to remember but to restore. There is need not only for a memorial at ground zero but also for small businesses filling the storefronts in the neighborhoods. To get there, one has to start somewhere. Perhaps this book can provoke a step in the right direction by showing not only ordinary acts of civic commemoration, but also how much remains undone.

Notes

1. Jonathan Hyman, "The Public Face of 9/11: Memory and Portraiture in the Landscape," *Journal of American History* 94 (June 2007): 183.

2. Ibid.

3. John Bodnar, *Remaking America: Public Memory, Commemoration, and Patriotism in the Twentieth Century* (Princeton: Princeton University Press, 1992).

4. Gerard A. Hauser, *Vernacular Voices: The Rhetoric of Publics and Public Spheres* (Columbia: University of South Carolina Press, 1999).

5. Robert Hariman, "Allegory and Democratic Public Culture in the Postmodern Era," *Philosophy and Rhetoric* 35 (2002): 267–296.

BEARING WITNESS
MEMORIAL MURALS IN BELFAST AND BETHLEHEM

Philip Hopper

The subway from Brooklyn through lower Manhattan on the morning of September 11, 2001, was crowded and delayed. At West Fourth Street the voice of our conductor came over the loudspeakers. Other voices were already speaking to him and garbled crosstalk bled out over our heads and was at first unintelligible. Then the conductor announced that because of a fire at the World Trade Center, trains were being rerouted. When I finally exited my subway at Grand Central Station, hundreds of people stood at a Hudson Newsstand before television monitors displaying live video of the twin towers burning. Among strangers we shared a common disbelief, staring at unimaginable images, "like a movie," feeling terror. Ambulances and fire trucks were screaming downtown, crossing Forty-Second Street. Still, I did not know what was happening, and I was not connecting what I knew about global terrorism and all of its associated political implications with what I was watching on television and seeing on the street. I simply felt fear. New York City police officers appeared at entrances to Grand Central Station, turning commuters back to their trains and subways. I made my way out of Manhattan and was unable

to return for several days. When I did, lower Manhattan below Canal Street was blacked out and a pall of smoke hung in the air. New York City airspace was a no-fly zone except for military fighter jets and police helicopters. It seemed to me that this familiar place was now something alien and unnatural.

I understand that I am not an eyewitness to the 9/11 attacks. Nor did family, friends, or colleagues of mine perish. Yet, like so many who were in the city that day, I remember viscerally the smell, sounds, and feel of the tragedy. When I confront an image or item related to 9/11, I feel sadness and loss. These feelings are partly a result of the complex negotiations with which many of us deal as documentary photographers. Documentarians like myself and Jonathan Hyman make secondary images of primary objects or subjects in an attempt to provide a contextualized social and historical record. Questions arise, however, when the need to create an objective document meets the subjective nature of a camera frame. We must determine how much context is allowed into a photograph. For example, wide shots that show much of the surrounding neighborhood—be it Belfast, Bethlehem, or the Bronx—often make important details difficult for the viewer to see. Icons, symbols, and texts may lose some meaning or become entirely lost when the sensibility, equipment, and shooting conditions to which the photographer is subject inevitably impose themselves. For me, losing details in the visual record, especially within memorial murals, diminishes the richness of meaning and further deepens a sense of loss. It can be difficult to achieve one's goals as a documentarian and artist because the very act of point-

ing a lens that cannot possibly record everything is a daunting task. Hyman and I grapple with this limitation on a daily basis.

Whereas Hyman has photographed a wide range of post-9/11 visual materials in America, I have recorded unofficial political art in Belfast, Northern Ireland, and the Palestinian West Bank, in particular public memorials to victims of violence. The genesis of my own photojournalistic project was a trip to Northern Ireland in 2004 for a conference about peace and conflict resolution. During that visit I was exposed, for the first time, to the visually sophisticated sectarian murals there, especially in the capital city of Belfast. I subsequently had the opportunity to travel throughout the West Bank, in particular to the Dheisheh Palestinian Refugee Camp outside Bethlehem. Time has passed, and I have come to believe there are both important links and telling differences between the unofficial public political art in Northern Ireland, the Palestinian Territories, and New York City. (I include New York City here and later will point out significant differences as a way to both connect my work to Hyman's and to make a comparative distinction between the murals each of us has recorded.) In one such obvious link of cross-cultural dialogue, murals on the Irish Republican Solidarity Wall in Belfast support Palestinian statehood, while graffiti in a Palestinian refugee camp pays tribute to a famous Republican inscription in Northern Ireland.

Although images of gunmen, martyrs, murder victims, and various local icons and symbols overlap, murals in Northern Ireland are changing. Cultural themes, sports stars, and even some billboard advertising have replaced many paramilitary murals. Vernacular image making there of-

fers a kind of visual bridge between sectarian communities, Protestants and Catholics, whose mutual animosity was once thought intractable. In Northern Ireland, popular murals and graffiti by and large mirror an effective peace process.

This is not the case in the West Bank. The separation barrier has provided a vast, divided canvas. In some locations facing Palestinian Territories, a chaotic jumble of images are painted and repainted mostly by foreign "protest" tourists and artists, some (like the British street artist Banksy) of international fame. Locally produced Palestinian murals do exist, but these are painted in hard-to-reach enclaves. They thus remain largely inaccessible to most foreigners, including Israelis. Conversely, the Israeli side of the barrier is largely blank except for the occasional sign or warning typically issued by Israel's ministry of tourism or defense forces. Few Palestinians ever see an Israeli political image, official or otherwise. There is very little visual evidence in the disputed territories, including Bethlehem, that suggests cultural, religious, or political dialogue of any kind. Without a doubt, this lack of dialectic vitality mirrors local politics, in this instance a long-term military occupation and highly fractious "peace process."

Photographs of murals—static or dynamic, visible or unseen—pose a difficult set of questions for photographers such as myself and Jonathan Hyman. Are we documenting the memorial or the passing of time in the memorial itself? I believe that we do both, but only with the help of passersby, spectators, and witnesses. These living individuals not only provide scale but also connect the past with a present that then also passes. Both Hyman and I are aware of the temporal process and always try to include that context by returning to the sites of our photographs over time to see what, if anything, has changed in the murals or their surroundings and who, if anyone, is passing by and paying notice or not. I think of these individuals as essential participants in the making of a photographic document. For me, the aesthetic value of my photographs depends on the inclusion, if possible, of largely anonymous people. Though Hyman and I agree that the context provided for a viewer when people are present in a photograph is important to the overall understanding of a documentary photograph, I also believe that this human presence— and not the search for any specific artistic style or form—is of the utmost importance.

Belfast

In July 2005 a man, wearing bedroom slippers, returns home with a liter of milk and a Sunday paper (Figure 6.1). He does not even see the image of a hooded paramilitary gunman because it is so much part of his daily routine. This is in the Lower Shankill, a Loyalist neighborhood in Belfast, Northern Ireland. Loyalists, or Unionists, are usually of the Protestant faith. The terms are often used interchangeably to denote individuals or a group, a majority of the population in Northern Ireland that would like to remain part of Great Britain.

Republicans, or Nationalists, are usually Catholic in Northern Ireland. They are the minority and almost unanimously favor union with the Irish Republic to the south. This is the basis for a long sectarian struggle, at one time pitting the paramilitary Irish Republican Army, or IRA, against the

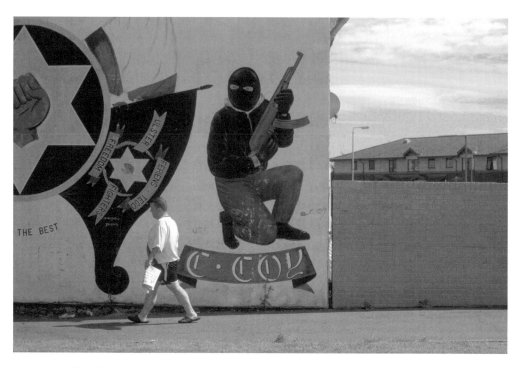

FIGURE 6.1. *Ulster Freedom Fighter Mural*, Belfast, Northern Ireland. This paramilitary mural, ignored by a man going about his daily routine, appears in the Lower Shankill, a Loyalist neighborhood in Belfast. Photograph by Philip Hopper, 2005.

British Army. Loyalists have their own paramilitary groups, like the Ulster Defense Association, or UDA, and the Ulster Volunteer Force, or UVF. Much has been written about this conflict, which resulted in "The Troubles"[1] and finally the April 1998 Good Friday Agreement, which put an effective end to most of the violence. My focus on the visual culture of this conflict in Northern Ireland centers on the conflict's difficult political resolution and the impact of that resolution on the images muralists create.

In Northern Ireland the symbol of the red hand, like so many issues and images, has been a matter of contention: it is claimed by both Unionists and Republicans (Figure 6.2). One of the best-known tales in the oral tradition of Ireland describes a Viking longboat war party ap-

proaching the shores of Ulster. The Viking leader promises the first man to touch land full possession of it. One of the men severs his hand with a sword and throws it ashore. Ulster is now his property and the mutilated hand becomes part of a local creation myth immersed in violence and territorial rights. The paramilitary mural shown in Figure 6.1 has now been repainted as a version of this Northern Ireland origination myth, as depicted in Figure 6.2. There are those in Northern Ireland who call for the wholesale removal of this symbol, and others who call for its "regeneration" as a symbol of unity. It can be found in Loyalist murals and on gravestones in the Catholic Milltown Cemetery.

These debates over emotionally loaded imagery speak to the complex nature of

the local conflict, as well as images more generally. Hyman and I have discussed at length his own experience dealing with emotionally charged subject matter and icons surrounding the 9/11 attacks. The experience and description of the mixed reactions he hears from people who view his photographs suggest there is some disagreement over the meaning and use of certain images. He notes, for example, that most agree on the meaning of the bald eagle and Uncle Sam, but the American flag, the Statue of Liberty, and the World Trade Center towers have to a certain degree become contested images (Figure 6.3). An image thus can be inflected by political agendas and emotional states once it exits the hand of the muralist.

In July 2005, I first encountered Republican muralist Danny Devenny. He was near Falls Road in an "estate" (a working-class housing project), painting a mural depicting a Celtic fantasy of swans and greenery for an upcoming street festival. He immediately said: "I also do the other kind," meaning he also paints political murals. As a young man, Devenny was wounded and captured in a bank robbery attempt. After his conviction he spent time in the infamous Long Kesh Prison, later becoming the director of communications for the IRA. He is largely responsible for the iconic image of

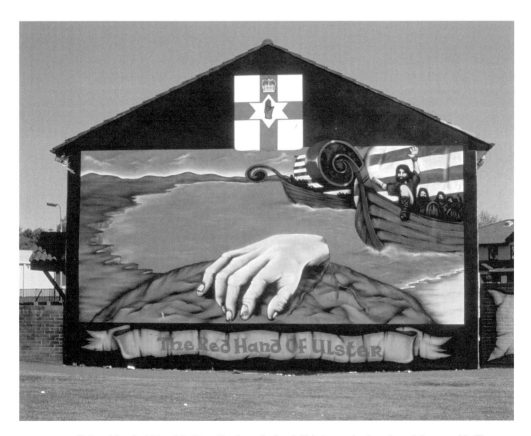

FIGURE 6.2. *Cultural Symbol Mural*, Belfast, Northern Ireland. This image had replaced the mural in Figure 6.1 by June 2008. Both Loyalists and Republicans make claims to the Red Hand origination myth as well as to the symbol that derives from it. Photograph by Philip Hopper, 2008.

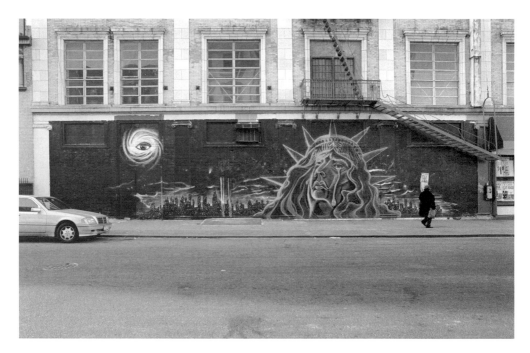

FIGURE 6.3. *Bleeding Statue of Liberty*, Manhattan, New York. This bleeding Statue of Liberty in the Harlem neighborhood of New York City has engendered starkly contrasting interpretations. For example, some see Lady Liberty as bleeding the blood of a nation and those who died in the attacks, while others believe that the notion of liberty itself is bleeding as a result of the American response to the attacks both at home and abroad. Photograph by Jonathan Hyman, 2002.

FIGURE 6.4. *Bobby Sands Mural*, Belfast, Northern Ireland. This mural of Sands, a well-known Republican who died in 1981 during a hunger strike, is just off Falls Road in Belfast. Photograph by Philip Hopper, 2008.

IRA hunger striker Bobby Sands as it exists today in various locations including on the side of the Sinn Fein bookstore and office just off Falls Road (Figure 6.4). Sinn Fein is the Republican political party that grew out of the IRA and is now in a power-sharing government with Unionist parties.

During the early to mid-1970s, at the height of "The Troubles," separation barriers or "peace-lines" were built in various locations around Belfast. These were meant as temporary devices that separated neighborhoods in an effort to limit sectarian violence. The longest peace-line in Belfast, separating the Republican neighborhood of Falls Road from the Unionist neighborhood of Shankill, is about 4 kilometers (2.5 miles) long. Some peace-lines

have now been in existence longer than the Berlin Wall, which divided East and West Berlin and measured 43 kilometers (27 miles) long. In stark contrast, the Israeli separation barrier, or "The Fence," as it is sometimes referred to in Israel, will stretch over 480 kilometers (300 miles) if completed according to current plans.

Visitors to Belfast step out of buses and Black Taxis to passively view and record murals and sites related to "The Troubles" and the subsequent peace process. The Falls Road/Shankill peace-line has become a popular destination for these "conflict tourists," whose presence is often debated in the local press and online blogosphere.

Depending on which Black Taxi stand they select in Belfast City Centre, tourists will visit one side or the other of the peace-line. One Black Taxi stand in Belfast City Centre takes passengers to the Unionist side of the wall in Shankill. There they will see displays of random graffiti and lackluster images. On the Republican, Falls Road side they will see a dynamic range of painted images that often refer to other regional and international conflicts, including the Palestinian conflict (Figure 6.5). The budding conflict tourist industry has benefited the Falls Road neighborhood in two ways: local images reach a more global audience, and the tourism generates economic growth.

During my 2005 visit, Danny Devenny was working with sociologist Bill Rolston on a mural depicting American antislavery

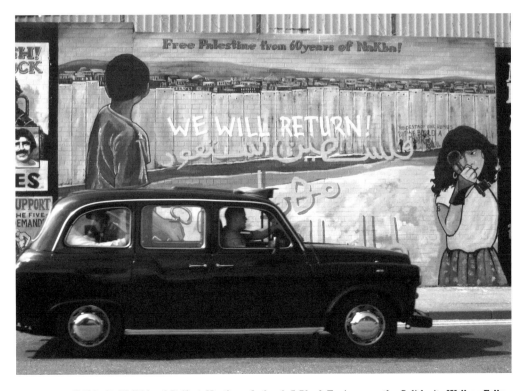

FIGURE 6.5. *Solidarity Wall Mural*, Belfast, Northern Ireland. A Black Taxi passes the Solidarity Wall on Falls Road. The wall is employed strategically by Republicans to espouse ideology through the making of prescribed images. Photograph by Philip Hopper, 2008.

activist Frederick Douglass. (Rolston is author of a series of books collectively titled *Drawing Support*, documenting the murals throughout Northern Ireland.) Danny's mural forms part of a block-long series of murals known as the Solidarity Wall. Images there are executed on the outer perimeter of an industrial complex directly abutting the Falls Road/Shankhill peace-line. In addition to evoking the American antislavery movement by depicting Douglass, the Republican Solidarity Wall features murals that tie the Irish Republican cause to other international conflicts, including Basque nationalism and the Palestinian struggle for statehood.

In an ironically self-referential gesture that comments on the divisive nature of walls, Danny decided to depict the Israeli separation barrier, inscribed "Free Palestine from 60 years of Nakba," on the Solidarity Wall. In Palestinian terms, the Nakba, or catastrophe, refers to the creation of the state of Israel. His mural also includes the inscription "We will return!" in both English and Arabic, as well as the graffito, "You destroy our homes but we build a nation." In the lower right corner, a Palestinian girl does not look out of the mural at us but instead directs her gaze either at a distant homeland or at a house key, the symbol of the Palestinian right to return (Figure 6.6). These images are one of the ways children, in both Belfast and Bethlehem, are used to embody forms of resistance as well as hope, return, and restitution. According

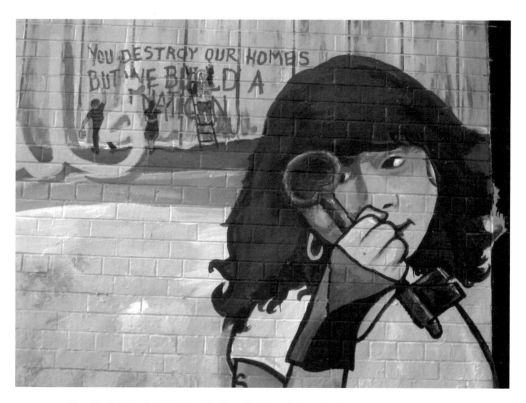

FIGURE 6.6. Detail of *Solidarity Wall Mural*, Belfast, Northern Ireland. With the Israeli separation barrier behind her, a Palestinian girl gazes at a key that symbolizes the ownership of property and the Palestinian political concept of "right of return." Photograph by Philip Hopper, 2008.

to Neil Jarman, director of the Institute for Conflict Research in Belfast, these are some of the ways Republican image makers have grasped the strategic importance of public murals as an appeal to a wider, potentially international, audience—an importance that until relatively recent years eluded their Loyalist counterparts.

I met Bill Rolston again during July 2007 in a Belfast coffee shop. As the peace process in Northern Ireland continues to gain traction, he sees a decline in the quantity and a shift in the quality of sectarian murals. He believes that, despite the ongoing work of active muralists like Danny Devenny, Republican imagery will lose its vibrancy. It is thus not surprising that sports stars, cultural icons, and occasionally advertising are now competing with and replacing images of paramilitary members bearing arms: the mixed-up visual culture in Northern Ireland reflects a largely successful peace process. It also reflects the money recently spent within Protestant communities by the British government as part of the "Renewing Communities" program. According to the published action plan for the program, £100,000 has been earmarked for the "replacement of existing paramilitary murals."[2]

I spoke at length with Danny Devenny again in 2008. He was working on a memorial mural in Andersontown, an outlying Catholic neighborhood of Belfast. He told me: "You know what's happened up here? In the last three days there's been three suicides up here. . . . It's an epidemic that isn't specific to age groups, from kids to forty-year-olds, . . . some are on drugs, some drink, some are just depressed. Overall it just seems to be a fuck-all attitude toward life in general." The mural Danny was work-

ing on that day represents Julie Livingstone, a girl who was fourteen when she was struck in the head and killed on May 12, 1981, by a plastic bullet fired by a member of the British Army. She is one of the children who are so often the tragic victims of sectarian violence. Julie Livingstone is also an icon of Irish nationalism. For these reasons, Danny has framed his mural with a Celtic knot design, which symbolizes a unified Irish Republic.

When asked about the future of the Republican murals, Danny responds: "What's happened now ten years into the peace process, there's a lot of tourists and media and people are realizing murals can be about different things. They can be about culture, about community issues. The whole point about making the murals is to get our message out, get the attention of millions of people through exposure in the media." This exposure has mostly benefited Irish nationalists, although the removal of images from their original contexts can result in other interpretations.

These kinds of images can mean different things depending on local idioms, changing circumstances, and the compatibility—or lack thereof—of national narratives of heroism, martyrdom, and victimhood through which these images speak. The audience for these images may be transnational, national, and local, as in the memorial murals of Julie Livingstone. Unlike the American 9/11 murals, which are relatively accessible on city streets or rural barns, Irish images exist within constrained Republican enclaves. Instilling fear or anger may be part of their intent, although it seems that proximity of "the other" community is necessary for these intentions to be operative. For example, in Belfast

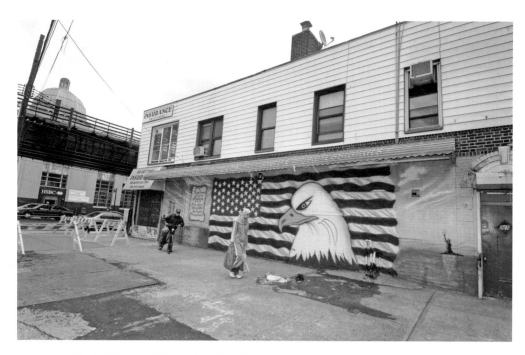

FIGURE 6.7. *Muslim Woman with Eagle*, Brooklyn, New York. In New York City, from neighborhood to neighborhood, people from all walks of life confront the artwork made in response to the 9/11 attacks. Here, a Muslim woman walks by with her head lowered as a stern eagle appears to be staring her down. Photograph by Jonathan Hyman, 2005.

a Catholic in a Protestant neighborhood may very well feel discomfort not only because of his or her surroundings but also because of graffiti and murals. In the West Bank, anger or resentment may be an immediate experience for an Israeli soldier when confronted by graffiti or a mural in support of Palestinians. A Palestinian may feel similar emotions at the sight of a large Israeli flag flying on top of the Mount of Olives in East Jerusalem. In the United States, Muslims walking past certain murals may experience negative emotions like fear, anger, and resentment (Figure 6.7).

Ironically, the confrontational aspects of such posturing may not be realized until the images are removed from their original contexts and transmitted through other media, like television or the Internet. As Bill Rolston suggests, this kind of transmission may cause further misunderstandings. For the most part, however, unofficial 9/11 murals served to consolidate public opinion in the immediate aftermath of the attacks. Hyman's interviews with muralists reveal that many of them, in addition to expressing their own sorrow, anger, or patriotism, wanted to make community members feel better by giving them a sense of security and belonging. Whether or not those images will continue to do so—and whether they ever really did fulfill that function—remains an open question.

Bethlehem and Dheisheh

In a café on the top floor of the Ibdaa[3] Cultural Center within the Dheisheh Palestin-

ian Refugee Camp, a young man tells me his name is Jihad Ramadan. I ask about his first and last name with naïve skepticism: "You mean Jihad as in holy war and Ramadan as in holy month of fasting?" He answers: "I did not choose this conflict, it chose me," pointing to the inevitability and consecrated nature of his destiny within the Israeli-Palestinian conflict.

Dheisheh is one of three Palestinian refugee camps close to Bethlehem in the West Bank. The camp came into being in 1948 as a tent city under the auspices of the Red Cross. Later the United Nations built one-room cinder block structures. At one time a tall wire fence surrounded the camp, and the only way in or out of it was through guarded turnstiles. The fence was removed in 1995, and today the camp is a jumble of multistory buildings spread across two hillsides facing Hebron Road just south of Bethlehem. At a central low point is an entrance gate for cars and foot traffic. One of the turnstiles remains near a taxi stand. Here, graffiti reads, "You Are Now Entering Free Dheisheh," itself a clear tribute to the well-known Republican proclamation, "You Are Now Entering Free Derry," in Londonderry, Northern Ireland. This is another obvious connection between the visual cultures of the Palestinian Territories and Northern Ireland.

Before arriving at the refugee camp, most visitors must pass through the Israeli separation barrier.[4] The main checkpoint into and out of Bethlehem from Greater Jerusalem is a military installation bristling with observation towers, antennas, and warning signs. The wall there is blank, gray, and imposing—except for the official admonishments touting peace. On the Palestinian side of the separation barrier there are extensive displays of graffiti. There are also some very sophisticated paintings. In one of the most striking examples, a dove—the universal symbol of peace—has been crucified by two nails, which recall Christ's crucifixion (Figure

FIGURE 6.8. *Crucified Dove Mural*, Abu Dies, Palestinian Territory. This image is painted on the separation barrier just outside of Jerusalem in the West Bank. Photograph by Philip Hopper, 2006.

6.8). The 26-foot-tall barrier is near the town of Abu Dies, and this large painting of the dove is made to scale with the structure. Handprints, a technique as old as Paleolithic cave art, appear in a long line of sanguine impressions. Here, the hands serve as markers representing individuals who have witnessed martyrdom, in this case the death of the individual along with peace for the Palestinian people.

Unlike their counterparts in Northern Ireland, Palestinian cab drivers in the West Bank are economically desperate. They wait en masse, on the opposite side of this well-known checkpoint between Jerusalem and Bethlehem, for tourists or an occasional businessperson. The casual visitors are for the most part Christians on a religious pilgrimage, although on occasion there are a few of what the Israeli tabloid press refers to as "protest tourists." A distinction should be made between these individuals who come to actively participate or protest in some way and "conflict tourists," who more passively observe, often as amateur photographers.

Many visitors leave their disapproving thoughts on the Palestinian side of the wall in English, Italian, Portuguese, French, and Arabic proclamations denouncing the barrier itself as well as the Israeli occupation. Few, if any, of these tourists stay long enough to aid the area's stifled economy, however. If terrorist attacks on Israel have been minimized because of the wall, so, too, has Palestinian economic activity.

In 2006, when I first visited the wall, the influence of international pop culture on these separation barrier images was undeniable. Today, it is even stronger, although there are now signs of rising tension between the local community and "activist artists" from elsewhere. In December 2007, "Banksy," "Blu," and other international artist-provocateurs executed large-scale murals on the separation barrier near Bethlehem. Like the annual guerrilla art shows that take place in London, this event was called "Santa's Ghetto." Of course the irony in that moniker is a bit deeper in the West Bank, and Bethlehem in particular. Peter Kennard, one of the artists who participated in the event, wrote an article entitled "Art Attack" in the January 21, 2008, issue of *New Statesman*, calling for artists to turn the separation barrier into an "international canvas of dissent."

Yet someone dissents to this dissent, taking a paint-roller to kilometers of mural work (Figure. 6.9). I believe whoever did this "scrubbing" read another motive in this work. These images are mildly provocative, but they were not created by and have little to do with the daily realities of most Palestinians. Although this work is intended to be altruistic, it is also an expression of ego, and it appears that some in the local population understood it as such. Almost immediately after Banksy executed his satirical work, some of it was deemed offensive by residents and so was painted over.[5] As of July 2009 most of the work in Santa's Ghetto had been overlaid with graffiti or purposefully defaced, pointing not only to tensions between outside artists and local Palestinians but also to an amorphous group of protest tourists who visit the area (Figure 6.10). These iconoclastic responses suggest that unofficial political art in public areas of conflict may serve as a kind of platform for debate over the meanings of local visual culture.

By contrast, 9/11 murals in the United States seem static; there is no detectable

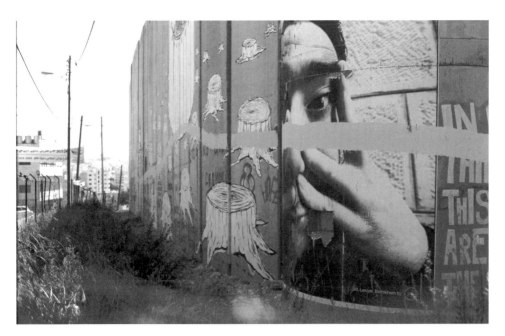

FIGURE 6.9. *Protest Tourist Murals*, Bethlehem, Palestinian Territory. This section of the Israeli separation barrier near Bethlehem displays "Protest Tourist Murals" that have been defaced. The works of Banksy, Blu, and other well-known activist artists were all deliberately defaced in this manner. Photograph by Philip Hopper, 2009.

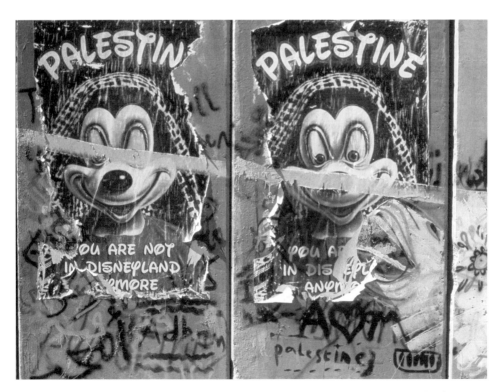

FIGURE 6.10. Detail of *Protest Tourist Mural*, Bethlehem, Palestinian Territory. This detail of defaced artwork appears on the Israeli separation barrier near Bethlehem. The artwork was created in December 2007. Photograph by Philip Hopper, 2009.

"visual debate." This is where the visual culture of memorial murals I have documented diverges from what Hyman has photographed.[6] Perhaps this is because, eleven years after the attacks, what the murals express is too far removed from any actual conflict on American soil, and because their content has not evolved over time in a way that reflects the changes and debates in American society that have arisen as a result of the attacks. Hyman has returned to murals over the past ten years and those that still exist have not changed at all: indeed, the imagery, iconography, and texts within them have remained the same, even if a mural has been touched up or repainted in its entirety. What's more, despite the Afghan and Iraq wars, an active and well-publicized "truth movement" espousing a massive conspiracy on the part of the United States government, the controversy surrounding health care for the rescue and cleanup workers at ground zero, and three hotly contested presidential elections, Hyman has not found a single oppositional mural in the states he visited. This lack of image battling is curious, to say the least.

As interesting as the larger scale, international works executed on the separation barrier near Bethlehem may be, I find the indigenous political art within locations such as the Dheisheh Palestinian Refugee Camp more compelling. They are not derived from Euro-American ideas of fine art or popular entertainment. Instead, they arise out of a genuine urge to consolidate a diverse community's opinion, using readily legible visual forms and textual language. On the side of what was his family's home in the Dheisheh Palestinian Refugee Camp is a memorial mural depicting a boy named Kfah Obeid (Figure 6.11).

Kfah, a thirteen-year-old at the time of his death, was taking part in a demonstration outside the camp. It was late September 2000, during the second, or al-Aksa, Intifada. He was with a group of boys who were reportedly throwing rocks at Israeli soldiers. According to one shopkeeper, he was killed by a single bullet to the heart. I later learned from Kfah's mother, Careema Obeid, that he had been shot twice, in the chest and in the leg. He died almost instantly. Careema moved her family to a new home overlooking a graveyard where her son is buried so that she could watch over him.

Kfah's mural was donated to the family by a local commercial sign painter, though no one could provide me with his name. The mural contains familiar icons and techniques, including a stencil stressing Kfah's status as a *shahid*, or martyr. The stencil is visible in the lower left of Figure 6.11. This mural also includes a chalkboard with a bilingual inscription as well as an image of Handala, the political cartoonist Naji al-Ali's (1938–1987) iconic barefoot boy, who serves here, as always, in the capacity of witness—in this particular case, as a witness to lost "childhood" (Figure 6.12).

As I was photographing the mural in 2006, a group of boys gathered. They posed for my camera with the image behind them. One boy bore a family resemblance to Kfah's image in the mural. At that moment the generational depth and intractable nature of the Arab-Israeli conflict became an image-driven narrative for me: a conflict where sympathy or anger may be expressed with a paintbrush, a can of spray paint, a gun, or explosives. It is a complex story with no apparent resolution, only a question asked from both sides:

FIGURE 6.11. *Kfah Obeid Memorial Mural*, Dheisheh Palestinian Refugee Camp. The young man depicted in this mural was shot and killed in September 2000 during the second, or "al-Aksa," Intifada. Photograph by Philip Hopper, 2006.

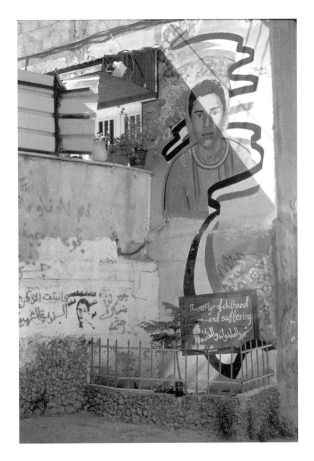

FIGURE 6.12. Detail of *Kfah Obeid Memorial Mural*, Dheisheh Palestinian Refugee Camp. The Palestinian political cartoonist Naji al-Ali's character Handala is featured here. Since al-Ali's murder in 1987, Handala symbolizes an innocent but observant witness. Photograph by Philip Hopper, 2006.

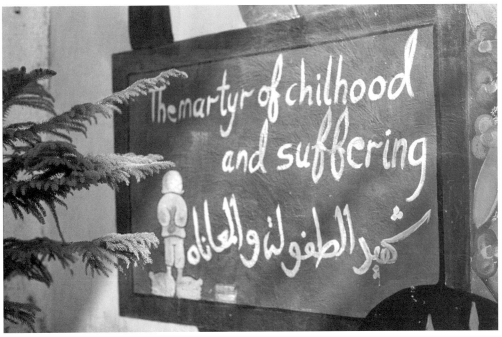

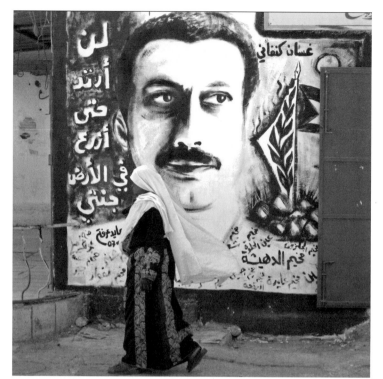

FIGURE 6.13. *Ghassan Kanafani Memorial Mural*, Dheisheh Palestinan Refugee Camp. A woman in traditional dress passes by this mural dedicated to Palestinian writer Ghassan Kanafani, killed by a car bomb in 1972. Photograph by Philip Hopper, 2007.

FIGURE 6.14. *Woman with Arched Back*, Bronx, New York. Echoing Hopper's photograph in figure 6.13, a woman walks past this 9/11 memorial mural in the Bronx without acknowledging its presence. Photograph by Jonathan Hyman, 2002.

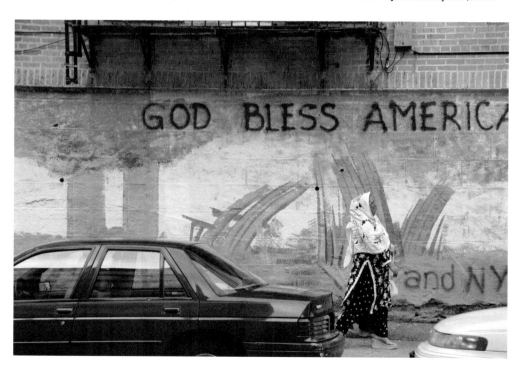

FIGURE 6.15. *9/11 Double Portrait*, Brooklyn, New York. A pedestrian passes a memorial in honor of two 9/11 victims memorialized in Brooklyn. This mural represents one of the very rare times Hyman saw African Americans who died in the attacks commemorated publicly. Photograph by Jonathan Hyman, 2005.

"How can you do this to me again and again?" Another group of boys gathered when I revisited this mural in 2009, and I quickly realized that they were not just being curious and cooperative. They were declaring: "I am Kfah, and Kfah is me." Through oral narratives and lived space, memorial murals thus can help to fuse the identities of the living and the dead.

If the conflict between Israel and the Palestinians is ongoing, so too are the public visual displays that comment on "the situation." The indigenous visual culture in Dheisheh is vibrant but exists largely out of sight to casual visitors, much in the same way that Irish Republican visual culture once did within Catholic ghettoes in North-

ern Ireland. Only time will tell whether local paintings will emerge in more public locations, like the Israeli separation barrier. For now, however, most of this work remains hidden, seen only in local environs by local community members.

Another Palestinian *shahid*, or martyr, depicted in a memorial mural is Ghassan Kanafani. He was a writer involved in the Palestine Liberation Organization who was assassinated by a car bomb in 1972. In the photograph, a woman walks by the mural; Kanafani stares out into the distance (Figure 6.13). The presence of passersby in a photograph provides more than scale. In the murals I photographed, they seem to blend with the identity of the subject portrayed,

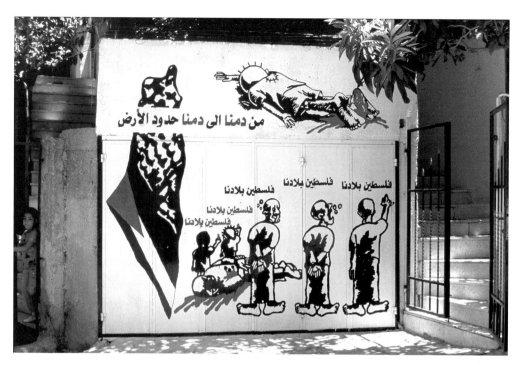

FIGURE 6.16. *Handala Memorial Mural*, Dheisheh Palestinian Refugee Camp. This stark monochromatic image depicts Handala both as a murder victim and a resurrected witness. The text at the top reads: "Palestine is for Palestinian blood." Photograph by Philip Hopper, 2011.

helping the memorialized dead, in a very real sense, retain a semblance of life. The photograph was taken in Dheisheh, not far from the location of Kfah Obeid's memorial mural. The woman does not look at the mural but ahead to her destination or the next street corner. Photographs of a Palestinian woman who passes by, a man walking past a paramilitary mural in his slippers, or a Muslim walking past a 9/11 mural in America—all contextualize painted images in popular culture (Figure 6.14). These are people who, for one reason or another (perhaps overfamiliarity or perhaps underfamiliarity) do not even look at the images as they walk past. However, even though their responses are "automatic" and the murals seem largely invisible to them, the murals serve as cultural markers of the liv-

ing in real time. Hyman's photographs of 9/11 murals and street memorials regularly include the living. Additionally, his photographs sometimes record interesting or jarring juxtapositions between the imagery and message in a mural and those who happen to pass by at a given point in time, thereby accentuating both the immediacy of these images and a continuing sense of loss (Figures 2.11 in Chapter 2 and 3.1 in Chapter 3, and Figure 6.15).

The Kanafani mural is part of a body of graphically sophisticated work that draws on a long history of Palestinian political cartooning and has emerged in Dheisheh and other locations. As noted, Handala, Naji al-Ali's iconic barefoot boy, often serves as a witness within some of these larger murals. Handala does not look out of the frame;

rather, he looks in to it. He sees what we see and is potent precisely because he is a witness to injustice and corruption. In Kfah Obeid's memorial mural, he witnesses the death of a child. In another image, he is one of several witnesses to his own death (Figure 6.16). The inscription at the top of the mural reads: "Palestine is for Palestinian blood." The text below, written in black and also blood red, contains a slogan that repeats "Palestine is our country" over and over again. Here, Handala is not only a witness to others' suffering but also embodies the hope for a resurrected and autonomous Palestinian state.

Beyond the Photograph

In documentary photography, a visual record cannot stand alone. Captions or titles simply cannot contain enough information, and texts that support visual information require multiple readings. This point has been made before, but it seems that in our era of "convergent journalism,"[7] a reminder may be helpful. A full record requires many forms of evidence, documentation, and investigation. Moreover, it requires many witnesses, both of actual events and their residual, or secondary, meanings. Photography is a way that practitioners like Jonathan Hyman and I can participate in national and international discussions about the creation and impact of visual culture, political conflict, and memorial expression across cultures. In the end, our photographs provide just one small way—and one particular medium out of many—to try to make sense of difficult times.

Note

1. For an excellent timeline of key events leading up to "The Troubles," see the University of Ulster website at http://cain.ulst.ac.uk/. For an exhaustive record of the visual culture of this conflict, see http://cain.ulst.ac.uk/photographs/.

2. *Renewing Communities: The Government's Response to the Report of the Taskforce on Protestant Working Class Communities*, available on the website of the Department for Social Development in Northern Ireland, www.dsi.gov.uk/, p. 42.

3. *Ibdaa* is an Arabic word that means "beginning" or, in the local vernacular, "something out of nothing."

4. A map of the Israeli separation barrier can be downloaded free from the B'TSELEM website: http://www.btselem.org/english/separation_barrier/.

5. See Rebecca Harrison, "Bethlehem Residents Vandalise Banksy Graffiti," *Guardian Weekly*, December 21, 2007.

6. Conversations with Jonathan Hyman, October 2009 to the present.

7. See Stephen Quinn, *Convergent Journalism: The Fundamentals of Multimedia Reporting* (New York: Peter Lang, 2005); and Jeffrey Wilkinson, *Principles of Convergent Journalism* (New York: Oxford University Press, 2009).

STRATEGIC STRIKES

IMAGES OF WAR AND DISASTER FROM IRAN TO AMERICA

Christiane Gruber

Those who lived through the events of 9/11 frequently tell us that for them the attacks remain, then and now, "beyond words." This statement might not strike us as bizarre, since trauma can shock us into silence or move us to express ourselves in nonlinguistic ways. Despite the difficulties, both political and emotional, that attend attempts to verbalize the response to such traumatic events, much ink has been spilled about the attacks and the consequent "War on Terror," deepening a perceived religious and cultural chasm between America and the Islamic world. However, now that more than a decade has passed since 9/11, a new picture of what unfolded in the arena of everyday life can be painted, thanks to the visual materials recorded by Jonathan Hyman, who traveled widely over the course of ten years, recording the many murals, memorials, tattoos, and ephemera that emerged during the aftermath of the coordinated attacks. Indeed, Hyman's unmatched photographic dossier presents us with what we might call a visual culture of trauma within contemporary America, thereby revealing how poignant expressions of grief and loss can take shape pictorially—and thus well "beyond words."

Mural arts, which are at the center of this brief contribution, are not a new phenomenon in the United States or elsewhere in the world. However, what is markedly different about the 9/11 murals recorded by Hyman is their emergence from, and their expressive indebtedness to, the worst attack on domestic soil in U.S. history. Not part of a top-down programmatic effort to embellish the ragged walls of inner-city neighborhoods, the murals flourished from the ground up, especially in and around New York City, filling in the concrete cracks available for public expression. Beyond a rather restricted palette of sentiments, the visual materials likewise display a relatively narrow repertoire of symbols and messages. Often depicting the U.S. flag, the eagle, Uncle Sam, the Statue of Liberty, the twin towers, and other national signs and sites, murals and other forms of public art

clearly fall within the parameters of patriotic expression (Figure 7.1). They do not criticize the status quo, and they do not engage in critical self-reflection.[1] To the contrary, they project outward to their viewers, both proclaiming and warning, for example, that "God forgives, but we don't." Not infrequently, they also declare war against a murky enemy made visually incarnate through the figure of Osama bin Laden.

Limited rhetoric, stock images, and iconographic shorthands such as these are typical of art in the public sphere, especially during tense periods of trauma and war. Not surprisingly, street art and graffiti are often likened to violent acts: they form a speedy "bombing" of the urban landscape, with the visual and textual messages part and parcel of an artist's armory. From images plastered anywhere and everywhere to those mounted singly

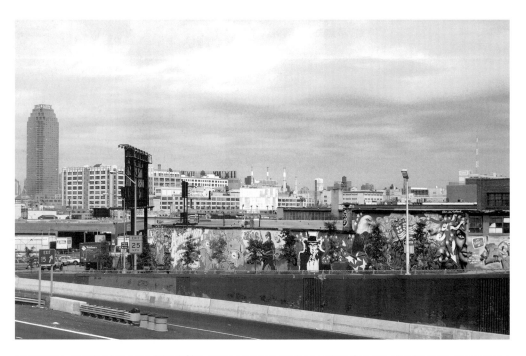

FIGURE 7.1. *Looking into Long Island City*, group mural by various artists, Queens, New York. Photograph by Jonathan Hyman, 2005.

in high-profile areas, muralists indeed use the artistic equivalents to carpet bombing and strategic strikes. On the one hand, this kind of urban Blitzkrieg harnesses rhetorical weapons to stake a belligerent stance toward a real or imagined enemy; on the other, it also provides fertile ground for formulating counterhegemonic discourses about culture, identity, and power. However, with anti-establishment narratives almost entirely absent from the mural arts of 9/11, memorial messages lead the way, frequently amplified by resistant or combative motifs.

In both form and content, many murals that emerged in America after 9/11 find close parallels in Iranian visual arts produced during the Iranian Revolution (1979) and the Iran-Iraq War (1980–1988). To point out the similarities between these materials might at first appear unexpected, especially since aligning Iranian and American visual culture is not an exercise that is commonly undertaken. Perhaps more problematically, it may also seem misplaced to embark on such a task since it sidesteps and rejects popular views on culture today, which unfortunately promote a perceived clash of civilizations[2] or announce the "axis of evil" *du jour*. However, even a cursory glance at American and Iranian murals makes it amply clear that they are not as far removed as one might imagine, and thus are deserving of paired study.

This said, cross-cultural and comparative work is never an easy task, since nationalist projects, cultural identities, and individual emotions are always at stake. When one engages in this kind of research, one must per force approach verbal and visual expressions not as unique and thus incomparable, but rather as common to a broader human experience and therefore similar in a number of salient ways. In other words, constructions of "self" and "other" can be placed side by side and analogized, especially if they are bound to one another through geopolitical relations.

However, when it comes to disaster, war, and trauma, the scholar treads on thin ice. This is in part due to the heightened emotions and sensitivities of those who suffer the loss of loved peoples and places. Further, most victims describe their own suffering as deep, acute, and trenchant—in brief, matchless. Such superlative statements consign suffering to the sphere of inimitability. Responding to this phenomenon, for example, Susan Sontag points to the outcry expressed by Sarajevans over a 1994 exhibition comparing photographs of their suffering with that of Somalis, stating: "Victims are interested in the representation of their own suffering. But they want the suffering to be seen as unique. [. . .] It is intolerable to have one's own suffering twinned with anybody else's."[3] Time and again, the pain of others simply drops out of the equation.

Yet it is possible, even fruitful, to twin images of suffering in order to explore the themes that emerge through their intersections. Such comparisons are admittedly never one-to-one, and surface similarities should not be oversimplified. Instead, through iconographic and verbal overlaps, it becomes quite clear that visual cultures of war and trauma share an alluring array of thematic correspondences that reveal to us the various ways humans—regardless of their national, cultural, and religious affiliations—can express a range of emotions by means of a visual language based on commonality rather than difference.

Although the parallels between Iranian and American images linked to war and disaster are too numerous to discuss here, a few common threads can be drawn out from the visual corpus.

Perhaps most importantly, the murals stubbornly reject fear, especially in its doubly inert forms of passivity and stasis. Instead, fear turns into firm resolve as well as a rallying cry to action and revenge through a series of counteroffensives, themselves deployed via assaultive visual devices in the public sphere. In this sense, vigilance is not thought of merely as an intramural act of self-preservation, but rather as a triumphalist projection of self through the issuing of counterstrikes that are couched as rightfully (even necessarily) combative in nature. Like death itself, fear is thus not without redeeming consequence, while lost souls are not just deceased—they are martyred and memorialized for a greater cause. The ends are typically described as transformative, and thus martyrs promise resurrection for the single body as well as a rekindling of society as a whole. In America and Iran, martyrdom thus partakes in the metaphorical language afforded by both Christian and Islamic conceptions of the sacred. By harnessing and subverting icons drawn from national cultures and religious belief systems, moreover, the murals coalesce to create new religious vernaculars that elevate the dual concepts of salvation and rebirth.

Shock Absorbers

From newspaper articles to television and computer screens, and onward to large murals and diminutive stamps, visual representations of war and disaster are like surround sounds: they encircle us, screaming for the crumbs of our easily diverted attention. When their imageries incline toward the violent and vitriolic, they turn into what Sontag has called "shock-pictures,"[4] whose pitch can be adjusted and tuned up at will. To be sure, as shock-pictures, images with graphic content invite us to look, observe, and cogitate for a bit. By activating the cognitive process through a visual stimulus, shock-pictures serve to fight the onset of collective amnesia through the collapsing of time itself. As such, they function as "living memorials,"[5] enshrining history within the storehouse of lived reality. In a constructive manner, they can operate in therapeutic ways, helping to heal past wounds; less laudably, they also can act as persistent fearmongers, prolonging and crystallizing a frozen state of trauma over the long haul.

One way or another, graphic images can help absorb the shock of an attack. A prime example of this trend can be seen in the Iranian commemorative stamp that was issued two months after the July 1988 downing of Iran Air 655 (Figure 7.2). Shot by a guided missile launched from the *USS Vincennes* over the Straits of Hormuz, the Iranian passenger plane came tumbling down to sea, killing nearly three hundred Iranians, among them sixty-six children. It was by far the most devastating aerial attack on civilians in modern Iranian history. Although the United States expressed regret over this "tragedy" and offered monetary compensation to the families of the victims, it never fully admitted to its errors. Instead, officials used a whole range of dissimulative counterattacks, including stating that the plane was somehow on a suicide mission, thereby forcing the ship's captain

(William C. Rogers III) to launch the missile as a preemptive strike. The United States has never issued a formal apology for the mass killing,[6] and, to this day, Iranians believe that the American attack was deliberate and premeditated, acting as a forcible caveat to the Islamic Republic to put an end to its bilateral war with Iraq.[7]

Iranian visual materials that memorialize the U.S. downing of Iran Air 655 tend to depict the event in a synoptic way, using visual shortcuts to push forward a discourse of victimization. For example, in the commemorative stamp the guided missile cruiser is essentially a U.S. flag floating at sea, and thus functions a stand-in for America as a whole. Not an isolated event, then, the sea-born attack is here couched as one nation's pernicious program against a group of people inauspiciously suspended in midair. The stamp shows the contest as terribly asymmetrical. Moreover, the U.S. naval officers standing on the ship are shown as black silhouettes—faceless and rather formless—thus allowing an Iranian audience to overlay onto this shadow "enemy" a variety of narratives.

There are parallels to the attacks of 9/11. The crashing of two planes into the twin towers also was an aerial assault against civilians. The attack was also launched by an obscure enemy, in this case a miscellany of hijackers harking from Saudi Arabia, Egypt, Lebanon, and the United Arab Emirates. And it too is considered the most vicious terrorist attack on domestic targets in one nation's history. There are, of course, major differences between these two brutal events; however, the similarities help to explain the symbolic parallels that are found within both Iranian and American visual culture. For example, one airplane is depicted as crashing into the wall of a printing shop in Merrick, New York, directly beneath a dangling sign boasting plenty of parking space as well as below an inscription stating, "We Will Never Forget, 9-11-2001" (Figure 7.3).

The sphere of solemnity collides with quotidian life, crashing the sacred plane into the surface of a vernacular wall. Like the Iranian stamp, which can be affixed to a dispatched letter, the crashing plane serves as an outspoken missive—a heraldic sign of sorts—present in the public domain. The wall here absorbs the impact, in no small part thanks to an American flag, itself acting as the metonymic proxy for the collective nation, one of whose citizens here boldly declares to his potential customers that 9/11 will never be forgotten. This cement entombment therefore blends the language of memorialization with that of publicity, making it difficult to distinguish between a genuine feeling of patriotism and its contrivance for commercial gain. Even if profitable, consumption itself can be packaged as a patriotic enterprise, linked as it is to supporting domestic businesses and items "Made in the USA" or, alternatively, to other traditions of acquiring and taking home mementos from sacred sites in a practice that David Chidester and Edward Linenthal term "venerative consumption."[8]

The mural also issues a blunt command to never forget. However, forgetting is a natural mental process, while remembering—or rather, the imperative call against amnesia—frequently relies on interpretive aids and visual props. Put differently, remembrance, whether experienced in an eyewitness or proximate manner or else through inherited constructs and products, demands an explanatory apparatus

that fruitfully exploits multiple expressive modes, including the pictorial. Iranian and American visual materials such as stamps and murals that represent a national trauma therefore are exegetical in nature, serving to interpret as well as to absorb a massive blow. Above all, through multiplication and mutation, images of war and disaster essentially engage in the labor of ensuring memory's continuance, especially when events begin to be absorbed into the annals of history.

Liberty Lost

Past events can thus be kept alive and projected forward into the lived spaces of everyday life. Without a doubt, the public

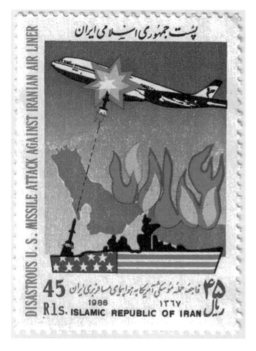

FIGURE 7.2. Stamp commemorating the downing of Iran Air 655 (July 3, 1988), issued on August 11, 1988. In author's collection.

FIGURE 7.3. *Plane Crash*, side wall of a printing shop, Merrick, New York. Photograph by Jonathan Hyman, 2005.

sphere and its mural arts provide urban venues for a variety of discussions and debates over the identity of a given society as imagined through its cultural entrepreneurs—whether state-sponsored agents or freelance street artists. In Iran, one major turning point in the Iranian Revolution that has been kept alive through regime rhetoric and the teaching of history in schools is the storming of the U.S. embassy in 1979–1980, when fifty-two Americans were taken hostage and held for well over a year. At this time, Iranians seized a number of secret papers from the embassy and used them to further their claims that the United States had actively intervened in internal affairs in order to destabilize Iran. These putative documents—along with the 1953

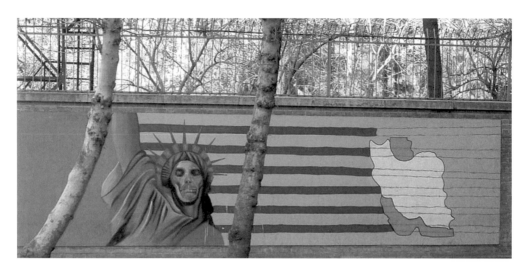

FIGURE 7.4. Statue of Liberty, U.S. flag, and map of Iran, "Den of Spies" (former U.S. embassy), Mousavi Street, Tehran, Iran. Photograph by Christiane Gruber, 2008.

coup against Mosaddeq and other real or imagined injustices leading to the events of 1979—cemented the image of the United States as pursuant in the politics of duplicity. By referring to the embassy as the "Den of Spies" and encircling it with graphic murals, the Iranian government ensures that tense episodes in American-Iranian relations remain on the agenda and can be stoked when necessary, even into the present day.

One mural on the embassy's walls uses figural imagery to make certain claims about American hegemonic power (Figure 7.4). Here, the face of the Statue of Liberty appears as a metallic cranium, while the red stripes of the American flag behind her slither forward and transform into barbed wire fences as they reach and traverse the map of Iran, bound by the Caspian Sea to the north and the Persian Gulf to the south. This site-specific mural uses the language of form alone, wholly divested of language, to transform the archetypical American symbol of life and liberty into an

instrument of death and subjection. What is curious in this case is that the strategic deployment of pictorial allegory is in essence parasitic of a famous American icon, rather than dependent on an internal Persian system of visual forms. Perhaps this is because the muralists are hoping to target a foreign audience to make their claims clear and legible, or else it is because images such as the Statue of Liberty belong more broadly to global (rather than strictly American) visual culture.

Lady Liberty has stood in the New York Harbor since 1886, an iconic symbol of the United States as a country welcoming of the world's poor and oppressed (Figure 7.5). As a threshold into the United States, she stands with a radiant crown, holding the torch of Enlightenment and a tablet inscribed with the date of the signing of the Declaration of Independence. On the statue's pedestal also appear inscriptions that describe her as a "mighty woman" and the "Mother of Exiles," with mild and welcoming eyes, beckoning the world to "give me

your tired, your poor, your huddled mass-es yearning to breathe free." As such, Lady Liberty is considered the embodiment of the United States, as well as the personi-fication of the concepts of freedom, inde-pendence, protection, and enlightenment.

When Iranian political grievances against the United States are expounded, they often use accusatory methods of counterpositioning. Certainly the branding of America as "The Great Satan" during the Iranian Revolution is the most famous example of this practice.[9] Visual invectives tend to be equally iconoclastic, in this in-stance dismantling the "mighty woman" into her polar opposite: that is, a metallic skull (not a fully fleshed face), topped with a crown of spikes (not light rays), while her torch and codex are nowhere to be found.

She has been dismembered and flayed, her symbolic attributes of enlightenment and independence eradicated from the picture. In Iranian tactics of striking back, Lady Liberty is just a ghastly specter—nothing but an internally degraded symbol of America's hypocrisy and tyranny when it comes to applying its highest ideals to countries other than itself. Or at least so goes the visual argument through its full-blown reversal of signs and their associ-ated meanings.

Political commentaries using Lady Lib-erty are as old as the statue herself. In America, artists in fact started subvert-ing her symbolic attributes even before the statue's official dedication in 1886. For example, in 1881, the political cartoonist Thomas Nast, inspired by mass demon-

FIGURE 7.5. Statue of Liberty, New York Harbor, 1886.

FIGURE 7.6. Thomas Nast, Statue of Liberty cartoon, *Harper's Weekly*, April 2, 1881.

strations against the unhealthy conditions of New York's streets, staged his own visual protest against official corruption (Figure 7.6). His protest took the shape of a satirical cartoon published in *Harper's Magazine*, in which a now skeletal Lady Liberty holds her torch upside down in her right hand and a Roll of Death in her left hand, while the pedestal upon which she stands includes the admonition "New York: Leave All Hope Ye That Enter" (itself based on the inscription above the gates of hell in Dante's *Inferno*). An American satirist commenting from within, Nast protests through visual metaphor, in effect equating New York to a latter-day Hades plunged into decay, death, and hopelessness.[10]

While Nast's cartoon proved a template for subsequent American cartoons that involved some form of internal political critique, a number of other depictions show the Statue of Liberty as a maternal figure that embodies a caring and nurturing motherland. As an anthropomorphized patria figure, Lady Liberty is often invested with emotive depth, welcoming her children in her warm embrace or else shedding tears of pain and sorrow during moments of collective crisis.[11] It is this image of a maternal "Lamenting Liberty" that appears most often in the murals of 9/11, oftentimes with squinted eyes and teardrops cascading down her swollen cheeks (Figure 7.7). In comparison to other standard icons of the United States—such as the U.S. flag and the twin towers, which remain inanimate objects—Lady Liberty can be infused with life and thus can become a living face for collective grief on a national scale.

Whether Lady Liberty sheds tears of water or tears of blood, and whether she appears as a metallic cranium or a flayed

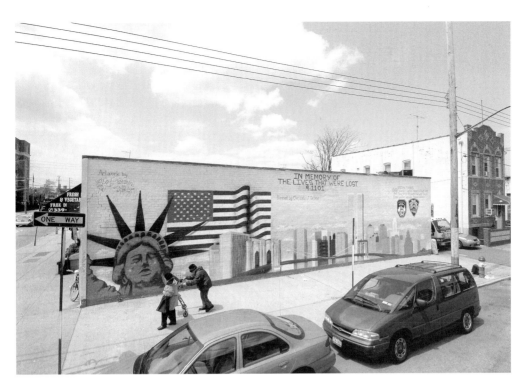

FIGURE 7.1. *Weeping Statue of Liberty*, Brooklyn, New York. Photograph by Jonathan Hyman, 2005.

corpse, she essentially fulfills parallel functions in Iranian and American visual cultures of war and disaster. In both cultural spheres, she comes to denote freedom or, if visually capsized, freedom corrupted or lost. As a recurring trope or popular formula, the Statue of Liberty signifies more broadly the peace of mind and preservation of body that come from not being under attack. However, with feelings of safety severely shaken, comforting images and "security narratives" must be formulated. As Erica Doss argues in *Memorial Mania*, the security discourses of 9/11 are aimed not only at restoring safety and harmony but also at perpetuating a general state of fear through omnipresent codes of mourning.[12] At the visual level, one could argue that images of a weeping Lady Liberty humanized an icon, joining those who lost

and suffered. On the other hand, such images also can engender feelings of anxiety, however inadvertently. As a result, this particular icon is affective in both senses of the word: it attempts to convey sincere emotions of grief and loss but it simultaneously acts as an artificial performance of pathos that spans the spectrum from heroic courage all the way down to pathetic cliché.

Just like visual images, slogans in trauma and war contexts often engage in invective, threat, and curse. In Iran, graffiti and street art exploded during the revolution, with cement walls marked by bloody handprints and battle cries like "U.S. get out of Iran" and "Death to America." The Islamic regime understood the rhetorical power of slogans and images in forwarding the basic principles of the revolution, and so quickly turned fleeting jingoistic messages into a

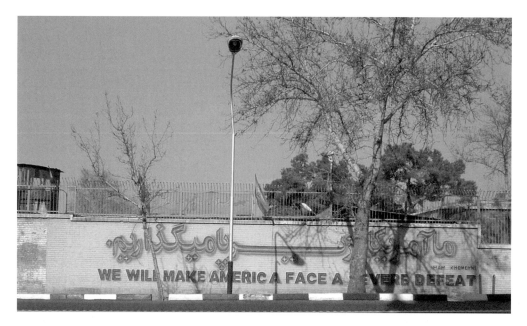

FIGURE 7.8. *We Will Make America Face a Severe Defeat,* "Den of Spies" (former U.S. embassy), Mousavi Street, Tehran, Iran. Photograph by Christiane Gruber, 2008.

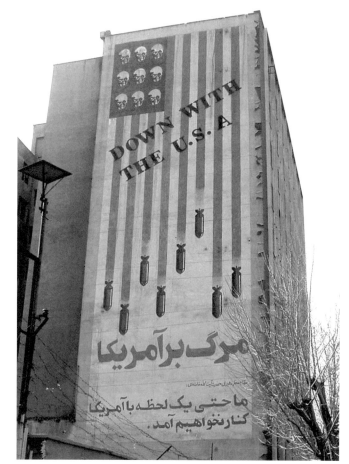

FIGURE 7.9. *"Down with the USA" (in English) or "Death to America" (in Persian).* Karim Khan and Qarani Streets, Tehran, Iran. Photograph by Christiane Gruber, 2008.

permanent official public arts program. The murals that have since emerged, including those dotting the perimeter of the U.S. embassy, essentially calcify a number of catchy revolutionary slogans and chants. These include, for example, "We Will Make America Face a Severe Defeat"[13] (Figure 7.8) and, on a fifteen-story high-rise, the menacing slogans "Down with the USA" (in English) and "Death to America" (in Persian) (Figure 7.9).[14] These slogan-murals are the products of the government and other semi-statal organizations, emanating from top-down endeavors. However, much like the murals of 9/11 in America, their genesis, messages, and ethos were all born in the street, spawned from spilled blood and nurtured by expressions of fear and anger. In Iran, however, the murals are folded under the umbrella of an official public art program; they are purposefully maintained and renovated; and they are put to ideological use by the state during national and religious holidays.

The bilingual English-Persian "Down with the USA" mural, which appears to aim for both a local and global audience, is further augmented by the image of the Star-Spangled Banner, which is altered so that the stars become skulls looming over a blue ground, while the stripes become blood-red bombs figuratively dropping on Iranian soil. As in the mural on the wall of the former U.S. embassy, in which the flag's red stripes turn into rows of barbed wire that crawl across a map of Iran, here another key icon of the United States is shown in two different modes: as the iconic "Old Glory" flag along with its inglorious mutation. The pictorial process of transformation has as its primary goal to show outwardly that which lies on the inside, a process em-

blematic of the Persian philosophical pursuit that seeks to distinguish between an entity's exoteric (*zahiri*) appearance and its esoteric (*batini*) nature. Through the tactic of visual metamorphosis, these kinds of images in essence seek to promote Iran as a savvy philosopher expounding on hidden truths as well as the ultimate decoder of America's inner core, itself pictured as deceitful and corrupt.

Assaultive Vulnerabilities

Besides embarking on a quest to expose the *batini* nature of the United States, Iranian murals also seek to combat the enemy through chest-thumping posturing. This, it seems, emerges essentially from feelings of vulnerability. Truth be told, aggressive behavior is not surprising in the least in such circumstances, since when humans find themselves in a fight-or-flight situation, they must choose one option or the other. If flight is inadmissible due to cultural codes of conduct, the only option is intimidation as response. As a natural stress response, then, a counterattack should also be considered a panic attack—a knee-jerk reaction induced by disorienting angst.

In Iran, panic hit hard during the revolution and war; in post-9/11 America it hit hard as well, and not just on cement walls. Bombings were unleashed on domestic soil and well beyond, all the way to Iraq and Afghanistan. On the home front, American graffiti artists led the strikes, "bombing" the blank walls of buildings, parking lots, and playgrounds with a wide assortment of messages, many of which are proudly assaultive in their visual language and verbal tenor. One such mural, expressly "made in the U.S.A.," shows a framed im-

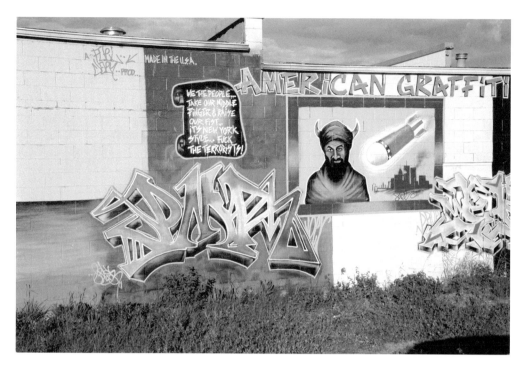

FIGURE 7.10. *We the People*, detail of mural on the side of a carpet store, Middletown, New York. Photograph by Jonathan Hyman, 2002.

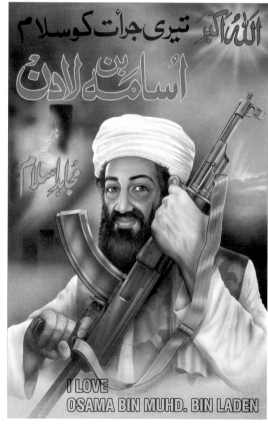

FIGURE 7.11. Poster of Osama bin Laden smiling as he holds a rifle, Lahore, Pakistan, 2001. The poster identifies bin Laden as the "Warrior of Islam" in the fiery background while an inscription located below proclaims affectionately: "I love Osama bin Muhd. [= Muhammad] bin Laden." Rays of white light burst out of the green inscription "God Is Great" (*Allahu Akbar*) in the poster's upper-right corner. Staatliches Museum für Völkerkunde, Munich, 02-323-605. Photograph courtesy of Marietta Weidner.

age of Osama bin Laden represented as a horned "eminence grise" with the twin towers ablaze in the background and a flag-designed missile in mid-flight, en route toward a most obvious target (Figure 7.10). To the left of the frame and immediately above the artist's calligraphic tag also appears a partially unwound scroll, chiseled with a statement transcribed in roughly hewn capital letters: "We the people . . . take our middle finger & raise our fist . . . it's New York style . . . fuck the terrorists!" Though written in the vulgate of street poetics, this epigraph recalls the preamble of the United States Constitution, which declares that "we the people" must seek to "form a more perfect union, establish justice, insure domestic tranquility, provide for the common defense, promote the general welfare, and secure the blessings of liberty to ourselves and our posterity." This verbal manifesto of defiance, along with its adjacent push-button imagery, is both fiercely protective and aggressive, wishing to secure defense and posterity for itself. With Newtonian flare, moreover, both text and image warn their reader-viewers that for every action there is always an equal and opposite reaction.

The mural presents visually its own disquisition on villainy, in turn mirroring and perhaps mimicking the notional "axis of evil" famously delineated by George W. Bush in his State of the Union Address on January 29, 2002. As the figurehead of al-Qaeda and the corporate stand-in for the aerial attacks, Osama bin Laden is represented in the mural as a shadowy, Lucifer-like character with horns sprouting out of his turban. He stares out in defiance, unaware of or unconcerned about the impending counterblow launched by a vic-

tim's urge toward revenge. Probably like its maker, the image refuses to turn the other cheek, as the Christian doctrine of nonviolence might dictate. Osama bin Laden is a fair target for the American street artist's ire. The vengeance does not need justification; the damage is done and must be avenged. Eye-for-an-eye, the image screams. It's payback time.

During periods of revolution, war, and disaster—or simply when two opposing entities face and dispute each other—turning to aggression is not necessarily contrary to seeking protection. Indeed, the wrangling for political and religious legitimacy also revolves around who is justified to use violence and consequently whose acts of belligerence can be claimed as morally necessary and therefore "righteous." In any number of cultural contexts, discourses on victimization make use of a range of "othering" tactics, including distanciation and demonization. For example, 9/11 victims of the aerial attacks frequently are referred to as "fallen heroes" and "martyrs"—and thus are ontologically incomparable to the "terrorists"—while Osama bin Laden is condensed into a symbol of supreme evil.[15] The American mural is a far cry from pro-*mujahid* visuals, in which this beloved "Warrior of Islam" is shown holding a rifle as he looks down upon his followers with a kind smile and the light of God shining down upon him (Figure 7.11).

During the Islamic Revolution in Iran, those who opposed the rule of Muhammad Reza Shah Pahlavi and who died in the process have been dubbed "martyrs" (*shuhada*) acting in the "way of God." Much like Osama bin Laden in American visual culture, within postrevolutionary Iranian graphic arts the monarch is shown as a

FIGURE 7.12. Reza Shah Pahlavi surrounded by devils, poster of the Iranian Revolution, ca. 1980. Special Collections Research Center, University of Chicago Library, Iranian Poster no. 164. Image courtesy of University of Chicago Library.

spectral presence. He often appears blinded to goodness and truth, corporeally disintegrating into a white haze of smoke. He also is shown encircled by wicked spirits grinning malevolently or whispering evil thoughts in his ear (Figure 7.12). From Iran to America and elsewhere, rivals and foes are remodeled into Satan or horned demons through the production of a "period rhetoric"[16] and its visual codes, concerned with figuratively distinguishing good from evil.

Within the realms of metaphorical thought and practice, at the individual level any person can exploit a variety of verbal and visual devices to confront an enemy—and this in no small part is a way to regain stability and control, or at least the semblance thereof. Like walls painted with the *memento mori* of 9/11, American roadside signs and storefront windows also provide zones for rooting collected forms of memory, voicing anger, and symbolically striking back. In one storefront window, we see these many elements at play through the collage of inscribed papers, newspaper clippings, diminutive flags, images, and photographs (Figure 7.13). Some of the written notes are commemorative and read: "For all our fellow Americans who lost their lives in this heinous act of cowardice . . . our thoughts and prayers are with you and your familys!! [*sic*]," "To those responsible for this act of war . . . your days are numbered!!!" With further triple exclamation points, an additional caveat warns: "You're either part of the problem or you're part of the solution. Choose wisely!!!" Interspersed between these verbal commemorations and warnings appear images of the Statue of Liberty, ground zero, the twin towers (as embodied by a police officer

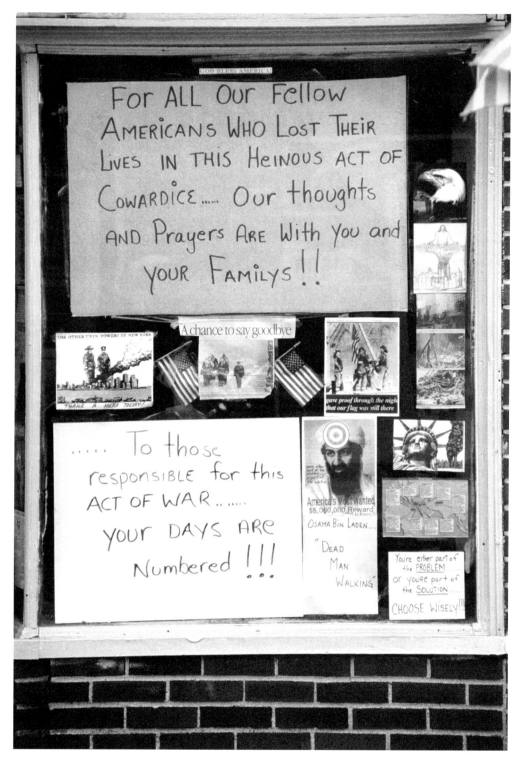

FIGURE 7.13. *Your Days Are Numbered*, storefront collage, Staten Island, New York. Photograph by Jonathan Hyman, 2002.

and firefighter), Jesus Christ rising from a cloud of smoke burning from the twin towers, and a photograph of a bald eagle. These many signs coalesce into a complex totality that relies on set images in support of state and religion, in turn positing itself against an enemy, represented here as Osama bin Laden with a bull's-eye pasted to his forehead and overwritten with the labels "America's Most Wanted" and "Dead Man Walking." The storefront window here functions as a relics case that enshrines the various visual and epigraphic remains of 9/11.

Whether in Iran or America, murals, graffiti, and other graphic media that emerge from situations of war and trauma disclose that ecologies of fear run in close parallel and that they flourish in part from feelings of vulnerability turned assaultive. Additionally, although visual materials draw a rather sharp dividing line between the angelic self and the demonic other, that line is difficult to uphold once an awareness—or what Judith Butler calls an "ethics"—of reciprocal vulnerability is established.[17] Without such an ethical approach, which carves out a place for bilateral engagements and mutual understanding, it is all too easy to point the finger and, Zola-like, bluntly scream "J'accuse!" to an all-but-clear enemy. What's more, in these types of frenzied situations, individuals run the risk of lapsing into forms of emotions and behaviors that enable fear to metastasize into attack—be it real or virtual.[18]

Trans-Substantiations

From anger to attack, a traumatic experience is both cognitively and spiritually transformative in a number of ways. The feelings of loss are likewise life-altering because they initiate new conceptions of self within systems of faith that attempt to provide meaning in death as well as hope in that which lies beyond it.

In Iran, it is estimated that up to 1 million young men lost their lives in the Iran-Iraq War. A number of coping mechanisms were developed in order to come to terms with the sheer enormity of the loss, one of which relied on the promise of restored life in the afterworld. Blending Islamic concepts of salvation in the afterlife with Persian mystical ideas about rejuvenation, Iranian wartime images engage in pictorial allegories to drive home the argument that those who perished live on, if not bodily then in spiritualized form. For these reasons, murals in Tehran have tended to represent a martyr with butterflies (or moths) and candles, as well as Ayatollah Khomeini's ethereal face floating above, a kind of divine *pater* benevolently overseeing his subjects (Figure 7.14).

The butterfly or moth is one of the most important motifs in classical Persian poetry, where it is described as a symbol for man's soul that, annihilated in God's fire, becomes one with the divine. As such, it functions as a symbol of most faithful love, oblivious to itself and sacrificial of itself.[19] Through its self-immolation, the moth lives on; this process is analogized to the martyr's self-sacrifice and his continued existence in the realm of God. Likewise, the martyr is frequently likened to a candle that extinguishes itself, thereby rekindling society as a whole. As Ayatollah Morteza Motahhari (d. 1979), one of the most influential ideologues of the Iranian Revolution, famously stated on the subject: "The martyr can be compared to a candle whose job it

is to burn out and get extinguished in order to shed light for the benefit of others. The martyrs are the candles of society. They burn themselves out and illuminate society."[20] Without needing the buttress of the written word, the two abstracted symbols of the butterfly and candle—themselves legible to an Iranian audience conversant with such culturally encoded signs—argue that death is not without meaning or purpose. To the contrary, death brings with it the promise of continued life in the all-encompassing unity of God.

In America, similar motifs and metaphors are used in mural depictions of the "fallen heroes" of 9/11. For example, one mural in a schoolyard playground shows the disembodied head of a young man named Roland emerging radiant from the smoke of ashes, with four burning candles on the right and an unwound scroll on the left (Figure 7.15). The scroll is inscribed with a message written in a lapidary script composed of uppercase letters, commanding the viewer to

RAISE UP A FLAG, LET FALL A TEAR, / ON THIS OCCASION WEEP— / LAMENT THE FALLEN LYING HERE / AND DON'T LET YOUR MEMORY SLEEP. / NEVER AGAIN TO BE DECEIVED / DECLARES THE POWER OF OUR BELIEFS. // AS THOSE WHO BROUGHT THEIR FALLEN HOPES / TO WHERE THE SEAS OUR CITY WASHES, / WE'LL SEE THEIR SPIRITS LIVE AGAIN / AS THE PHOENIX RISES FROM THE ASHES.[21]

The inscription analogizes the martyr's eternal spirit to the rising of the phoenix from the ashes, in a figurative resurrection not too dissimilar from the butterfly. However, the symbol of the phoenix is not rooted in Persian poetic expression but rather in Christian doctrine, where it functions as an analogy for the resurrected body and spirit of Jesus Christ. By drawing upon Christian narratives, the phoenix symbolizes the promise of the body's revival, transformed and imperishable.[22] Whether in Iranian or American contexts, such murals encourage a transformative spiritual process for society through a series of trans-substantiations, which themselves promise a restitution of life. This form of initiatic passage toward purity and eternity is shown in a number of religious contexts, including Christian and Islamic ones, as achieved through a kind of sacrificial baptism in blood.

Beyond addressing resurrection through martyrial paradigms, many 9/11 murals further expand the symbolic seams of religious experience. These vernacular expressions of the vox populi are consecrated by meta-narratives that tackle the problem of salvation in the duality of its temporal dimensions: namely, salvation in the here and now (freedom and safety from attack) and salvation in the hereafter (corporeal and spiritual resurrection). To give redemptive meaning to the attacks, many murals include religious imagery, including the resurrected Christ, the bleeding heart of Christ, the Virgin's assumption to the heavens, weeping angels and crying cherubs, crucifixes (some of which are Celtic crosses), and hands clasped in prayer. They also include inscriptions that implore God, such as the warning that "God forgives, but we don't," or, in greater religious obedience, "In God We Trust" and "God Bless America." These many elements—both iconographic and epigraphic—add a palpable patina of the sacred to street art, itself a practice that we might otherwise (and, quite obviously, erroneously) con-

sider merely a secular visualization of colloquial speech.

Alongside religious images and captions, a frequently recurring motif in the 9/11 murals is that of the inscribed scroll (as in Figures 2.8 and 2.33 in Chapter 2, and Figures 7.10 and 7.15 in this chapter). The rotulus form itself is archaizing and suggestive of sacred scriptures, including the Dead Sea scrolls (the oldest surviv-

ing collection of biblical texts) and Torah scrolls. As such, a number of American murals attempt to use an age-old writing surface indicative of God's revelations to mankind, ensconcing 9/11 narratives into a religious plane that stretches back to a distant past. Similarly, the scroll recalls the founding texts of the United States, in particular the Declaration of Independence, which was written on a parchment scroll

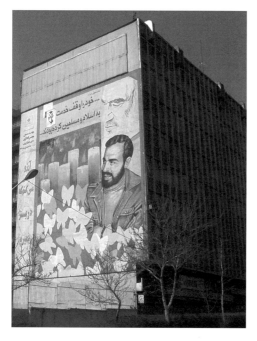

FIGURE 7.14. *The Martyr (Shahid)*, Sepahbooh Qarani Street, Tehran, Iran. Photograph by Christiane Gruber, 2008.

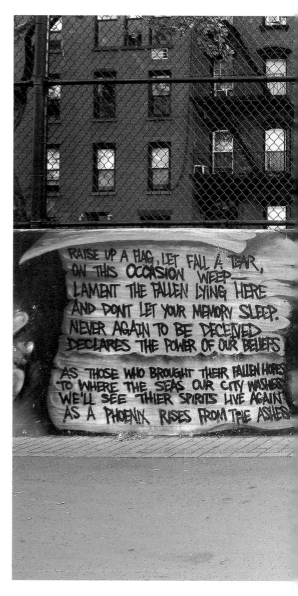

FIGURE 7.15. *Roland Tribute*, schoolyard mural, Brooklyn, New York. Photograph by Jonathan Hyman, 2006.

in an old-fashioned cursive script known as "copperplate" calligraphy. Like other scripts that look like etchings, or are somehow chiseled or lapidary in quality, copperplate calligraphy rejects modern typography in favor of more ancient written forms that were used in texts at the heart of the United States as an independent nation-state. These scroll and script forms blend religious and national vocabularies, creating painted manifestos that call for revenge or else issue mandates bidding remembrance and respect. Just like other images that engage in trans-substantiations, they too cast street argot as sacred language.

Reflections

More than thirty years have passed since the Islamic Revolution in Iran, and over a

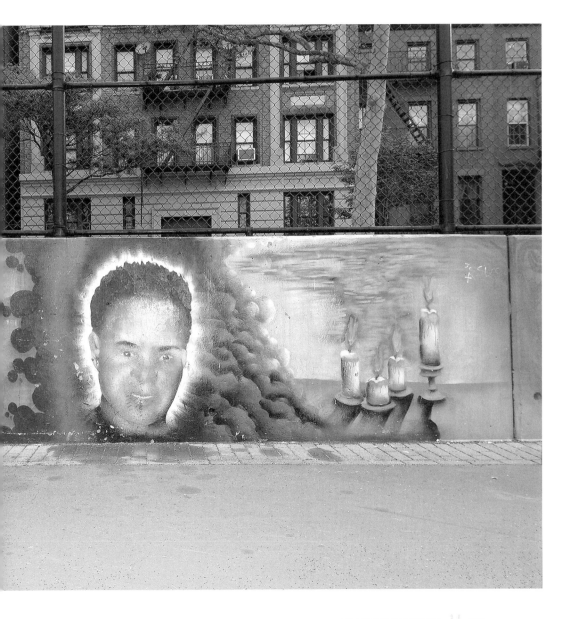

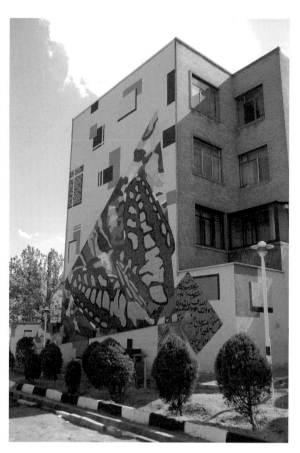

FIGURE 7.16. *Butterfly Mural*, Jalal-e Ahmad Street, Tehran, Iran, 2004. Photograph courtesy of Pamela Karimi, 2010.

FIGURE 7.17. *Flower Power Mural*, Manhattan, New York. Photograph by Jonathan Hyman, 2002.

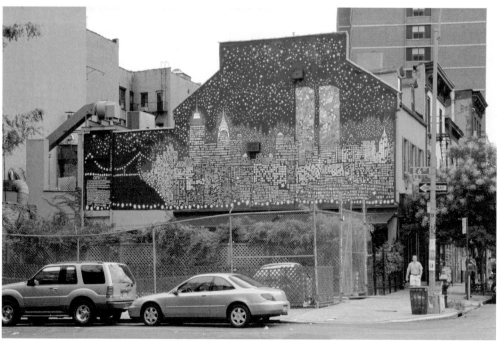

decade has gone by since 9/11. It is said that time heals, and visual expressions of grief and anger may help in the healing process. Along with the passage of time, Iranian murals have lost some of their initial mordancy, with martyrs giving way to butterflies that nevertheless retain the message that deceased souls will ascend to heaven to dwell with God (Figure 7.16). Similarly, in America, a few 9/11 murals do not engage in visual counterstrikes or patriotic posturing, instead opting for a more muted palette of colors as well as a more starry-eyed view on the potential power of peace (Figure 7.17). Such images essentially argue for a spiritual transcendence of shock and anger, heralding a more hopeful vision of the future while concurrently being vigilant to not forget the past.

We are told that images are worth a thousand words, but they also can "do" many things. In moments of war and disaster, images can shock and they can bring comfort. They can engender fear and anger, and they can activate feelings of renewal and hope. They also are comparable, even across disparate cultures, because they emerge from the same pool of human emotions, regardless of religious differences and the accretions of cultural practice that separate peoples into distinct groups. Indeed, in twinning images of war and disaster from postrevolutionary Iran and post-9/11 America, we cannot help but become aware of the other's vulnerability, thereby realizing that we are all interconnected beings. These images encourage us to look at the other with the grace and humanity with which we ourselves would like to be looked upon. And in searching a little deeper, perhaps we will find within us a reflection of the other.

Notes

I wish to thank Edward Linenthal and Jonathan Hyman for our many spirited discussions and their helpful comments on an earlier draft of this article, as well as the Institute for Iranian Studies, which provided a senior postdoctoral fellowship that enabled me to gather further images of Iranian murals while in residence in Tehran during fall 2007.

1. This is also the case for 9/11 cartoons, which likewise exclude critical commentary, opting to act as tributes and memorials instead. See Donna Hoffman and Alison Howard, "Representations of 9-11 in Editorial Cartoons," *PS Online* (April 2007), 272; www.apsanet.org/imgtest /PSApr07Hoffman_Howard.pdf.

2. On the notion of the inevitability of intercivilizational strife, see Samuel Huntington, *The Clash of Civilization and the Remaking of World Order* (New York: Touchstone, 1997).

3. Susan Sontag, *Regarding the Pain of Others* (New York: Picador, 2003), 112–113.

4. Ibid., 7.

5. On "living memorials," see Andrew Shanken, "Planning Memory: Living Memorials in the United States during World War II," *The Art Bulletin* 84, no. 1 (March 2002): 130–147.

6. For a discussion of the various problematic U.S. explanations on the downing of Iran Air 655, see Robert Fisk, *The Great War for Civilization: The Conquest of the Middle East* (New York: Alfred A. Knopf, 2005), 318–331, with Reagan quoted on p. 319 as saying that it was a "tragedy" and that "his expressions of regret are [thus] sufficient."

7. Elizabeth Gamlen and Paul Rogers, "U.S. Reflagging Kuwaiti Tankers," in *The Iran-Iraq War: The Politics of Aggression*, ed. Farhang Rajaee (Gainesville: University of Florida Press, 1993), 142–145.

8. See the analysis of the *USS Arizona* at Pearl Harbor in David Chidester and Edward Linenthal, "Introduction," in *American Sacred Space*, ed. David Chidester and Edward Linenthal (Bloomington: Indiana University Press, 1995), 4. The authors point out that tourist pilgrims come to pay their respects but also buy "relics" at Pearl Harbor. Such relics include T-shirts, books, slides, videotapes, maps, and photographs.

9. For a detailed discussion of America as the "Great Satan," see in particular Abbas Amanat, "Khomeini's Great Satan: Demonizing the American Other in the Islamic Revolution in Iran," in his *Apocalyptic Islam and Iranian Shi'ism* (London: I. B. Tauris, 2009), 199–219; and William Beeman, "Images of the Great Satan," in his *The "Great Satan" vs. the "Mad Mullahs": How the United States and Iran Demonize Each Other* (Westport, Conn.: Praeger, 2005), 49–67.

10. Roger Fischer, "Oddity, Icon, Challenge: The Statue of Liberty in American Cartoon Art, 1879–1986," *Journal of American Culture* 9, no. 4 (1986): 64 and fig. 1.

11. Ibid., 69 and fig. 8.

12. Erika Doss, *Memorial Mania: Public Feeling in America* (Chicago: University of Chicago Press, 2010), 147–150.

13. The Persian statement above the English inscription reads literally: "We will place America under our feet."

14. For further discussion of these murals, see Christiane Gruber, "The Message Is on the Wall: Mural Arts in Post-Revolutionary Iran," *Persica* 22 (2008), 21–25 and figs. 3–5.

15. In post-9/11 America, images of evil were not confined to representations of Osama bin Laden. For example, the face of Satan was thought by some television viewers to be decipherable within the large clouds of smoke billowing out of the twin towers after they were hit by the hijacked planes. See http://www.christianmedia.us/devilface.html.

16. On "period rhetoric," see Stuart Hall, "Encoding, Decoding," in *The Cultural Studies Reader*, ed. Simon During (London: Routledge, 1993), 96–97.

17. Judith Butler, *Precarious Lives: The Powers of Mourning and Violence* (London: Verso, 2004).

18. On fear, "group think," and violent behavior, see Joanna Bourke, *Fear: A Cultural History* (Emeryville, Calif.: Shoemaker & Hoard, 2005), 65.

19. Annemarie Schimmel, *A Two-Colored Brocade: The Imagery of Persian Poetry* (Chapel Hill: University of North Carolina Press, 1992), 198–199.

20. See his essay "*Shahid*" [Martyr] in *Jihad and Shahadat: Struggle and Martyrdom in Islam*, ed. Mehdi Abedi and Gary Legenhausen (Houston: Institute for Research and Islamic Studies, 1986), 126.

21. Through the text's particular layout, "Roland" has been spelled in the first six lines of the inscription's left vertical column.

22. On the phoenix as a symbol of Christ's resurrected body in Christian thought, see Valerie Jones, "The Phoenix and the Resurrection," in *The Mark of the Beast: The Medieval Bestiary in Art, Life, and Literature*, ed. Debra Hassig (New York: Garland, 1999), 99–115.

CONTRIBUTORS

Charles Brock is Associate Curator of American and British Paintings at the National Gallery of Art in Washington, D.C., where he has worked since 1990. In addition to his expertise in American and British painting, Brock has participated in a number of important projects related to photography. He was a major contributor to the catalogue for the landmark show *Modern Art and America: Alfred Stieglitz and His New York Galleries* (2001) and in 2006 authored *Charles Sheeler: Across Media*. Among the numerous other publications Brock has contributed to are *Winslow Homer* (1995), *James McNeill Whistler* (1995), *The Victorians: British Painting, 1837–1901* (1997), and *American Modernism: The Shein Collection* (2010). Brock most recently served as the volume editor of the catalogue for the critically acclaimed retrospective exhibition *George Bellows*, organized by the National Gallery of Art in 2012. He is currently working on a show devoted to the first generation of American modernists.

Christiane Gruber is Associate Professor of Islamic Art at the University of Michigan, Ann Arbor. Her primary field

of research is Islamic book arts and paintings of the Prophet Muhammad. She is the author of *The Timurid Book of Ascension (Mi'rajnama): A Study of Text and Image in a Pan-Asian Context* (2008) and *The Ilkhanid Book of Ascension: A Persian-Sunni Devotional Tale* (2010). Gruber's second field of specialization is modern Islamic visual culture, about which she has written several articles, including "The Writing Is on the Wall: Mural Arts in Post-Revolutionary Iran," *Persica* 22 (2008). Moreover, with Sune Haugbolle, she recently finished editing a volume entitled *Visual Culture in the Modern Middle East: Rhetoric of the Image* (2013), and her next book, *The Art of Martyrdom in Post-Revolutionary Iran*, examines the visual and material culture of the Islamic Revolution and Iran-Iraq War from 1979 to today.

Robert Hariman is Professor in the Department of Communication Studies at Northwestern University. His publications include *Political Style: The Artistry of Power* and *No Caption Needed: Iconic Photographs, Public Culture, and Liberal Democracy*, co-authored with John Louis Lucaites. He and Lucaites also maintain the blog *No Caption Needed*, where they provide commentary on photography, politics, and culture.

Philip Hopper is currently an independent artist and scholar. He was awarded a Fulbright to teach and conduct research at Al-Quds University in the West Bank during the 2012–2013 academic year. He also has twelve years full-time experience as faculty at the college and university level. He wrote and produced the television documentary *Route 66: The Road West,* which aired in the United States on A&E and in Japan on NHK, and which has been presented at the Smithsonian Institution in Washington, D.C. Another of his documentary films, *The Road Home,* profiles a group of servicemen and women, who were injured in Iraq and Afghanistan, as they go through physical therapy and then compete in the New York City Marathon. It won the Best Feature-length Documentary Award at the 2008 Garden State Film Festival. Hopper's photography has been displayed at the Central Branch of the Brooklyn Public Library, the Exit Art Gallery in downtown Manhattan, the New Jersey Center for Visual Art, and many other venues. His long-term photojournalism project, *Images of Conflict and Conflict Resolution in the Public Sphere,* includes images of murals and graffiti from Belfast, Northern Ireland; the Palestinian West Bank; and Israel. He holds an MFA from the San Francisco Art Institute.

Jonathan Hyman is a freelance photographer and Associate Director for Conflict and Visual Culture Initiatives at the Solomon Asch Center for Study of Ethnopolitical Conflict at Bryn Mawr College. He holds an MFA in painting from Hunter College in New York City, where he was an Eagelson Scholar and a Somerville Art Prize recipient. His main areas of interest include memory, memorialization, social class, and public art. He has lectured widely in the United States and Europe about his work and experience documenting the vernacular responses to 9/11. His photographs have been exhibited in solo exhibitions at the National September 11 Memorial & Museum, the National Constitution Center, and the Duke University Special Collections Library. His work has been published

in *Time* magazine and the *New York Times*, and has been featured on the *PBS News-Hour* as well as in other print and online media outlets in the United States and Europe. Hyman lives in the upstate community of Bethel, New York, with his wife, Gail, daughter Jane, and German Shorthaired Pointer, Quincy.

Edward T. Linenthal is Professor of History and Editor of the *Journal of American History* at Indiana University, Bloomington. His books include *Sacred Ground: Americans and Their Battlefields*, *Preserving Memory: The Struggle to Create America's Holocaust Museum*, and *The Unfinished Bombing: Oklahoma City in American Memory*. Linenthal has been a longtime consultant for the National Park Service, and from 2002 to 2005, he was a Visiting Scholar in their Civic Engagement and Public History program. He has been a Sloan Research Fellow in the Arms Control and Defense Policy Program at MIT and a member of the Flight 93 National Memorial Federal Advisory Commission.

John Louis Lucaites is Professor of Rhetoric and Public Culture in the Department of Communication and Culture at Indiana University. He is also an adjunct professor in American Studies. His most recent work focuses on the relationship between rhetoric and contemporary visual culture, and in particular on the role that photojournalism plays as a mode of public art that functions as a key site of critical and inventional engagement in liberal-democratic public cultures. He is the co-author (with Celeste Michelle Condit) of *Crafting Equality: America's Anglo-African Word* (1993) and (with Robert Hariman) of *No Caption Needed: Iconic Photographs, Public Culture, and Liberal Democracy* (2007). He also has edited (with Carolyn Calloway Thomas) *Martin Luther King, Jr., and the Sermonic Power of Public Discourse* (1993) and (with Barbara Biesecker) *Rhetoric, Materiality, and Politics* (2009). He co-hosts, with Robert Hariman, the blog *No Caption Needed*, a daily analysis of the visual carnival of democratic public culture with a focus on photojournalism. He is also a contributing editor to the blog *BagNews*.

Jan Seidler Ramirez is Chief Curator and Director of Collections for the National September 11 Memorial & Museum in New York City. Prior to her appointment in April 2006, she worked as consulting curator to the memorial museum with Howard+Revis Design. Previously, she served as Vice President and Museum Director of the New-York Historical Society, where she played a major role in developing that institution's History Responds initiative, a series of exhibitions, public programs, and collection acquisition efforts focused on the 9/11 attacks in their broad historical context. Ramirez has held curatorial, interpretation, collections management, and directorial posts at several museums in Boston and New York over the past three decades. She also has taught and lectured on American arts and antiques, interpretation of American historical subjects, and historic preservation at institutions and conferences across the country, and has authored numerous publications relating to American arts and cultural history. A graduate of Dartmouth College, she received a doctorate in American Studies from Boston University.

ADDITIONAL IMAGE CREDITS

Figure 1.1. Mural by Eddie Gonzalez.

Figure 2.1. Mural by Hope Gangloff, Jason Search, and others for "City Arts."

Figure 2.3. Mural by Fly I.D. crew: Clark, Ribs, Rath, and Clif.

Figure 2.4. Mural by Fly I.D. crew: Clark, Dave, Asylum, and Man One.

Figure 2.5. Mural by Rocco Manno.

Figure 2.6. Mural by Rocco Manno. In memory of FDNY firefighters who lived in and around Warwick, New York.

Figure 2.7. Mural by Joe Indart. In memory of Timmy Stackpole, Danny Suhr, Philip Hayes, Lucy Fishman, Kathleen Moran, and Brian Hennessey.

Figure 2.8. In memory of Timmy Stackpole, Danny Suhr, Philip Hayes, Lucy Fishman, Kathleen Moran, and Brian Hennessey.

Figure 2.10. Sculpture by Ted Walker.

Figure 2.12. Mural by Wizard of Art crew: Denise Cartelli-Arena, Melissa Cartelli, Jennifer Arena, and Allyson Arena.

Figure 2.13. Tattoo on the back of FDNY firefighter Kirk Smith.

Figure 2.14. Construction by Jared Stevens.

Figure 2.15. Tattoo by Angel. In memory of Paul Salvio.

Figure 2.16. Tattoo by Dave Lopez on the leg of retired FDNY firefighter Anthony DeRubbio. In memory of FDNY firefighter David DeRubbio.

Figure 2.18. Masks by Gorgi "Liberty George" Dukov.

Figure 2.19. Mask by Gorgi "Liberty George" Dukov.

Figure 3.7. Mural by Matthew Ahrendt, Joseph Somma, and Joe Marino.

Figure 3.8. Tattoo by Jim Quinn on the arm of William Pfaff.

Figure 3.9. House display by Don Jones.

Figure 3.10. House painted by Kevin Sabia.

Figure 3.11. See credit for Figure 2.3.

Figure 3.12. Memorial founded and overseen by Wendy Pelligrino, with landscaping by Fred Ariemma.

Figure 3.13. Engraving by Tony Sgobba.

Figure 3.14. Engraving by Tony Sgobba.

Figure 3.15. Tattoo by Chris Dingwell on the arm of firefighter Mike Johansson.

Figure 3.16. Mural by John Sacchitello.

Figure 3.17. Mural by John Pierce. In memory of Sheldon Robert Kanter, Brian E. Martineau, Deepika K. Sattaluri, Vincent Anthony Laieta, Kaaria Mbaya, Scott Schertzer, Kevin S. Cohen, Prem N. Patel, and Edward T. Strauss.

Figure 3.18. Truck painted by Jimbo.

Figure 4.4. Mural by Cope, T-Kid, Jew, Ces, Ewok, Yes2, and Jez.

Figure 4.5. Mural by Joe Indart. In memory of James Coyle, Steve Belson, Jeffery Palazzo, Randy Scott, and Kathleen Moran.

Figure 4.6. Mural by Jat, Meres, Leia, and Bisc Ars.

Figure 4.7. Mural by Phymeone. Wallnuts Crew.

Figure 4.9. Flag made by Phil Adamson, Linda Higby, and Crispell Middle School students.

Figure 6.3. Mural by Hulbert Waldroup.

Figure 6.4. Mural by Danny Devenny and others.

Figure 6.5. Mural by Danny Devenny and others.

Figure 6.7. Mural by Joe Indart.

Figure 6.15. Mural by Anthony Ewing. In memory of firefighter Vernon Richard and Carolyn Rogers.

Figure 7.1. Murals by Lady Pink, Smith, Erni, Muck, Dalek, Ezo, and Cycle.

Figure 7.3. Mural by Ron Buono.

Figure 7.7. Mural by Stem, Ynn, and Web.

Figure 7.10. See credit for Figure 3.7.

Figure 7.15. Mural by Meres.

Figure 7.17. See credit for Figure 2.1.

INDEX

Page numbers in italics indicate photos. The abbreviation "CS" indicates that a photo appears in the color section.

Abbott, Berenice, 6, 114, 117
Afghanistan: immigrants from, 95; Russian veterans of war in, 8; U.S. military engagement in, 7, 148, 167
African Americans, 151
al-Ali, Naji, 148, 149, 152
Alario, Peggy, 76n8
Alfred P. Murrah Building, 3
All Gave Some, Some Gave All (Fig. 2.28), 37, *38*, CS
Almon, Baylee, 3
al-Qaeda, 169
American Airlines Flight 11, 86, 101
American Airlines Flight 77, 100, 103
American eagles. *See* eagles, American
American flag: "Flagkeeper," and enormous handmade, 31–33; garage painted as, 54; house painted as, 49, 52–53, *96*; in Iranian murals, 8, 159, 162, 164, 167; in Jasper Johns's work, 119, *121*, 122, 124n9; meaning of, in 9/11 memorials, 3, 6, 8, 32–33, 44, 55, 56–57, 59, 63, *66*, 71, 89, *96*, 110n18, 118, 120, 121, 129, 130, 139, 164; raising of, at ground zero, 19, 32, 33, *69*, 127; trees painted as, *53*; vehicles painted as, 21, *57*
"America's Ride," 31
And We Got It (Fig. 2.8), 12, *16*, 44, 174, CS
angels, in memorial art, 37, 38, 39, 110–111n20, 127, 130, 132, 173